RECORD

for

G

MARINER BOOKS • A Mariner Original

COURTNEY E. SMITH

UNLEASHING YOUR INNER MUSIC NERD,
ONE ALBUM *at a* TIME

COLLECTING IRLS

HOUGHTON MIFFLIN HARCOURT BOSTON • NEW YORK • 2011

For information about permission to reproduce selections from this book,
write to Permissions, Houghton Mifflin Harcourt Publishing Company,
215 Park Avenue South, New York, New York 10003.

www.hmhbooks.com

Library of Congress Cataloging-in-Publication Data
Smith, Courtney E.
 Record collecting for girls : unleashing your inner music nerd,
 one album at a time / Courtney E. Smith.
 p. cm.
 ISBN 978-0-547-50223-6
 1. Rock music—Anecdotes. 2. Women rock music fans—
 Anecdotes. 3. Sound recordings—Collectors and
 collecting—Anecdotes. 4. Smith, Courtney E. I. Title.
 ML3534.S577 2011
 781.64'0266075—dc23
 2011025158

Book design by Alex Camlin

Printed in the United States of America

DOC 10 9 8 7 6 5 4 3 2 1

Excerpt from "Car Wash Hair" © 1991 Jonathan Donahue (BMI).
Used with permission. All rights reserved.

CONTENTS

RECORD COLLECTING FOR GIRLS

RECORD COLLECTING FOR GIRLS

THERE ARE THOUSANDS of people who work behind the scenes in the music industry and bring artists, big and small, into the public consciousness (and a precious few executives who take credit for everything). For the first decade of the new millennium, I was one of the people who helped determine what music you listened to: I worked in the music-programming department at MTV. My career there started unassumingly enough. In college in the late 1990s, I developed an addiction to online chat rooms. This was back in the early days of social networking, when you had to pay per hour to use AOL. I soon realized that I could get a free account, with as much chat time as I wanted, if I took a job as a chat host for MTV. I turned that gig into a series of internships in their New York offices, which led to a job as a production assistant and then a move into the music-programming department. Within a few years, I was spearheading MTV's first promotional campaign for Death Cab for Cutie, from videos on TV to interviews for the web to live performance bookings, because I was able to persuade everyone that the band was going to be huge. I had a hand in the launching of acts such as Interpol, Franz Ferdinand, Arctic Monkeys, the Shins, M.I.A., Vampire Weekend, and Lykke Li. I also

managed to convince MTV to do some odd, rather interesting things (that I hope they don't regret), like putting the Klaxons in proper rotation and debuting a No Age video on their blockbuster summer music show. And, in the interest of full disclosure, I kind of accidentally made Fall Out Boy happen too. I prefer to think of it as an act of God that I simply hastened along by putting them in front of some very influential people, but on my bad days, I feel the shameful weight of my role in kick-starting emo 2.0. In a small way, I've been shaping the music you've listened to for a decade.

The very nature of my job required me to think about music in analytical ways, particularly across gender lines. What I would suggest programming for teenage girls to watch on MTV was different than what I would expect twenty-something men to watch on MTV2. When I was programming MTV2's *Subterranean*, I began to think about how many female artists and bands I was programming. I felt it was important to make each week's show a 50/50 split of male and female artists, and I was amazed by how difficult it was to achieve gender balance. This realization (and having the differences between the genders in our audience hammered home in PowerPoint format on a regular basis by MTV's research department) inspired me to reevaluate my history with music. Curious about the influence of female voices vs. male voices, I started analyzing my own and my friends' record collections with that question in mind. From my childhood dabbling in my parents' records (the Beatles and Stevie Nicks) to the music that soundtracked my teenage romantic disasters (the Cure, specifically *Wish*) to the mix tapes guys made for me in college (still trying to figure out the one with Otis Redding and Carla Thomas's "Tramp" on it) to the music of my breakups (Fiona Apple embodies my inner sense of

injustice), the majority of my music collection has in some way been shaped by guys.

According to the Recording Industry Association of America, women buy nearly 50 percent of the music sold every year. Sometimes it's a little more, sometimes it's a little less, but on average it's an even split. While a pay gap may still exist between women and men, female economic leverage cannot be ignored: women fans make the careers of as just as many musicians as guys do. But when it comes to music writing, the shelves are lined with men. Most of the books I've read and enjoyed about music have been from a male perspective. I wondered, what would a female music nerd have to say? Because girls get their hearts broken and make mix tapes about it, too.

I knew there was much still unsaid in all the music writing out there by dudes after a conversation with my friend Gina about music. We spent an afternoon scrutinizing the likelihood that the guys we were seeing would break our hearts based on their favorite bands. Sometimes this line of analysis works and sometimes it doesn't. Gina's boy of choice at the time loved the National and Leonard Cohen (two very messed-up lyricists), so it seemed obvious that he had to be a bastard. The boy I was obsessing on loved Yo La Tengo; we were both surprised that he turned out to be a jackass but were not at all surprised he was romantically hapless. As I talked to more women, it became obvious that many of us are talking about music in the same way, and while relationships are part of the conversation, there's so much more. It is time for a discussion that encompasses more than the stories of guys and the girls who dumped them.

This is where you and your record collection come into the

picture. Most women don't collect records just to own them, we invest in the way music makes us feel. Music is wrapped up in our personal experiences. You might like different songs than I do or have different deal-breaker bands — and you might think I'm a total sellout to like the Pussycat Dolls — but I bet we also have a lot in common. I bet you've looked at people's record collections to determine what they are like. I bet you've wished Madonna would grow up and stop thrusting her crotch at you or wondered how a couple chose their wedding song. You may even have (on occasion) needed someone to explain to you why dating a rock star is *always* a bad idea, even when it seems like a really good one. I know I have . . .

TOP FIVE LISTS

IF YOU'VE READ the book *High Fidelity* or seen the movie, even just for the sake of John Cusack, then you've been witness to the art of the Top Five list. Music nerds everywhere delight in making Top Five lists of obvious, obtuse, and obscure records tailored to every categorization of music you could possibly imagine. I am one of those nerds. When my mind begins to wander, I think about what albums I could listen to if I were stuck on a desert island. (Usually this train of thought ends with the realization that I'd hate *any* album by the sixth straight year of listening to it.) Instead of counting sheep to lull myself to sleep, I make a list of all the songs I can think of about masturbation. (There are a lot.) I keep a running tab of what I think are my favorite songs right this minute vs. my most-played songs in iTunes vs. what's accrued at the top of my last.fm most-played list. I can't seem to stop myself from obsessively thinking about music.

I've always loved music, but I wasn't always a music obsessive. That started when I was a college student and worked at a radio station in Dallas. I fell in with a group of music snob guys who regularly debated topics like Blur vs. Oasis and whether Cat Power was the cutest indie rock girl or just the craziest. The guys carried on conversations as if they were characters straight out of *High Fidelity*, constantly judging and ranking music. It was obvious they

believed Nick Hornby's adage that what you like is what you're like, and they were judging people based on their musical taste. Girls were generally dismissed from their reindeer games. I can't even tell you the number of times I'd heard them say obnoxious things like, "Yeah, she's hot, but she likes Alanis Morissette, so you know she's kind of an idiot." I didn't want to be one of those girls who was so easily disregarded, so I faked being knowledgeable enough to pass muster. After listening to them make and revise their Top Five lists, probably hundreds of times, I developed a list of short-cuts for making a Top Five artists list. As time went on I added requirements of my own, and before long I had a cheater guide that helped me narrow in on my Top Five. When I don't have the whole history of released music at my fingertips, it makes my list-making more manageable, and the guidelines force me to take an analytical look at my music collection.

These are strictly my rules, so if you feel like adding new criteria or ignoring one of my standards to better reflect your own taste, knock yourself out.

Except #3. Do not ignore rule #3. You'll see why.

The most important thing is that your Top Five list reflects your favorites and not what you think someone wants to hear. Dare to be uncool.

Here's my Top Five artists list right now:

1. **ELVIS COSTELLO**—British post-punk artist who developed into a multi-genre music maven

2. **R.E.M.**—Athens, Georgia, college rock band that paved the way for indie-to-mainstream success

3. **SLEATER-KINNEY**—Portland, Oregon, riot grrrl rock band with a feminist agenda

4. **STEVIE NICKS**—'70s and '80s songwriter with the world's most amazing stage costumes

5. **FIONA APPLE**—the songwriting port in a world full of breakup storms

Here's how I got there . . .

RULE #1: YOU MUST OWN ALL THE FULL-LENGTH ALBUMS RELEASED BY ANY ARTIST IN YOUR TOP FIVE.

The exceptions to this rule: greatest hits albums and anything you've deemed to be a low point in an artist's career. I see no reason to clog up your record collection with either. Completists everywhere just hissed through their teeth at me, but why would you own a record you don't enjoy, or multiple copies of songs you already have? For decoration? When music collecting becomes obsessive-compulsive disorder, it's time for a new hobby.

I was late in discovering Elvis Costello, both late in my life and late in his career. I think the first time I heard of him was when I saw his video for "Veronica." It was inexplicable to me in 1989, the halcyon days of Debbie Gibson and Poison, why the video for "Veronica" was on MTV so often. Costello seemed old even then, and his video was set in a nursing home, so in my eyes it didn't hold a candle to Madonna's video for "Express Yourself." The video got less airplay than Madonna's, or even Paula Abdul's, but he walked away with the 1989 Best Male Video award for "Veronica," because respect for the man was due. (Paul McCartney cowrote the song, so double the respect.) The melody was catchy, but the lyrics

were a mystery, and I memorized them all wrong. I couldn't figure out what he was talking about, because the idea of a pop song about an old lady with Alzheimer's was unfathomable and unrelatable to me at age twelve.

After "Veronica" in my discovery of Elvis Costello came "Alison," which had actually been released twelve years earlier — the same year I was born. I grew to love this one while listening to my parents' Elvis Costello greatest hits album, and if you don't know it, I recommend you buy it immediately. His unforgettable delivery of the line "My aim is true" is a knee-buckler — the sort of bittersweet sentiment that I dream of a guy writing for me in some tragic soap-opera scenario where we can't be together.

My family and I were big perpetrators of the Columbia House scam. It was a great way to build a collection, considering that my allowance was a mere $5 a week. We would all constantly join, leave, and rejoin various mail-order companies that offered eight albums for a penny if you bought three at full price. In college I ordered *The Very Best of Elvis Costello & the Attractions* from one of those clubs and found myself really getting into his clever lyrics. His songs are so easy to fall in love with.

I went to the next level of Costello fandom when I bought the Rhino reissue of *This Year's Model*. It was in the dead of winter at the beginning of 2002. I had recently moved into an apartment in Brooklyn and was consumed by a long-distance flirtation with a boy in a band who lived in Dallas. He mailed me a loaf of honey wheat bread (which was impossible to find in New York City) and a packet of forget-me-not flower seeds, and he called me on the phone nearly every day. I was totally crushed out. A few months later, when his band toured through town, he explained to me that

it all meant nothing, that he was just a flirtatious person, and suggested we should just be friends. It was infuriating, and I hated him for stringing me along. Listening to the first track of *This Year's Model*, "No Action," while stomping the cold, mile-long walk from the subway through the housing project near my apartment was the only time I felt like a rational, thinking person rather than a girl who had been turned into a chump and who secretly still had a little crush. It's frustrating when someone treats you horribly, but being a jerk back to them just doesn't seem worth it. Instead I pretended to be sternly nice and above it, but that farce left me with a lot of anger to work out. Power-walking to a collection of songs full of venom, vigor, and a dash of bitter longing got me through that romantic humiliation and the feeling of annoyance with myself for not telling him off. I didn't get the guy, but I did get Elvis Costello.

I quickly became a devotee. I still get chills listening to certain turns of phrase in his songs. His album *When I Was Cruel* came out the next year, and I tumbled headfirst into obsessively listening to it, dissecting it. I saw him live three times. I worked my way through most of his catalog over the next five years, first focusing on his pop albums with the hits. I still discover new songs to love when I re-explore those albums. Next I delved into his collaboration with songwriter Burt Bacharach, his classical compositions, and even his British TV program scores. The man has a giant back catalog of material, and I'll admit I cheated and put him on my Top Five list before I owned everything. I'm still growing into some of his work. I expect when I get older and tired of pop music, Elvis Costello will still have something to offer me. I'm not sure I can say the same for anyone else on my Top Five list.

Elvis Costello is my number one with a bullet because I want to own all of his work and can't get enough of listening to him. That is how you should feel about the number one on your Top Five. Number one becomes your family, your boyfriend, and your comfort food. It's indispensable.

RULE #2: ARTISTS CANNOT BE IN YOUR TOP FIVE OF ALL TIME IF THEY'VE ONLY RELEASED ONE ALBUM.

Perhaps you feel you have intensely bonded with an artist who only has one album. You may think you love them. You may put them on your list of the top ten albums. However, it's still too early to give them a spot on your Top Five artists of all time. To me a favorite artist is someone I have history with, a band that has earned their place in my heart. I don't take it lightly or include someone on a whim. Besides, there's a very high probability a new artist's second album could hit the sophomore slump hard and totally suck. That's what happened to those poor bastards the Strokes, who made a hell of a great and timely first album and became the leading band on the New York City (aka media capital of the world) scene circa 9/11. How could they possibly have followed up on that? They were damned from the moment they started making a second album.

I distinctly remember the first time I really heard an R.E.M. song. *Eponymous*, their first greatest hits album, had recently come out, and my stepdad was blasting it on the stereo. He had this amazing sound system that you could hear all over our small house. I was in the TV room and remember being annoyed by the music, but then "The One I Love" came on and I started listening to it. Really listening. I'd heard the song before and seen their lo-fi videos on MTV, but this time Michael Stipe's voice and the dark,

swirling music of the song really hit me. I found myself adding it to the mix tapes I made off my parents' CD collection.

Aside from a passing fascination with "Orange Crush," I missed most of the excitement around their breakout album *Green*. I thought "Pop Song '89" was annoying and that they'd made a stupid video. I was eleven at the time, and the artistic merit was lost on me. I became a bona fide fan with the release of 1991's *Out of Time*, thanks not only to the giant hit "Losing My Religion," but also to Jane Pratt's constant mentions of R.E.M. in *Sassy* magazine. When *Automatic for the People* was released in 1992 I was truly obsessed.

Somewhere along the way, Courtney Love stumbled into the picture and started screaming at anyone who'd listen that *Murmur* was one of the greatest albums ever, and so I found myself buying up R.E.M.'s back catalog. As I started collecting R.E.M.'s early albums, bootlegs, and singles, I gained an appreciation of how different the R.E.M. albums of the '90s were from those of the '80s and how they were changing as a band. *Monster, New Adventures in Hi-Fi*, and *Up* are not in most rock critics' canons of key R.E.M. albums, but I enjoy each one because I like hearing the band evolve and try new things. If R.E.M. had just made the same '80s jangle pop albums over and over (which they did for most of the '80s, actually) then what would have been the point of continuing to listen to them?

For years R.E.M. was number one on my list, and there are two reasons why I bumped them down. The first is that their output in the 2000s, save 2008's *Accelerate*, has been phoned in. Even the band has admitted as much. While doing press for *Accelerate*, guitarist Peter Buck said to *Spin* magazine, "It was kind of like the

11

war in Iraq — we didn't know why we got in [the studio], we don't know how to get out, and we don't know what we're trying to accomplish. If [2004's *Around the Sun*] had been the best record we'd ever made and everyone said it was *Pet Sounds*, I could put up with eight months in the studio and the frustration. But it wasn't." Buck is right, because the seminal Beach Boys' album *Pet Sounds* was crafted with care and Brian Wilson's killer intentions of besting the Beatles. In fact, Wilson had a nervous breakdown when the Beatles took up his challenge and followed *Pet Sounds* with their own release of *Sgt. Pepper's Lonely Hearts Club Band.* One hardly gets the idea that R.E.M. was trying to best even themselves with the records they made in the 2000s.

I'm all for growing and experimenting, which is why I'll stand by their critically panned late-'90s output, but as a fan I don't appreciate the release of material a band doesn't care about but that got recorded for the sake of money or running out a record deal. If the magic's not there anymore, the band should break up or take a moment and pull itself together, not insult the fans with albums they can barely be bothered to work on. Far too many bands stay together past their sell-by date and ruin the value of their back catalog by releasing progressively worse music as they get older. It's painful, and I couldn't help but take it as a personal affront when I realized one of my favorite bands might be doing exactly that.

The second reason for downgrading R.E.M. is entirely personal. In the course of interning for and working at MTV, I attended two interviews with R.E.M. Their obnoxious attitudes at the tapings were a complete turn-off. Granted, I was very new to the music industry then and did not yet understand that everyone hates the interview circuit, where they're asked the same five

questions about making their album over and over again for days on end. They were clearly so unhappy to be doing the interviews on both occasions that it turned into an unpleasant experience for everyone involved. I found the band members to be rude, dismissive, and arrogant. It was such a blow to my idea of them that I couldn't even listen to their records for two years. Meeting your musical heroes is a real risk. Sometimes it is better not to look behind the curtain.

R.E.M. remains at number two on my list for now, but my disappointment in them has admittedly chilled the air between us. We'll see how it goes.

RULE #3: UPDATE YOUR TOP FIVE LIST OFTEN.

This seems obvious, doesn't it? I think a lot of people balk at creating a Top Five list because they think they'll have to stick by it forever. You won't. Your list is fluid and should be revisited as often as necessary. You don't ever have to feel like you're married to a Top Five. But I bet that once you've figured out a few of your core artists, they'll always be on your list. If you ask me to name my Top Five again a year from now, it's likely that I'll have completely revised it. Well, okay, Elvis Costello will still be number one, barring any massive exposé of his life as a monster who eats babies. But the other four slots are subject to revision.

I only recently realized that Sleater-Kinney had earned themselves a place in my Top Five, knocking out longtime favorite Neil Finn (a great New Zealand artist in his own right and the lead singer for Crowded House and his brother, Tim Finn's, band Split Enz). I first checked out Sleater-Kinney after I saw their picture on the cover of the *Dallas Observer* in 1999 for the release of *The Hot*

Rock. I was a college student at the time, and finding female voices in music felt important. I'd heard their name in conjunction with the record label Kill Rock Stars, but I had never listened to their music. Knowing only that they were a staunchly feminist band and that two of the girls used to be a couple, I went out and bought a copy of the album. I loved it. Corin Tucker and Carrie Brownstein screeched at each other through dual vocal performances that felt immediate and angst-filled; after all, it was a breakup album full of resentful songs. It quickly became one of my favorite albums of that year.

I didn't immediately buy their earlier albums, though, or feel any particular need to. I picked up *All Hands on the Bad One* in 2000, and that was when their feminist message smacked me in the face. It's an album of songs about how it feels to be a woman in a band, a woman in the music industry, and a woman in American society. Those lyrics could have been ripped out of my head from my own feelings about rock music at the time. Mainstream female images are often watered down to focus on love and girly stuff. This band wasn't about that. These were the days after the riot grrrl movement had cooled, when the only female-fronted rock bands that could get on the radio were No Doubt and Garbage. I was working at the alternative rock radio station in Dallas, and the question of what female artists they played weighed heavy in my consciousness every day. I interviewed the station's music director for a feature in my college paper and asked him why they didn't play more female artists. He explained that they thought too many songs by women would alienate their predominately male listeners, so they never played two female voices in a row and kept the number of songs by women added into the rotation each week to

a minimum. The geniuses behind corporate radio were absolutely sure men didn't care to hear women singing. *All Hands on the Bad One* conveyed how annoyed lots of women, myself included, felt by the culture surrounding rock music in the late 1990s and early 2000s.

I've slowly accumulated all of Sleater-Kinney's albums. I keep going back to them when I need to reassure myself that other women see what I see in our culture and that there is another point of view outside of the hypersexualized pop tartlet or the acoustic guitar hippie feelings girl, neither of which are my speed. Most guys don't realize how shortchanged women have been by the predominately male retelling of music history. We're segmented to the level of specialty audience and programmed to in a cloud of pink fairy dust. I don't want another Rihanna. I want to know this: Where's the female equivalent of the Foo Fighters?

It's taken a while for me to realize it, but Sleater-Kinney has become the band I respect for their message and politics as well as their music.

RULE #4: DIVERSIFY YOUR TOP FIVE WITH ARTISTS FROM SEVERAL DECADES.

This rule has a "something old, something new, something borrowed, something blue" quality to it. It was originally developed because I realized I thought less of people whose entire Top Five list was comprised of artists from the same decade. It's my own little music snob prejudice. If your list is all recent bands, then I assume you don't know much about music history. If it's all bands from the '80s, then I assume you've stopped listening to new music since C+C Music Factory. Either way, you're boring. It's a rule that forces me to dig deep into my own record collection to find

artists whose music I like. It motivates me to listen to things I otherwise might not (lately that's been Neil Young and jazz legend Helen Humes). It's less about diversifying your list for the sake of looking smarter and more about making yourself listen to a wider swath of music in a smarter way. I find it easy to slip into thinking only of new artists whose albums I'm listening to lately and forgetting about those with whom I've had a long-term love affair or who inspired the newer bands I like.

When you think of Fleetwood Mac, you're most likely thinking of the post-1975 band lineup that included Lindsey Buckingham and Stevie Nicks. That version of Fleetwood Mac released a trio of the best-selling albums of all time, including *Rumours*, which became a historical marker in California soft rock and is one of the most confessional pop albums ever. To this day *Rumours* remains a fascinating document for rock music historians, not just for the great pop songs but also for the rich band history, which was the basis for many of the songs on the album: Stevie and Lindsey break up; John and Christine McVie divorce; and, Mick Fleetwood ends his marriage to Jenny Boyd (who was the inspiration for Donovan's "Jennifer Jupiter").

I discovered and subsequently fell in love with Stevie Nicks when I was six years old. Fleetwood Mac's terrible *Mirage* album had come out in 1982 and her solo album *The Wild Heart* followed soon after. "Gypsy" and "Stand Back" were on the radio constantly. A friend of my parents was an amateur photographer who shot the odd concert here and there, and he supplied me with multiple action shots of Stevie, blown up and framed to feed my hero worship. To me she was beautiful and weird. I was obsessed with her beaded lace skirts and witchy-woman persona. Her hippie

facade was already outdated in a world of new wave, but the spookiness she brought to the stage was enough to make her seem more than original — she seemed like a woman possessed. It suggested a depth beyond what Bananarama and Madonna had to offer me.

There were manifestations of Fleetwood Mac before the Buckingham-Nicks era. They started out as Peter Green's Fleetwood Mac, a revered blues band. Green was the troubled genius — with guitar skills rumored to rival Eric Clapton's — who wrote the original "Black Magic Woman," later popularized by Santana. The first album from the original Fleetwood Mac lineup was a big UK chart hit, but never quite made an impact in the States. I was never much of a fan of the bluesy pre-1971 Fleetwood Mac, but after Christine Perfect (soon to become McVie) joined the group and Peter Green left, things started to go in an interesting direction.

At some point in the '90s my stepdad started playing the 1972 album *Bare Trees* in heavy rotation on the family CD player. He had hundreds of vinyl records, and the transition from records to CDs took years — he was quite upset when I told him that vinyl was back — so his motivation may have been simply that he'd recently re-bought the album in a new format. To my knowledge it was the first pre–Buckingham-Nicks Fleetwood Mac work I'd heard. Repetition made me quite fond of the title single "Bare Trees" and the extremely sappy "Sentimental Lady."

By the time Fleetwood Mac released their next album in 1985, I didn't care anymore. This apathy continued until Hole covered "Gold Dust Woman" in the '90s. I really thought anything Courtney Love did was genius for a while there, but we have significantly diverged since. Just the same, between public praise from Love and all-over-the-place promotion for Fleetwood Mac's reunion, I

was inspired to go back to them. I was living an Angela Chase–esque, hypersensitive existence at the time, and the wide variety of songs about rejection resonated with me. I got deep into the 1975–79 Fleetwood Mac catalog (the "Little Lies" era still sucks) and eventually gained an appreciation for Christine McVie's songs like "Over My Head" and "Don't Stop."

I didn't listen to Fleetwood Mac during the eight years I lived in New York City, aside from the occasional spin at karaoke. (I do a mean "Gold Dust Woman" when I'm in the right voice.) I also overdosed on "Silver Springs" during a dumping, but I've since retired that song and emotionally torture myself with it no more. I don't think Fleetwood Mac's music is the kind of thing you can listen to while living in NYC, because the ambiance of the music is contradictory to everything happening around you. It may sound silly, but there just isn't enough sunshine to warrant listening to Fleetwood Mac. Also, it felt like there were more exciting things going on musically in my backyard, with the Strokes, Interpol, and the Yeah Yeah Yeahs all breaking out in the local music scene, so why revisit bands from my childhood? Thinking about how insular I was in my listening habits at the time is actually what inspired this rule. While it's important to keep up with the new, it's never good to get lost in any single decade. Understanding the influences of the past only leads to a greater appreciation for the music made in the present.

Someone told me not long ago that he was obsessively listening to *Tusk* and that he thought it was underappreciated. When I revisited it myself, I realized I really only like the Stevie Nicks and Christine McVie songs on that album. *Tusk* is largely a boy's

album, dominated with percussion-heavy Lindsey Buckingham material with an almost uncomfortably aggressive tone. It's an album dominated by machismo. I'd rather hear *Rumours*, with its big pop songs, any day.

When I moved to California I drove through Joshua Tree National Park with Fleetwood Mac and Stevie Nicks (and a bit of Gram Parsons) as my soundtrack. With the change of atmosphere, they jumped back into my Top Five and back into my everyday consciousness.

RULE #5: ALWAYS BE PREPARED TO DEFEND YOUR LIST.

One evening in college, the aforementioned *High Fidelity*–loving guys were sitting on the porch of their shared house in Denton, Texas, and making a list in which they ranked the movies in the Star Wars series in order of preference. I wasn't contributing much to the conversation that evening. In fact, I was barely paying attention. My friend Josh noticed my uncharacteristic silence and asked me what my favorite Star Wars movie was. I said *Return of the Jedi*, because it was the first thing that popped into my head. He nodded at me very seriously and said, "It's because of the Ewoks, isn't it?"

I nearly did a spit-take. The Ewoks were the teddy-bear-like inhabitants of Endor featured in the sixth (third if you count in order of release date, but apparently sixth overall in this geekiverse) Star Wars film. I knew, from being subjected to several mindnumbing conversations on the topic, that Ewoks = death to Star Wars nerds. Depending on whom you ask, Ewoks fall just above or just below Jar Jar Binks on most Star Wars fanboys' lists of things they despise

about the franchise. I had made a serious misstep in forgetting about the Ewoks in *Return of the Jedi* and so, knowing I was going to be mocked anyway, I decided to mess with the guys.

"Yes," I replied with as much false integrity as I could muster, "I loved the Ewoks. They were my favorite thing in the Star Wars films. They're just so cuddly." This was met by a chorus of groans. Those dorks never asked me about Star Wars again, thank God. Ever since, I haven't shied away from having an artist who is the equivalent of *Return of the Jedi*, the chick flick of Star Wars movies, in my Top Five — even if it will either completely offend the sensibilities of the person I am talking to or cause them to out themselves as sympathetic to what I consider an underappreciated artist.

It is inevitable that any person who asks you who your Top Five artists are will also want to critique your list. That's part of the fun of list-making for music nerds. Fiona Apple is probably the artist on my list who is a musical boner-killer for most guys. She certainly wouldn't get the approval of the Star Wars fan club from that night.

If you're a fan of Apple, then you're probably already thinking, "What's to defend, that's just good music!" If you're a guy (especially a guy I hung out with in Denton, Texas, in the late '90s) you're probably thinking, "She's crazy." That is the impression Apple creates with her ranting, cathartic songs about fucked-up relationships and bad ex-boyfriends. It is a huge part of her appeal to me, but if you mention that to a guy, there's every chance he'll think it means you're melodramatic, needy, and going to go crazy on him.

Maybe that assessment isn't entirely inaccurate, because I'm most likely to play a Fiona Apple record when I feel I have been seriously wronged in love. Her album *Extraordinary Machine* came out right around the time I hooked up with this guy I'll forever regret. He dropped a bold pick-up line on me at my friend Josh's wedding. We circled each other through the reception but couldn't seem to find any privacy, so we stuck to holding hands, kissing, and agreeing to e-mail. When his band came to my town a month later, he was all over me with the hand-holding and kissing and making eyes that led to a "Let's make out at your place?" And since he was a friend of my friends, I assumed he was a stand-up guy.

I found out six months later from another friend that after I left the wedding he'd found some privacy with another girl — in the parking lot. It seems that after he'd decided I should be his wedding fling, someone else swooped in with her own wedding-fling plans, which involved her knees on gravel. By the time all of this information came to light we'd moved on to being friends and he didn't understand why I was still pissed off by this incident. Several songs on *Extraordinary Machine* were on high rotation on my iPod during the fallout from this bombshell and will forever remind me of my unabated loathing for him. (To clarify: I hate him because he refused to apologize or admit that his behavior was straight out of the skank-boy handbook. Is it really too much to ask that someone who holds your hand could keep his man bits out of another girl's mouth for the duration of that same evening? I bet Fiona Apple is with me on this one.)

I have stories just like this one to complement the music on

her first album, *Tidal,* from my freshman year in college and my misguided crushes on boys who did dumb stuff like ask out my best friend instead of me. To go with her second album, *When the Pawn . . . ,* I had a crush on a guy at work that led me in the wrong direction and a fling that ended in disaster. Apple is my go-to for romantic situations where I feel helpless. She's with me when the lines are blurred, ready to sympathize and growl about her own love breakdowns.

Apple's songs are an emotional force of nature surrounded by beautiful instrumentation. It doesn't help her reputation as ambassador to crazy girls that she spent much of her early career shunning fame in such a way that made her seem erratic and, well, a little crazy. She aired her beef with how *Spin* magazine presented her in the form of a single from her second album called "Limp." It was a bold strike against the mainstream media for a twenty-two-year-old girl, as well as an attempt to break out of the velvet Lilith Fair shackles that the music press wanted to put on her. I can't help but admire her bravado, especially when it seeps into her music. She always seems to definitively be who she wants to be; that's something I aspire to.

Any sort of outspoken expression of emotions from a woman seems to give dudes a free license to call you crazy. In Apple's case it gives music nerds room to question her credibility, even though she's obviously a talented musician, songwriter, and singer in a world of disingenuous pop stars who try to get by on hair extensions and scary makeup. A lot of guys don't feel comfortable with women expressing raw emotion in any format: sung, spoken, or via a homemade arts and crafts project. Would I be as into Fiona Apple if I didn't make tons of terrible choices in men? Possibly not.

Maybe she is crazy. Maybe I'm crazy too. At least we crazy girls have each other to lean on. Just know that if you catch me hiding under the covers and crying along to a Fiona Apple record, I most likely didn't get there on my own. Some guy probably drove me there.

TOP FIVE PLAYLIST

ELVIS COSTELLO, "Veronica"

ELVIS COSTELLO, "Alison"

ELVIS COSTELLO, "No Action"

ELVIS COSTELLO, "Beyond Belief"

R.E.M., "The One I Love"

R.E.M., "Orange Crush"

R.E.M., "Pop Song '89"

R.E.M., "Losing My Religion"

SLEATER-KINNEY, "I Wanna Be Your Joey Ramone"

SLEATER-KINNEY, "All Hands on the Bad One"

SLEATER-KINNEY, "Get Up"

SLEATER-KINNEY, "Jumpers"

FLEETWOOD MAC, "Gypsy"

FLEETWOOD MAC, "Bare Trees"

FLEETWOOD MAC, "Gold Dust Woman"

FLEETWOOD MAC, "Don't Stop"

FIONA APPLE, "Get Him Back"

FIONA APPLE, "Better Version of Me"

FIONA APPLE, "Never Is a Promise"

FIONA APPLE, "Love Ridden"

EXTRA CREDIT:

MADONNA, "Express Yourself"

CROWDED HOUSE, "Don't Dream It's Over"

DONOVAN, "Jennifer Jupiter"

SANTANA, "Black Magic Woman"

JOHN WILLIAMS, "Star Wars: Main Theme"

WHERE HAVE ALL THE
GIRL BANDS GONE?

In junior high I joined the school band because I wanted to play the drums. I had several years of piano lessons under my belt, which made me qualified to play instruments like the marimba or anything with a keyboard layout, but I had my heart set on the drums. I wanted to learn how to pound on them and make loud noises like a wild thing. Learning how to grip the sticks and play triplets and cross-stick on the snare drum was just as exciting and satisfying as I had hoped it would be.

Unfortunately, my first trip to the music store to buy my percussion kit with the little snare drum pad and tiny set of bells to practice on at home was a huge disappointment. Just after I announced that I was there to buy, but before I could say what instrument, the salesman asked me if I would be playing the clarinet. The clarinet, flute, and French horn (the last is inexplicable to me still) were considered the most girl-friendly instruments, judging by the urgings of the band instructors. In fact, those sections of the band were 99 percent female. Only one other girl and I made the cut for drums that year. And, fittingly, percussion was taught by the only male teacher in the music department.

I was irritated at being immediately pigeonholed as a clarinet

player by the daft but well-meaning music store clerk. He didn't know it, but I was not and would never be the kind of girl who would play a woodwind instrument. I didn't want to blow into anything, I wanted to hit things. But girls aren't supposed to be aggressive. We're meant to look cute, get manicures, and daydream about weddings. I managed to obsess on all those things and still have a deep, burning desire to bang drums. Hard. And it bugged me that the guy in the music store wanted to girly me up from the get-go.

So I've always empathized with women who want to play in a band, and I'm doubly impressed by ladies who manage to pull together an all-girl band. It sounds simple, but practically speaking, it means finding a group of women who've braved the music-store guys who tend to think any female who wanders in is looking for a clarinet or is just someone's girlfriend,* women who possess the drive and wherewithal to pursue the very unglamorous lifestyle of a touring musician, women who have a passion for music that is so all-consuming that they want to make it their life in spite of having very few female role models for inspiration. Oh, and then once they form a band, they all have to get along. And they'll have to confound the expectations of their male road crew, who will assume they can't play.

When I was a young girl growing up in small-town Texas with a pack of boy cousins for playmates and little better to do on hot summer days than watch MTV, the Go-Go's had a huge impact on me. I had no interest in the underground at that age, but I loved pop music, and the video for "Our Lips Are Sealed" was one of my favorites. I didn't know that the Go-Go's were originally

* If you think that is an antiquated notion think again: in interviewing Jane Wiedlin of the Go-Go's for this chapter she told me it is still a problem for her.

a dirty punk band who had gotten all shined up for MTV, but the ways they were different from the other female pop stars of the day weren't lost on me. I loved that in their video they were a little bit goofy, instead of posing sexily all the time like Pat Benatar or Debbie Harry. I loved that they each had their own distinct style. And there wasn't a guy in sight — a big deal to me at the time. Most of my days were spent with an army of male relatives who insisted I go fishing and watch their Little League games (both boring). In my preteen years, having the Go-Go's and the Bangles around solidified the idea that an all-girl band wasn't a big deal. It was something I and any girls I knew could do. Later I developed a teenage obsession with Hole and Belly, while Garbage, the Cranberries, and No Doubt loomed large on my radar. But the idea of girls' having their own bands started, for me, with the Go-Go's. But as fundamental and significant as the Go-Go's were in the history of girl bands, they were far from the first. There was a long line of girl groups who came before, paving the way for their success.

If you read about the history of girl bands, you'll find an overwhelming number of references to the men who discovered them, validated them, promoted them, or in some way svengalied them. It's as if no girl group could exist in the minds of music historians without the endorsement of a few major male figures to prove they weren't just another publicity stunt.

Take, for instance, Goldie & the Gingerbreads, the first girl rock band signed to a major label in the early 1960s. Considering that rock and roll only took off in the 1950s, the band's existence was pretty impressive. The road to equality has historically been a long one: remember, it wasn't until 1920 that women earned the right to vote in the United States. Given that fewer women worked

outside the home in the '50s, and most female musicians were singers, an all-girl band strikes me as extremely progressive for 1962. They weren't entirely without precedent, having the all-girl jazz orchestras of the Prohibition era for musical inspiration, but these groups were largely viewed as pinup gimmicks and rarely granted their due respect as musicians.

Goldie & the Gingerbreads came together after singer Genya Zelkowitz spotted drummer Ginger Panabianco playing in a New York club. Excited by the idea of an all-girl band, the two quickly recruited pianist Carol O'Grady. They had a harder time finding a female guitarist and relied on an ever-changing lineup of touring and studio musicians. Organist Margo Lewis joined the group to replace O'Grady, and eventually they found singer and guitarist Carol MacDonald to complete the roster. They were by all accounts hardworking, serious musicians, yet their success is attributed not to their own ambition or skill, but to the interest of legendary Atlantic Records chairman Ahmet Ertegün and Keith Richards, who took them out on tour with the Rolling Stones. Goldie & the Gingerbreads were never regarded by audiences as anything more than a gimmick, in spite of the band's total sincerity and real talent. They released a few singles and then broke up.

Svengalis were a plague on the vocal girl groups of the 1960s. One of the most infamous examples is Phil Spector and the Crystals. The Crystals are still considered one of the premiere 1960s girl groups, and Spector was among the first to recognize their talent. He signed them as the first act on his Philles Records label, which should have been a dream come true for a rising girl group at the time. In the deal, he secured the rights to their name and likenesses, also taking for himself the right to produce them, to

select the songs they would sing, and to market and release their albums. He was in complete control. It could have been an okay deal for the Crystals. They didn't write their own songs, so it wasn't as if this power-grab cost them the opportunity to collect royalties on lyrics, and Spector's famous Wall of Sound production techniques contributed to their reputation as one of the defining girl groups of the era. However, we are talking about Phil Spector — the only man to reportedly hold both the Beatles and the Ramones at gunpoint, so we can assume he's a little bit on the thuggish side of crazy.

Spector's mismanagement of the Crystals' career led to several embarrassing blunders, including the recording and release of "He Hit Me (It Felt Like a Kiss)." Written by Brill Building stars Carole King and Gerry Goffin and inspired by the singer (and their babysitter) Little Eva, the song was a disturbing ode to domestic abuse based on an off-the-cuff story Eva told them about some bruises her boyfriend had left on her. She considered his abuse to be a sign of his love for her. The song was roundly rejected by radio listeners and left an odd stain on the Crystals' musical legacy. Not long after that unfortunate song was released, Spector began recording and releasing songs under the Crystals' name that were actually sung by Darlene Love and her group the Blossoms, as well as tracks featuring Love on lead vocals and the Crystals on backup.

In the case of "He's a Rebel," Spector may have mixed up performers strictly for convenience. He wanted to record a new song and the Crystals couldn't get from New York to L.A. fast enough, so he cut a cover of the song before another group could. This was a weird but common custom in the '50s and '60s. Writers sold their songs to groups, managers, labels, and producers, and then an

"original" version would be cut. However, if someone else heard the song and thought it was a hit, they might produce their own version and release the "cover" before the "original," and the cover could easily be more successful on the charts. Some say he got tired of the girls' arguing over who would sing lead vocals and he put an end to the fights by not letting any of them sing. Whatever the case, the real Crystals had no recourse. And Spector seemed to feel that his work as producer was more important than their development as artists.

This would become a pattern for the treatment of '60s girl groups, from that other famous Spector group, the Ronettes, to the Barry Gordy–backed Supremes at Motown to songwriter Shadow Morton and the Shangri-La's. These groups sold a significant number of singles, but they were beholden to the men who drove their successes and ultimately many of the performers ended up broke. This led to a prevalent attitude in the music industry that girl groups were disposable, which didn't exactly pave a smooth road for a future full of girls in bands.

Girl groups were falling out of style by the end of the '60s until a rock band called Fanny appeared in 1970, becoming the first all-female band to release a full album on a major label, the venerable Reprise Records. The band was made up of a rotating cast, with sisters Jean and June Millington at the center of things. Being discovered by George Harrison didn't save them from vicious infighting after Patti Quatro (sister to the more-famous Suzi) joined the band. The battles — coupled with overall disappointing sales — led Fanny to fall apart in 1974. After their breakup, they were lauded by David Bowie as one of the great forgotten rock bands, though his praise is a bit tainted by rumors of his involvement with

founding band member Jean Millington, who allegedly wrote the band's most successful single, "Butter Boy," about him (she went on to marry Earl Slick, who played guitar for Bowie).

The mid 1970s brought the Runaways, one of L.A.'s most famous girl bands, whose legacy has been recently revived. The 2010 movie *The Runaways*, starring Dakota Fanning and *Twilight's* Kristen Stewart, details their formation and early success. The biggest problem for the Runaways was their svengali, Kim Fowley, who was as famous for his creepy sexual advances and acid tongue as he was for the gold records he received for writing songs and producing some big-name groups. After his attempts at a solo recording career failed, he settled on the idea of founding an all-girl, all-underage rock band. He put the Runaways together, managed them, produced them, and ultimately made a lot of money by signing them to a contract that would have made Phil Spector proud — he essentially owned the band and controlled their finances.

The Runaways girls had very different personalities: Cherie Currie was the glam rocker, Joan Jett was the punk girl next door, Lita Ford was the metal-loving Cali girl, and Sandy West was the lovable stoner. The band also had a series of rotating bassists that rivaled Spinal Tap's drummers, the longest lasting of whom was Jackie Fox. Amazingly, their varied tastes meshed together into a cohesive rock sound, and they put out one really great, self-titled record in 1976. The band dissolved when the pressures of life on the road and the desire for fame led to borderline riots between the girls, but not before Joan Jett and Lita Ford established solid platforms from which they launched successful solo careers.

Throughout the '70s, for every Suzi Quatro who was allowed to mock-rock to songs written for her by professionals, there were

twenty groupies like Sable Starr and Lori Lightning perpetrating the idea that while women could serve as muses for music, they had no business trying to play it. It was a fine time for women in music, as long as you were a disco diva who didn't mind singing to prerecorded tracks and could be satisfied by a one-hit-wonder career.

And then along came punk, with an ethos that leveled the playing field in music. By the time the punk movement hit, the fight for gender equality was real. Punks were all for embracing equal rights, or at least giving them serious lip service. Within this small subculture, the idea that girls — or any other outsider minority — shouldn't be in a band was dismissed. And because their world existed in the underground, no industry types came around to expound on the financial or marketing difficulties of an all-girl band.

Out of that world where anything was possible came the Go-Go's. In the band's early days, they were punk misfits. The original lineup included singer Belinda Carlisle, guitarist/vocalist Jane Wiedlin, bassist Margot Olaverra, singer/keyboardist Charlotte Caffey, and drummer Elissa Bello, with manager Ginger Canzoneri helping them pull it all together. They emerged from the L.A. punk scene alongside bands like the Germs, X, and the Weirdos. It was a time when, as Jane Wiedlin described to me, "if you had the balls to start a band, you could do it."

If you listen to some of the early recordings on *Return to the Valley of the Go-Go's*, especially "Johnny, Are You Queer?"* and "Living at the Canterbury," you can detect the punk aesthetic. It's

* Read more about this in the *Romeo and Juliet* section on page 51.

easy to imagine that iteration of the Go-Go's running around with green hair in dresses made of trash bags, trying to write angry political punk songs. They learned to be a band through trial and error, playing in high schools and at L.A.'s premiere punk gathering place, the Masque. Before too long Bello and then Olaverra were kicked out of the band, to be replaced by Gina Schock and Kathy Valentine on drums and bass, respectively. By 1980, these five girls formed the Go-Go's as the world would come to know them.

The punk scene in L.A. was late developing relative to the New York and London scenes, and it fizzled out very quickly. The Go-Go's probably would have stayed dirty punk girls if that act had a chance to get them the fame and fortune they were seeking, but punk was already slipping out of fashion in favor of new wave by the time they went on tour opening for Madness in 1980. They realized they had some strong pop-song writers in the band, and so they adapted.

The Go-Go's eventually landed a deal with Stiff Records in the UK to record a single that became an underground import success in the United States, but the girls still couldn't get a proper US record deal. There are a variety of factors that influence an Artist & Repertoire (A&R) person's decision to sign a band — from their fit at the label and how the band members look to who their manager is — the latter being a pretty good indication of how well the band and the label will work together. Many a weak manager has been pushed out of the picture because record labels don't like him.

For the Go-Go's, the problem was an altogether different issue. Kathy Valentine explains: "When we were trying to get a record deal, we were told over and over that whatever label didn't want to

sign us because there hadn't been a successful all-girl band before. So we thought if we had a hit record we would just abolish that." Even the serious girl bands, such as Goldie & the Gingerbreads and Fanny, had been received by the marketplace as fads with little prospect for long-term success. So the idea of signing a band that might never be taken seriously by consumers, in an emerging genre with no track record of sales, a band whose greatest support came from a new music TV channel called MTV that record labels didn't yet understand, was a tough sell for the old-school record-label guys. Plus, these guys typically courted bands with the promise of professional groupies and drugs, tricks that were ill-fitting for an all-girl band with punk roots.

MTV played the videos for "Vacation" and "Our Lips Are Sealed" on heavy rotation, sending the songs into millions of suburban homes and reintroducing them to hundreds of radio station program directors who had previously dismissed them. Eventually the Go-Go's landed at a relatively new record label called I.R.S., also the home of the original college rock band, R.E.M. I.R.S. was founded by Miles Copeland — brother to Stewart Copeland, the drummer in the Police — which explains how the Go-Go's ended up opening for the Police on a few world tours.

I.R.S. and the Go-Go's turned out to be a perfect match. I.R.S. was an upstart label with trendsetting backers, a number of singles from popular UK bands, and a roster of rad bands like the Buzzcocks and the English Beat. I.R.S. made a fortune on the Go-Go's, and the Go-Go's got access to the record-industry machine that could help make their songs into radio hits, thereby selling millions of albums. The girls found themselves surrounded by a staff of mostly young people who were concerned with both

credibility and success. This meant the Go-Go's were allowed to develop their own style without a lot of meddling from stylists, media trainers, and marketing consultants. In conversations with Charlotte Caffey, Kathy Valentine, and Jane Wiedlin, all three confirmed that the Go-Go's truly were the girls you saw: they picked out their own clothes, styled themselves (and their hair) as they wanted, and wrote their own songs. They saw themselves as a group of all-American California girls and didn't think of themselves as sex symbols.

But every band needs a narrative, so male music critics became fixated on describing them as hot, fun girls — whose musical skills were secondary to descriptions of how they looked. In this storyline, the girls were presented as fresh-faced and very girl-next-door, but this sanitizing of their behavior stood in great contrast to the reality of their partying, drinking, and drug use, which was on par with — or more excessive than — their male counterparts. While that wild-child rock-star behavior was a story *Rolling Stone* could tell about Led Zeppelin, when it was time to put the Go-Go's on the cover of their magazine, as shot by famous photographer Annie Leibovitz, the girls were outfitted in virginal white underwear and framed as cute girls any guy could fantasize about. Though the headline scandalously teased, "Go-Go's Put Out," writer Steve Pond concluded, "The Go-Go's are safe, wholesome, and proudly commercial." This was around the same time their infamous "groupie video" was leaked, in which someone taped the very high and drunk members of the band watching a roadie masturbate while they provided running commentary. It's a rock legend as famous as the story of Led Zeppelin's Robert Plant ordering a shark from room service to use in a sexual act with a groupie.

The episode still comes up in interviews today, but at the time it was verboten to even imply in print that the Go-Go's were anything other than a lighthearted Southern California girl band.

In 1987 Belinda Carlisle told *Spin* magazine about their infamous cover, "The whole sex thing was uncomfortable for us. [The *Rolling Stone* cover] caused a lot of shit, but the thing was, we were laughing at the typical way a female band could be packaged. A lot of people thought we were serious about it." The Go-Go's had initially rejected the idea of posing in their underwear, but eventually agreed to Leibovitz's vision. They had never resorted to exploiting their sexuality, either in song lyrics or personal presentation, and yet it still became the lens through which they were portrayed. It's rare that a female musician is able to develop her image in a way that doesn't revolve around her physical appeal to the male population.

With hit singles "We Got the Beat" and "Our Lips Are Sealed," the Go-Go's earned their place next to the biggest acts of 1981, including Duran Duran, the Police, and the Cars. The success of their first album, *Beauty and the Beat*, was a shock to everyone involved. It stayed at number one on the *Billboard* album chart for six weeks and was certified gold with sales of 500,000 by the end of the year. It ultimately went two times platinum by 1984, and the Go-Go's became the most popular, best-selling all-girl band in the history of rock music. When Jane Wiedlin quit the band and set out as a solo artist in 1985, the other girls planned to go on without her. They played a big festival in Rio and started writing a new album, but Carlisle and Caffey realized within a few months that their hearts weren't in it, and the Go-Go's effectively disbanded.

While the Go-Go's were going double platinum and slowly

coming apart at the seams, the Bangles were rocketing into the girl-shaped hole left behind. Though the band was officially formed in 1981, sisters Vicki and Debbi Peterson started their own all-girl garage band in the late '70s and played gigs at small local venues when they were teenagers. Vicki and I discussed this period in her life, and she remembers, "I was in high school when I found out about the Runaways, and I was kind of furious, in a weird way, that somebody had put together this concoction. They were getting all this attention and moving forward when we were playing hideous bars in Redondo Beach."

The Petersons met Susanna Hoffs and formed a band that went through multiple name changes before they eventually became the Bangles. Having had bad experiences in bands with ex-boyfriends, the women wanted to give forming an all-girl band a try. Annette Zilinskas, the band's original bassist, was replaced by Michael Steele, who had played briefly with the Runaways. These women all found each other in L.A. and began the work of establishing their band in a scene known as the Paisley Underground, where the '60s reigned supreme as the influence of choice. Comprised of dedicated scenesters who embraced the style of the '60s during the heyday of new wave and synthesizers, Hoffs describes the Paisley Underground as having a real cult feeling.

In the wake of the success of the Go-Go's, the Bangles had no problem generating interest among record labels. They released their first album, *All over the Place*, in 1984 on CBS Records. Though the album achieved moderate success, it wasn't until Prince wrote "Manic Monday" for the band, and it was released as the lead single from their second album, *Different Light*, that the Bangles charted with a hit. "Walk Like an Egyptian" propelled

the album to the number-two spot on the *Billboard* charts, and the album went double platinum within a year.

While the Go-Go's had been able to get away with being their goofy selves, the Bangles weren't so lucky. In the music industry, especially with female stars, looks are a commodity — part of the record label's investment that must be protected. The labels' approach to styling female musicians doesn't always make for a pleasant experience. According to Susanna Hoffs, "It is so not that scene in *The Wizard of Oz*, that great scene where they're fluffing and puffing and making [Dorothy] up and transforming her. It is so not that. In a sense it was terrifying. When we did our first photo shoot for Columbia [Records] and our first video, all of the sudden it was scary because all these people were coming up to us and saying, 'Wear this, do this, and here's makeup for you.'" The Bangles had to fight for the right to style their own big '80s hair and look like themselves.

The narratives of the Bangles and the Go-Go's were intersecting from the start, and it became a lazy comparison to mention the Go-Go's every time someone wrote about the Bangles. The ground became so well trod that by the time the Bangles did a cover story for *Spin* magazine in 1988, the Go-Go's were listed first on their press agent's list of topics to avoid. It is an understandable comparison. Here were two all-girl bands from L.A. who wrote and performed their own songs and achieved mainstream success within the same five-year time period. They had common influences, including the Shangri-La's, the Ronettes, and even the Beach Boys, and mutual admirers, from Rob Lowe to Prince. There was overlap in their back-end support as well, namely Miles

Copeland, whose record label released Go-Go's albums and who also managed the Bangles.

These were two hardworking, very real bands. They were not, however, cut from the same cloth the way the music press would have us believe. The Bangles got the short end of that stick. They had to listen to the comparison for the entirety of their career, as if they could never have been successful without the Go-Go's to blaze the trail. Ultimately the Bangles imploded, like so many other girl bands. Female jealousy is potent, and it pulled the Bangles apart when the other members felt Hoffs was getting more press attention. Like Belinda Carlisle, Susanna Hoffs launched a solo career. While her singles didn't chart as high as "Heaven Is a Place on Earth," she had a successful enough career on her own.

After the Go-Go's and the Bangles came Vixen, also from L.A., who had one hit with a song written by Richard Marx. And then girl bands seemed to disappear. There were a number of riot grrrl bands in the early to mid '90s whose modus operandi was to avoid the mainstream in order to maintain control over their image. And there was a Kurt Cobain–fueled resurgence of the Shaggs and the Slits, two great underground girl bands. But it's a long, long way to the underground, particularly for teenage girls, who are often self-conscious. They are not likely to embrace underground culture at that time in their life when fitting in is one of their most important concerns.

I certainly wasn't. I consider myself lucky to have discovered *Sassy*. In my very small town, Jane Pratt's magazine was my only exposure to a world where high-school football games were not the main attraction. This is why there need to be more Belinda

Carlisle and Jane Wiedlin–style pairings in the world: it is comforting to see some other ideas of what being cool can look like.

The Dixie Chicks came along at the end of the '90s and became the most-successful girl band of all time. After a political scuffle in the early 2000s lost them the approval of the country-music industry, they became pariahs to their core country fans. Today the great girl bands I can think of (Vivian Girls, Au Revoir Simone, CocoRosie, Dum Dum Girls, Care Bears on Fire, the Like — really the list goes on and on) are hiding in the underground. The utter dearth of successful girl bands is enough to make me wonder: Do women feel they have to remain on the outside because the female voice is not considered universal?

The popular images of women in music we see most frequently today are solo female singers and all-girl singing groups who are glamazoned and processed within an inch of their hair falling off. Often these ladies are singing songs written and produced by men. It's true that many of the teenage girls watching these videos may be unaware of this fact, but that doesn't negate the impact of watching women through the filter of the male perspective. These girl singers become blank canvases for any sort of image or emotion, and they promote the idea that looking pretty and dancing are more desirable than creating. Of course, there are female artists who have railed against this idea, but for the most part they have stayed underground or turned into Courtney Love. My problem with bands that avoid the mainstream is that they're depriving girls whose only cultural barometer is Katy Perry of an alternative point of reference for what is acceptable girl behavior. It's difficult to challenge the norm when you remain so far outside it.

In spite of the successes of the Go-Go's and the Bangles, we're still a long way from seeing a plethora of all-girl bands. Girls are taught to be sexy, and it isn't sexy to be the drummer in a band, as I learned in junior high.

After leaving band during my junior year in high school, I never went back and picked up my drumsticks. Instead I picked up a pen and started pointing out to people how few female singers were in their Top Five, or on their radar at all. I started putting as many underground girl bands as I could into the lineup on MTV2's *Subterranean*, the music-video show I programmed. I get it: music as a whole is more niche than ever. The underground girls don't want to lose their cred, and the sellouts end up selling us makeup and hair dye instead of great songs. Girl bands have gone quiet for the time being, but I keep hoping for a new set of idols who will convince the next generation of girls to buck the stereotypes and pick drums over the clarinet.

WHERE HAVE ALL THE GIRL BANDS GONE? PLAYLIST

THE GO-GO'S, "Our Lips Are Sealed"

GOLDIE & THE GINGERBREADS, "Can't You Hear My Heartbeat"

THE CRYSTALS, "He Hit Me (It Felt Like a Kiss)"

THE CRYSTALS, "He's a Rebel"

FANNY, "Butter Boy"

THE RUNAWAYS, "Cherry Bomb"

SUZI QUATRO, "The Wild One"

THE GO-GO'S, "Johnny, Are You Queer?"

THE GO-GO'S, "Living at the Canterbury"

THE GO-GO'S, "Vacation"

THE GO-GO'S, "We Got the Beat"

THE BANGLES, "Manic Monday"

THE BANGLES, "Walk Like an Egyptian"

VIXEN, "Edge of a Broken Heart"

DIXIE CHICKS, "Goodbye Earl"

INTERLUDE

my scrobble, myself

I AM CONVINCED that last.fm is the greatest social network ever invented. The appeal is in the scrobbling. For those neophytes among you, scrobbling is last.fm-speak for uploading a list of everything you've played from your iTunes and iPod and publishing this list on your last.fm profile. If I've ever asked if you have a last.fm account, it's because I want to stalk your music.

In addition to being my own personal music-stalker paradise, last.fm is also one of the best ways to find new music. You can easily check out what your friends are listening to. If you scrobble, then last.fm will recommend bands for you to add to your library that are similar to the ones you've been listening to. In the summer of 2010 my favorite album was by a Swedish band called Club 8. They had been around for a decade, but I had just discovered them. Last.fm politely noted this and recommended another little-known Swedish band called Sambassadeur, offering up a few tracks for me to listen to. I liked what I heard. So I downloaded more from the Hype Machine, a blog aggregator that lets you search for a band's name and then returns links to every blog that has posted their tracks. Now I

have one more Swedish indie band in my digital music library. Last.fm is like a kind friend who is slightly more knowledgeable than I am about obscure bands and who manages to be 70 percent right in guessing what else I might like.

It also keeps stats on what I listen to, along with all the people whose music I'm stalking. I can see what artists I've played most in time frames ranging from the last week to the entire known history of my digital music. I can look at my friends' profiles and see what they're actually listening to as well. This eliminates most of the need to ask about their top-five artists—although it's fun to ask anyway, find out what they think they like, and then compare it to what they've actually listened to the most. For example, during the writing of this book I racked up a lot of listens to the Beatles, the Rolling Stones, and the Smiths in particular. Elvis Costello, R.E.M., and the Cure follow in short order. Over the course of my lifetime I'm certain I've listened to Elvis Costello far, far more than any other single artist, and if you give it six months, he will likely lap the Smiths in spins. I needed to listen to a lot of Smiths songs while I ruminated in depth on various offensive lyrics, but if you looked at my last. fm profile right this minute you'd think I was some sort of sad-bastard Smiths fanatic. I've now listened to the Smiths enough to satisfy that urge for the next five years.

I also have some bad last.fm behavior. Perhaps you've heard of Facebook stalking? I tend to last.fm stalk men I am crushed out over. Facebook and Twitter status updates pale in comparison to what I can divine about someone's day if I look at their last.fm profile. For example, I met an insanely charming Italian man who lives across the Atlantic Ocean from me. He

is as in love with music as I am, and we quickly took to sharing MP3s with each other via e-mail each day. I found it essential to talk him into creating a profile on last.fm ASAP. Now I find myself obsessively stalking his last.fm page to see whether he's gotten my latest track and how quickly he listened to it. I spy on what he's listening to and figure out what sort of mood he's in. For example, I knew the day he listened to the National for six straight hours, he was going to be in a bad mood. Sure enough, his car had been towed that day and we had a little tiff that night when we spoke. Sometimes what he's listening to strikes a chord with me. Like when he has a Velvet Underground day and it occurs to me it would be lovely to hear "Beginning to See the Light." Sometimes his last.fm playlist will register a song I haven't thought about in years and I'll feel compelled to listen to it myself. And when he proposed that we should have a song of our own, I stalked his last.fm hard, scoping out what tracks he was going to put in the suggestion mix we agreed to exchange. In the past I've felt guilty about this behavior, but when I confessed to him what I'd done, he admitted he was doing the same thing. So it can't be that bad.

Statistics, recommendations, and stalking are a beautiful trifecta that makes last.fm indispensable to me. You should scrobble too, if only for the lifetime tally of how many times you listen to unexpected things. How else would I know I've listened to Pulp's "Razzmatazz" forty-one times since 2008?

MAKING OUT WITH ROMEO AND JULIET

EVERYONE CAN EMPATHIZE with the plight of two star-cross'd lovers separated by their families. Or by a popularity gap. Or by a vampiric inclination to suck human blood. Anything beyond their control will do, really. Shakespeare's *Romeo and Juliet* has been influencing love stories since the sixteenth century, making it one hell of an enduring tale, as well as the inspiration for dozens of tragic teenage love stories. Love is unbearably hard on this hormone-challenged couple, whose affair is an ideal illustration of the boneheaded things kids take part in to get their own way. Teen emotions tend toward the exaggerated; rejection feels as awful as the seventh circle of hell, while love feels like that all-encompassing center of the universe. Where better to look for the soundtrack to your next makeout session than the music of *Romeo and Juliet*?

The Bard himself did not supply a ready-made set of hit songs to accompany his teen angst dramedy, so instead we can look to a trio of modern descendants for inspiration: *Valley Girl*, Baz Luhrmann's *Romeo + Juliet*, and the Twilight Saga: *New Moon*.

VALLEY GIRL (1983)

Never was there a tale of more woe than that of a totally bitchin'
Val Juliet and her punk-rock Hollywood Romeo. If you tried to
make this movie today (and there are rumors of a remake in the
works), our two main characters — Randy, as a Sunset Strip emo
dude, and Julie, as an aspiring actress from Long Beach — would
come off as irritating jerks. In 1983, however, their story launched
an unlikely cultural appreciation for Valley-speak and led to thou-
sands of exclamations of "gag me with a spoon!" and "like totally,
I'm sure!" The heavy Val-speak dialect in this film is almost as
incomprehensible as Elizabethan English. The movie hits all the
right Los Angeles notes, from making Randy a student at Holly-
wood High to sending Julie's crew of friends to scarf down frozen
yogurt at the Sherman Oaks Galleria.

The conflict for these two young lovers doesn't revolve around
meddling parents and feuding families. In fact, we never meet
Randy's mom or pop, and Julie's parents are perfect ex-hippies who
like to give Julie all the space she needs, which means no curfew
and only light judgment on her materialistic lifestyle. No, the con-
flict here originates with Julie's friends, who don't want her to be
with a weird-looking dude who dresses like a punk and isn't from
the Valley. This typical conformist teenage behavior is made all
the more tragic when it becomes apparent that the guy her friends
want her to date is devastatingly boring. In Teenage Land, the bat-
tle between popularity and true love is a close call.

Though the movie's soundtrack became legendary for intro-
ducing a generation of listeners to underground new wave music,
it was originally supposed to feature well-known bands like the

Jam, the Clash, and the Go-Go's. Just a year earlier, *Fast Times at Ridgemont High* had established the practice of loading teen movie soundtracks with as much pop music as dialogue. However, the plan was scrapped when it became clear that licensing tracks from highly sought-after bands would kill the movie's entire production budget. So director Martha Coolidge went local. At the time, Los Angeles radio station KROQ was developing its status as a legend in modern rock by mirroring MTV and embracing the British invasion of virtually unknown new wave bands. Coolidge chose to set the film to music by bands she was hearing on the radio and in clubs across town, many of whom she knew personally, along with a few unknown Brit bands who were second string in the genre. Even so, they reportedly spent almost for song rights as they did making the film.

If *Fast Times at Ridgemont High* created the template for scoring a film with pop music, then *Valley Girl* perfected it. Even though Cameron Crowe wrote *Fast Times* at age twenty-four, the songs featured in that flick lean toward the middle-aged: Jackson Browne, Don Henley, Joe Walsh, Graham Nash, and Jimmy Buffett. Perhaps Crowe made these selections because these dudes were huge stars in the 1970s, when he was writing for *Rolling Stone*. In any case, by the time of the movie's release in 1982, the tracks were outdated. *Valley Girl,* on the other hand, used unknown artists who had bizarre haircuts and played synths. They were the very representation of new-wave music that was gaining popularity in the '80s. There is a reason the *Valley Girl* soundtrack is legendary — it connected with what was new and cool in youth culture. John Hughes adopted this method of incorporating music in his films — which was easy for him as an avid record collector — and

it later became standard operating procedure for movies aimed at teen audiences.

There are four songs in particular from *Valley Girl* that can go on any make-out playlist and get you to at least third base. A lot of the music is up-tempo, in keeping with the style of the day, so this soundtrack lends itself more to the playful make out.

1. THE PLIMSOULS, "A Million Miles Away"

If they had been from Athens, Georgia, the Plimsouls would have fit right in to the early-'80s jangle-pop scene as contemporaries of R.E.M., but since they were in Los Angeles, their break came via Hollywood when they were asked to perform as the Sunset Strip club band in *Valley Girl*. They didn't embody the new wave look, though they did rock some sunglasses at night. Their sound was more akin to power pop than anything British, so they were an unlikely choice for the part. The Plimsouls make multiple appearances in *Valley Girl*, scoring Randy and Julie's first date and also Randy's ultra-steamy bathroom make out with his ex-girlfriend. In both instances, the song illustrates the distance, either cultural or emotional, between Randy and Julie. Something about remembering how they kept themselves apart while this song played in the background makes it feel so right for that make-out moment just before you lunge at each other for the first time.

2. THE PSYCHEDELIC FURS, "Love My Way"

This song is only for those who are seriously looking to get down. It's got the sexual impact of Al Green, and you should only put this on for hard-core sensual seduction. It's the emotional neutron bomb of a song on the *Valley Girl* soundtrack. The song makes

only a small appearance in the film as background music when Randy is hiding in the shower at a house party, waiting for Julie to use the bathroom so he can convince her to leave with him. The Furs would go on to be one of the biggest bands on the *Valley Girl* soundtrack, and their most identifiable song, "Pretty in Pink," served as the title track for the 1986 John Hughes film.

3. JOSIE COTTON, "Johnny, Are You Queer?"

This is a terrible song choice for making out with shy boys who are afraid to make the first move. Hit those guys with the Psychedelic Furs. For the pompous ass in your love life, however, drop the needle on this one. He'll think you're sassy and adorable for putting something so unconventional on the speakers. On a make-out mix, this song issues a subversive challenge to the boy you've brought home that will implore him to prove his manhood. Once you've implied that you don't think he's able, he will immediately want to do all the things Johnny won't.

This track has an interesting history. The chorus was written by the famous L.A. punk band Fear. Then the Paine brothers, a couple of scenesters-turned-managers who had produced a Fear album, came in and filled things out, turning it into a full song. They were managing the Go-Go's at the time and gave it to them to perform. After the Paines and the Go-Go's parted ways, the brothers barred the girls from performing "Johnny," according to Josie Cotton. Josie was dating Bobby Paine at the time, and when they were looking for a female vocalist to record a demo of the song, Josie ended up doing it, much to the dismay of most of Los Angeles. Everyone assumed she'd stolen the song from the Go-Go's and blasted her for it, but "Johnny" became a local hit for her

anyway. Josie claims her label, Elektra, killed the budget for a music video for the song in 1982, saying there was no future in MTV. Without the kind of exposure MTV provided back then, Cotton found herself taping lip-synch performances for *Solid Gold*, singing on the new wave–centric TV show *Square Pegs* (starring Sarah Jessica Parker before she was Carrie), and playing as the prom band in *Valley Girl*, but she never made it in the mainstream. The song remains her signature hit.

4. MODERN ENGLISH, "I Melt with You"

Although the practice was gaining popularity at the time, no soundtrack album was released to complement *Valley Girl*. There was a collector's item dummy six-track album created but never officially released, so for years people just checked the movie credits and cobbled together their own mix-tape versions of the soundtrack. Finally, in 1994, Rhino Records released an official *Valley Girl* soundtrack, to great success. The one band who managed to parlay their placement on the soundtrack into a hit single was Modern English.

Modern English were always going to be a one-hit wonder. Their first album was a sort of dark, Joy Division–influenced affair that, in spite of being on the venerable British label 4AD (home to important subculture bands such as the Cocteau Twins, the Birthday Party, and Bauhaus) got them nowhere. Their second album included "I Melt with You," which had a more distinctly pop feel than anything on the first album, and a bunch of other songs that were not nearly as good as "I Melt with You." I suppose if they'd had the imagination of Duran Duran and churned out oddball music videos, we might better remember the depth of their

catalog. Instead they have cashed in on the success of "I Melt with You" for nearly thirty years now. The song was re-released and became a hit again in 1991, something that almost never happens in pop music, and it was revitalized a third time when Burger King used it in a national ad campaign in 1996. Versions of the song have scored commercials for Taco Bell, Hershey's chocolate, Ritz crackers, General Motors' Arcadia, and M&M's. This one particular song has literally scored your life since 1982; you might as well have it score your make outs.

You would have to be a heartless bastard to rebuff the chance to make out to this song. It's easily one of the most sugary sweet hits of the '80s. A word to the wise, however: up-tempo songs like this are best kept to the start of your make-out playlist. It can be odd to have a dancy new-wave song come on when things are getting heated.

ROMEO + JULIET (1996)

This Shakespeare adaptation by way of MTV music video was released during my freshman year in college, and I went to see it with a bunch of girls from my dorm. At least half of us promptly bought the soundtrack, and it joined Ben Folds Five, 311, and Cake as one of the albums in constant rotation on our floor. None of us knew that much, historically speaking, about music. We frequently bought the albums we heard blasting out of each other's rooms, which led to a group of eighteen-year-old girls with identical CD collections to go with our matching dorm-room posters and Bed Bath & Beyond shower caddies. The late '90s were a messy time in rock music. Over the course of the decade, the previously forward-thinking modern-rock radio format (responsible

for breaking artists like Nirvana and the Lemonheads) devolved into a showcase for mediocre post-grunge bands like Limp Bizkit and Bush. Record labels turned the word "alternative" into a marketing tool, and the corporations who owned radio stations made alternative a sellable format, taking it into the mainstream.

The *Romeo + Juliet* soundtrack captures the all-over-the-place quality of '90s music and displays how record labels were using soundtracks as a new marketing tool. Frequently the label releasing the soundtrack would stack the album with artists from its own roster, which meant you could find very underground acts selected by the filmmaker next to mainstream bands foisted on them by a record label. This soundtrack, released by Capitol Records, places Radiohead right next to Everclear, who were bastions of mediocre pop songwriting beloved by the masses. The selection of tracks for the soundtrack aptly reflects the sense that anything, from amazing to putrid, could be a hit on modern rock radio in the mid to late '90s.

The way music was incorporated into the film, however, was completely unique. Impressed by super-producer Nellee Hooper's work with Massive Attack and Björk, director Baz Lurhmann brought on Hooper to create the score. Hooper worked with Scottish composer Craig Armstrong, who had created Massive Attack's *Protection* with Hooper, and arranger/programmer Marius de Vries, who had worked with Hooper on Björk's *Debut* and *Post*, not only to score the movie, but to twist the pop songs to fit the film. Most films simply lay music down to accompany the film with a bit of mixing to make it all work, but Hooper and his team were remixing the songs themselves to complement the story — like the slowed-down and drugged-out treatment Kym Mazelle's "Young

Hearts Run Free" gets. During the song, the characters go on an Ecstacy-fueled party bender. The song is eventually sped up into a disco anthem that makes the head reel and echoes the increasing intensity of the scene. Next Armstrong draws on Des'ree's "Kissing You" to create an orchestral accompaniment to a moment of impossible love when Romeo and Juliet see each other for the first time. Most interesting is how they use the soundtrack's lead single, Garbage's "#1 Crush." The music is never overtly in the movie, but Hooper and Vries take elements of the track — a haunting melody, or just the vocals run through effects — and insert them into the background of scenes to foreshadow the deaths of the title characters. If you're not listening closely for the Garbage song, you won't hear it.

The visual style of *Romeo + Juliet* drew heavily on the hyperquick cuts and saturated colors popular in music videos and on MTV shows at the time. Featuring a fresh-off-*Titanic* Leonardo DiCaprio and Claire Danes in her first film post–*My So-Called Life*, this film, with its super-slick soundtrack and guns in place of the swords in Shakespeare's original work, became a Gen-X manifestation of reckless, selfish, dramatic teenage love.

1. GAVIN FRIDAY, "Angel"

There is every chance a guy might find this song a touch fey when you initially put it on and ask him to touch you there. If his dreams aren't made of the wonderstuff found in high-pitched male vocals on top of typical early-'90s UK dance pop with a repetitive bass thump, here's what you do about it: inform the make-out partner in question that Gavin Friday is the singer of an '80s post-punk group called the Virgin Prunes. Scoff when he doesn't know who

they are and explain that they're old mates of U2 from Dublin, that as a matter of fact the Edge's brother was in the band and that Friday went on to record tracks with Bono for *In the Name of the Father*. But the Prunes weren't commercial sellouts with a hard-on for that old-time religion like those bastards in U2. In fact, "virgin prunes" is slang for outsiders. When the know-it-all boy in question has been sufficiently baffled by your outpouring of knowledge, tell him maybe he should just worry about looking pretty and get back to kissing you, because you've got the soundtrack situation totally under control.

2. GARBAGE, "#1 Crush"

Certain bands become relics of their time. Garbage is undeniably one of those bands who perfectly encapsulate the aural landscape from 1995–2000. At the time it was defining, but it's since become a noose. That said, I do not object to some nostalgia in a make-out mix, especially if the other half of your kissy face is in the same age group as you. You probably knew this song when you were both younger, and that could add a sort of teenage love vibe to the proceedings.

Singer Shirley Manson's deep voice and producer/performer Butch Vig's industrial soundscapes come together in an unexpectedly lusty combination. She uses unromantic and powerful words like "violate," "die," and "drown." The dirge is backed up with masculine guitars, dreary keyboards, and a decidedly feminine backing-vocal track with equal parts singing and moaning. The song has the yin and yang of male vs. female. Manson could be singing from the point of view of a psychotically needy woman

or lovesick stalker Lloyd Dobler from *Say Anything*. The track just oozes sex.

3. RADIOHEAD, "Exit Music (for a Film)"

This song was created for people who exist inside their own bubble. Literally. Radiohead was sent only the last thirty minutes of *Romeo + Juliet* and asked, based on that, to write an end-credits song. The moment where Claire Danes as Juliet holds Romeo's gun in her mouth was the exact frame that inspired singer Thom Yorke to write what he calls, "a song for two people who should have run away together a long time ago." It attempts to give star-crossed lovers the happy ending they so desperately desire, which is a lovely sentiment. It is, by design, the kind of song you can lose yourself in over the course of four minutes.

This song was not included on the film's official soundtrack, at the request of Radiohead, who released it a year later on their masterpiece album *OK Computer*. Instead, the song "Talk Show Host" was included, but it is far inferior for the purposes of communing with your soul mate. Or for appearing to have good taste in music during a one-night stand. Much like its placement in the movie, this particular song should appear near the end of your make-out playlist, with any luck hitting you after things have . . . er, concluded. It is an excellent track for the post-coital moment, before you close your eyes and the world goes black.

4. THE WANNADIES, "You and Me Song"

Three years before the release of *Romeo + Juliet*, Sweden cruelly exported Ace of Base to the rest of the world. We all saw the sign,

wanted another baby, did not turn around — all the things their catchy songs instructed us to do. Their music was sweet enough to give you a cavity, as the girls from *Clueless* would say. Lately Sweden's musical exports have gotten a lot cooler, from raunchy pop star Robyn to clapping gurus Peter Bjorn and John (PB&J). The Wannadies paved the path for groups like PB&J, creating music more akin to the cool Britannia movement out of the UK in the early '90s than to derivative, Roxette-esque pop (another terrible Swedish export).

Making out to this particular track is perhaps best for committed couples. It appreciates the shorthand that develops when you've been with someone for a while and doesn't shirk from embracing the intimacy of coupledom. Nothing will make a guy you just met bolt like a power chorus of "you and me always and forever!" The samba rhythms are a sweet sort of sensual, though, bursting through into power pop at every chorus. It's the kind of song you can see a romantic montage being set to. The kind of song you can hold hands to.

THE TWILIGHT SAGA: NEW MOON (2009)

Part of me cannot believe I'm going to tell you that anything about *New Moon* will get you hot and bothered if you're older than fourteen years old. The whole Twilight franchise is a teen dream, but there is also something disturbing about the slavish devotion from legions of teenaged girls and their moms (aka Twi-hards). Don't get me wrong: I loved the books. They rehashed the longing feelings of my unrealistic high-school crushes, when everything felt possible (even the notion that the cute, shy, pale boy in school might be a vampire/superhero/Jake Ryan from *Sixteen Candles* who was

secretly in love with me). That naive romantic illusion inevitably ends in disappointment for 99 percent of people, who realize their lives are going to be just as boring as everyone else's. The Twilight books are great for escapist entertainment, but the movies are terrible. The kind of slow-paced romance, set to meaningful glances, that the Twilight series tries to evoke — where being apart inspires the same sort of heart-stopping emotion as being together — works great in a thousand-page saga but comes across as both dull and immature on screen.

The first film, *Twilight*, owes a debt, thematically, to *Pride and Prejudice*, but the second film, *New Moon*, takes its nods to classic literature a step further and gives blatant homage to *Romeo and Juliet* with actual, unsubtle references to the play. In the opening scene, for instance, Bella wakes up with a copy of *Romeo and Juliet* on the pillow next to her. Later Edward and Bella watch the classic 1968 Franco Zeffirelli version of *Romeo and Juliet* in class and debate, in hushed tones, the classic relationship. Not that there's anything wrong with citing your references: *Valley Girl* did the same, sending its two leading lovers to see *Romeo and Juliet* on a date.

The difference between the way music was chosen in the two previous films and in *New Moon* reflects the increasing commercialization of movie soundtracks since the days of *Valley Girl*, when no one would even pony up the investment necessary to release the soundtrack. Now the soundtrack album is a crucial wheel in the marketing plan of any movie aimed at teenagers. CD sales have been declining for the last decade, and the number of media outlets where new artists can catch a break, like radio or music television, is diminishing. The Pew Internet study of 2008 revealed that the most popular way for people to discover new music was

through TV shows, commercials, and movies. Thus, getting songs placed in these vehicles has become essential for bands — and I'm not just talking about up-and-comers. Even for the most successful bands it's a tough market, which is why you'll see a band like Radiohead or Muse willing to license a song for placement on a Twilight franchise soundtrack.

Music supervisors select music for placement in films, commercials, and TV shows. Charged with the task of finding songs that *feel* like the moment they are being used to score, they present multiple options to the director and clear the selected tracks with artists, labels, and publishers. It was a position that was unheard of circa *Valley Girl* and had only just become indispensable around the time of *Romeo + Juliet*. So while Martha Coolidge just asked friends and local L.A. acts for permission to use their songs for *Valley Girl*, directors today employ music supervisors to handle all the licensing work, sifting through the hundreds of music submissions they get each day.

For the studio, a movie soundtrack can be a revenue loss leader used to promote a movie, so they make an effort to keep licensing costs down. Because it's less expensive to license artists signed to the label that's releasing the soundtrack, the song selection for the first Twilight movie was tied heavily to Atlantic Records' roster, which resulted in some bizarre choices. The soundtrack features vaguely ill-fitting artists like Paramore, whose screaming-girl-anthem sound is the antithesis of *Twilight's* hero, Bella, whose character is more of a mousy everygirl. Also included were the past-their-prime Linkin Park. I can only assume '90s throwback Collective Soul, the band we'd all prefer to forget, also appeared because of their affiliation with Atlantic. The high point of the film musically

was the inclusion of Radiohead's song "15 Steps" during the clos-
ing credits (an interesting touch of synchronicity with *Romeo +
Juliet*), but this song wasn't included on the soundtrack. Everyone
was taken by surprise when the soundtrack debuted at number one
and went on to sell over two million copies.

Due in part to the massive sales success of the *Twilight* album,
there was a bigger budget for *New Moon*, and new director Chris
Weitz brought a very different musical aesthetic to the film. He
was the creative input behind the film adaption of Nick Hornby's
About a Boy, which was set to a score entirely by Badly Drawn Boy.
The feel of the music in *New Moon* led to numerous comparisons
to subversive soundtracks from blockbuster movies of the '90s, like
Romeo + Juliet and *The Crow*. Again, Thom Yorke was on board,
lending a solo song, "Hearing Damage." Clearly he's the guy to
call when a modern-day retelling of *Romeo and Juliet* needs music.

The result is a soundtrack of dark songs that convey a sense of
yearning true to the original tale of *Romeo and Juliet*, but that's
where the similarities stop. In *New Moon*, Bella and Edward spend
some time apart after his family nearly kills her. While apart, she
considers falling in love with a werewolf but changes her mind (un-
derstandably). The plot may be convoluted, but the conflict is not:
they are not together and they want to be. Much of the soundtrack
is music you might listen to while lying in bed alone, not because
you're out of love, but because there is a great distance between
you and your love. It is music for the lonely, and like everything
in Twilight, it's rife with longing but gives no relief. To be honest,
I'm a huge fan of setting a mood and slowing down. I hate over-
excited make-out sessions that turn into something else entirely in
less than ten minutes. This soundtrack does a great job of setting

the tone for a yearning round of kisses after you've been apart from your love.

1. GRIZZLY BEAR with VICTORIA LEGRAND, "Slow Life"

There was a lot of speculation about how all these indie bands ended up on the *New Moon* soundtrack, and Grizzly Bear became inadvertent spokespeople for the credible artists who contributed their songs to a vaguely bizarre teen vampire story. In an interview with *Pitchfork*, singer Chris Taylor fielded the question of how they got involved, and he responded, "Initially, it was like, 'What?!' But Thom Yorke did it, and we like him. It's like: 'If Dad does it, it's okay, right?'"

Grizzly Bear recorded this new song for the film with Beach House singer Victoria Legrand. The Brooklyn band is known for their harmonizing, which is front and center on the track. This song is a slow buildup of sexy with no release, making it so very PG-13-make-out. The lyrics are almost unbearably romantic. It's not actually a song, but the embodiment of a swoon.

2. LYKKE LI, "Possibility"

When presented with the opportunity to sing about love, Lykke Li is likely to come at it from the oddest angle. She's the Woody Allen of attractive Scandinavian pop singers, obsessed with death and rejection. In this song she takes the concept of possibility, which for many people is positive and hopeful, and turns it into a theme about dying because your lover leaves you. It's practically a requiem, except for the percussion, which leads your mind to the little spots of sunshine on the outside of the possibility, sunshine that gives someone who's lost all hope a little spark of longing to

keep them going. The track moves so slowly you might find your-
self staring in someone's eyes for the duration.

Some people might think underground or indie rock artists let-
ting their music be used on soundtracks to blockbusters like *New
Moon* is a big sell-out move. I think it's a helpful lift to the music
taste of future generations. Like giving kids a little bit of fiber with
their hefty dose of sugar. Lykke Li agrees with me about this whole
indie-rock soundtrack thing. In an October 2009 interview with
MTV, she says, "We've been feeding people such shit. Why can't
we feed them good things . . . because I know Robert Pattinson is
this big teen idol, but I remember watching *Romeo + Juliet* with
Leonardo DiCaprio, and I was, like, in love . . . and the soundtrack
to that movie is so good, you know? Really well-chosen songs. Not
commercial. I think it's great, and hopefully we can do that again."

3. BON IVER & ST. VINCENT, "Rosyln"

Have you gotten the point by now that everyone was shocked by
how indie-centric the *New Moon* soundtrack was? As though it
should be all Rihanna and Taylor Swift because it's a juggernaut
series for teenagers. Annie Clark, aka St. Vincent, weighed in with
some revelations in an interview with *Pitchfork*: "We were basically
all suburban tweenagers at a point. I know for damn sure I was. I
think if I had this soundtrack . . . I probably would've been a lit-
tle further along and probably better off." I think we can all agree
with Clark here that to some extent *New Moon* is saving teenagers
from worse music, one soundtrack at a time.

This song, like most of Bon Iver's work, is ethereal, haunting,
and deeply romantic. It captures that feeling of waltzing through a
dark room, sneaking closer and closer to your dance partner. Clark

sums it up perfectly to *Pitchfork*: "I'm singing along with Justin [Vernon of Bon Iver], and . . . our voices combined create this kind of strange, androgynous — it kind of like, coalesces into one voice, and you're going like, 'Oh, what is that? Who is that?'" It is ideal music for melding into someone.

4. DEATH CAB FOR CUTIE, "Meet Me on the Equinox"

Ah, *New Moon*'s romantic lead single, from the band who once wrote a lovely ballad called "The Face That Launched 1,000 Shits" in homage to a woman. The restyling of Death Cab as romantic heroes has been slowly evolving over the last decade. The old-school version of Death Cab, from 1998 to 2002, was a band on the verge of joining the ranks of the emo, when it was still cool, alongside Jimmy Eat World and the first two Weezer records. They wrote oodles of songs about hating ex-girlfriends, hating Los Angeles, and hating girls who would never become their girlfriends and probably lived in Los Angeles. It was a little hard for any woman to relate to, let alone make out to. Then, somewhere around the *Transatlanticism* album, love came to town, and their music became infused with a romantic edge. Now they specialize in complex, symbolic love songs rife with aching, like "Meet Me on the Equinox." Just the same, this is a love song that could translate quickly into a breakup song, with a chorus that reminds you the end is always nigh.

MAKING OUT WITH ROMEO AND JULIET PLAYLIST

THE PLIMSOULS, "A Million Miles Away"

THE PSYCHEDELIC FURS, "Love My Way"

JOSIE COTTON, "Johnny, Are You Queer?"

MODERN ENGLISH, "I Melt with You"

DES'REE, "Kissing You"

GAVIN FRIDAY, "Angel"

GARBAGE, "#1 Crush"

RADIOHEAD, "Exit Music (for a Film)"

THE WANNADIES, "You and Me Song"

RADIOHEAD, "15 Steps"

GRIZZLY BEAR with VICTORIA LEGRAND, "Slow Life"

LYKKE LI, "Possibility"

BON IVER & ST. VINCENT, "Rosyln"

DEATH CAB FOR CUTIE, "Meet Me on the Equinox"

GUILTY PLEASURES

IN MY WORLD it's not okay to like the Black Eyed Peas. It doesn't matter how many albums they sell. It doesn't matter how many hit songs will.I.am writes or how many corporations use their music in advertisements. It doesn't matter that millions of people love them. In my world, if you choose to proclaim an admiration for the Black Eyed Peas, someone will scoff, "How embarrassing for you." As a matter of fact, that sounds like something I would say.

Welcome to the world of music snobbery.

It's not just the Black Eyed Peas who suffer this scorn, although they do have some of the more ludicrous lyrics in pop music ("Let's Get Retarded," anyone?) so they're a lightning rod for taunts. They are part of a world of music embraced by the mainstream and looked down upon by purists. Those considered unworthy of being taken seriously are generally chart-topping artists who write dumbed-down songs for teenagers, middle-aged people, and the unwashed masses of NASCAR enthusiasts. The Jonas Brothers, Celine Dion, Nickelback. A scenario in which you actually like any of these artists is only okay under the guise of a guilty pleasure.

A guilty pleasure is the music you hesitate to admit to your friends that you like. It's the album you hide in the closet and the songs you hope don't come up if anyone else is in the room when

your iTunes is shuffling. It's music that causes you to roll up the windows in your car for fear a pedestrian or biker might hear. Your guilty pleasures are a key part of what makes your taste in music unique, but admitting them to others can leave you feeling more vulnerable than a Feist song in *Grey's Anatomy*. There is nothing more loathsome than someone who proclaims she has no guilty pleasures because she's proud of everything she listens to. That person is either a fool with little actual knowledge of music or a pompous ass. You don't want any part of either one.

I planned to begin by telling you that my guilty pleasure is Kylie Minogue. I was going to try to be cool, even in my selection of a guilty pleasure, and defend her work by explaining that she's recorded a duet with the Bukowski of dark pop, Nick Cave, played with performance-art acts like Fischerspooner, and been remixed by every credible producer under the sun. This was all going to illustrate that it's much cooler to like Kylie Minogue than you might realize. I was busted by my friend Gina.

"Courtney," she said to me, "you need to write about your real guilty pleasure: the Pussycat Dolls."*

It's true, I like the Pussycat Dolls. A lot. I don't mean I like them in the sense that one of their songs is a fluke earwig thing that caught my attention. I mean I get shivers of happiness when I hear "Stickwitu." I can sing along to every word of "Buttons." I flip my hair around and make a Megan Fox–ish pouty sexy face in the mirror to "Beep." There is no defending myself from this

* One good guilty pleasure outing deserves another, so I'll tell you: Gina's guilty pleasure is Sisqó, specifically "The Thong Song." Her assertion that the key changes in that song are quite difficult to sing is accepted by me as a valid argument in Sisqó's favor, but she is obviously still insane.

flagrant lapse in taste on any level. The Pussycat Dolls are the embodiment of a manufactured pop group, which is deplorable to people who consider themselves real music fans. Their outfits are excessively slutty, and they sing about gender politics with the kind of inane Spice Girls "girl power!" message that's light on substance and pisses off most women who consider themselves feminists. And now that I think about it, I cannot name anyone in the group except Nicole Scherzinger, who serves as their leader. The other women are interchangeable and replaceable. Literally. When an older-looking faux redhead left the group in 2008, she was replaced by another faux redhead who was about a decade younger and blended right in. Rumors on the Internet tell me there's a good chance everyone in the group except Scherzinger will be kicked out before their next album comes out, and I bet no one will even notice. This group is another example of how some people in the music industry think women are just dancing bodies who need a half shirt and heels and nothing else. I wish I could at least say something positive about their dance skills, but as my friend Lisa, a trained dancer, said to me when I asked for her opinion on the group, "They're basically strippers with some classical dance training."

I realize most of what I've said so far has made a stronger case for hating the Pussycat Dolls than explaining my affection for them. I mean, it's not as though I like Lady Gaga, who benefits from the legitimacy of her whole performance-art angle, or Kelly Clarkson, who is at least a relatable human being — two artists who are absolutely not cool, but are justifiable. No, my weakness is the Pussycat Dolls. I will never try to convince you of their artistic

merit. They're the Twinkies of my music consumption: sweet, empty calories inside an attractive spongy cake filled with enough preservatives to last a hundred years.

Just the same, when a Pussycat Dolls song comes on the radio, I'm not at all inclined to change the station. I turn it up.

I can't tell you what does or doesn't qualify as a guilty pleasure. It's different for every listener, but you know it when you feel yourself falling into a shame spiral when a particular song comes on. If you are either a) too embarrassed to let a record-store clerk look at your purchases, b) hiding music from your kids and the other carpool moms, or c) spending all your time with headphones on so your friends don't bust you on the "weird" music you like, then congrats! You've found your guilty pleasure.

It's been easy for me to hide my guilty pleasure, as the relative merits of the Pussycat Dolls is a topic that rarely comes up in the world of indie-music snobs. In fact, the Pussycat Dolls are so broadly marketed that they owe no allegiance to any subculture and have no roots; that's part of what makes them so painfully uncool. It is also what makes it punk as fuck for a music snob to like them. If I embrace them in spite of the naysayers, that makes me the embodiment of the Devo song "Through Being Cool," wherein Devo philosophizes that the path to coolness is effortless. If you try to be cool, you never will be. By facing the slings and arrows of outrageous snobbery, I am singlehandedly bucking the trend against this girl group, who are underdogs in my judgmental world.

It's like when Sid Vicious released his cover of the Sinatra standard "My Way" as his comeback single after the Sex Pistols broke up. The Sex Pistols were all about overthrowing the sort of

bourgeois ethos that Frank Sinatra (as well as the classic rock of the '70s) embraced, so the punkest and most offensive thing Vicious could do in his first post-punk act would be to rail against the narrow ideological constraints of the punk scene by embracing something you would fully expect a punk to hate. One of the most nonconformist things I could do in a community of people who consider themselves above music for teenagers is to enjoy music for teenagers. I don't want you to like the Pussycat Dolls: it takes away from the awesomeness of my liking them.

You don't have to be an indie-rock snob to consider the Pussycat Dolls a guilty pleasure. You could be a soccer mom with a minivan full of tweens and think yourself above them. You could be a high-school cheerleader who loved the Pussycat Dolls only to evolve into a coffee-loving college freshman who realizes they're the lamest. The ever-changing opinion of the masses heavily influences what is and is not a guilty pleasure, but so too does your musical self-image.

Anthropologists will tell you music is traditionally a group activity used to unite tribes, like the use of religious music to express a shared belief in God. In modern times the music industry and its crack marketers have developed a different word for what used to be called tribes: demographics. The Pussycat Dolls are teenage music (please note, you do not have to actually be a teenager to fit into the teenage-music demographic): inauthentic, crude, and primitive in both topic and construction. Soccer-mom music is a few rungs up on the ladder, with less sophomoric lyrics and more complex musical structure, but still not a demographic a music snob would aspire to, as their taste is considered too middle of the road (in other words, dull, as in Michael Bublé, Coldplay).

Indie-music fanatics, both male and female, are captivated by the idea of being first. We want to feel ownership over artists before anyone else even knows who they are, and we have a soft spot for atypical music with lyrics that relate to our life experiences (see: Animal Collective, Dirty Projectors, Björk). I, for one, will admit it: I am very concerned with my unique snowflake–ness. I worry about how cool I am and whether I know as much as other music snobs. I use what's on my iPod to impress guys I suspect of having a big record collection. I'm not a haphazard record collector, and I don't want to spend my time listening to music that makes me feel like I'm losing IQ points simply by turning it on. Except when I want the Pussycat Dolls.

Music is constantly changing context, going from in vogue to outdated and back again, as a result of shifts in perception by both tastemakers (snobs like me) and the masses (everyone else, like my mom). Obviously, your own opinion on whether something is cool gets the most weight,* but it's undeniable that outside forces can come along and completely recast anyone's status. A band can swing from passé to hot again in a few thousand well-placed video streams (no, that doesn't mean you, Rick Astley — Rickrolling was too popular, so Astley stays in guilty-pleasure land). For example, take the curious case of *Yacht Rock* and Hall & Oates.

Let's go way back to 1987. My first celebrity sighting ever was on a trip to New York City with my grandmother, aunt, and uncle when I was about ten. Somewhere in the wilds of the Upper East Side (well, it seemed wild to a ten-year-old from Texas with limited

* There's a chance your opinion could be wrong, as people continually tell me I am in my adoration for Chris Isaak, but I choose to willfully disregard them and insist he is cool, and one day you will all regret not listening to me about this.

life experience), John Oates and his trademark mustache strolled by us. I did a double-take and had just enough time to say, "Hey was that . . . ," when Daryl Hall passed us too, about a block behind Oates. I out-and-out gawked at Hall. He gave me a wink and a knowing smile. IT WAS THEM! I tried for about twenty minutes to explain to my grandmother who Hall & Oates were. She still doesn't know.

How did a ten-year-old recognize Hall & Oates in the street, you ask? My cousins and I spent a lot of time in our grandparents' bedroom watching MTV. It was our primary group activity in the mid to late '80s, aside from playing *Dukes of Hazzard* (which involved the two of them running around pretending to be in a car and me sitting under a tree looking at them like they were morons). Hall & Oates were certainly no pretty-boy act like Duran Duran, but their videos were live-performance based and showed me what they looked like up close and personal. I have always had a knack for keeping track of what bands sang which songs, even as a child. I knew all the lyrics, what everyone looked like, and the salient details of rock stars' personal lives, thanks to the helpful asides from MTV VJs. When I wasn't watching MTV (like when it was temporarily banned by my grandfather after he saw the stripper- and motorcycle-heavy video for Mötley Crüe's "Girls Girls Girls") I was listening to the radio and making mix tapes or playing records on my sweet Fisher-Price turntable. What I'm saying is: You bet your ass I knew Hall & Oates when I saw them.

I also knew there was no point in telling the other kids at school about this celebrity sighting. No one was going to be impressed. Hall & Oates had no cachet and had peaked five years earlier — half a lifetime to us. I wasn't savvy enough about music

to think of Hall & Oates, or anyone, as a guilty pleasure. I just knew they weren't cool enough to matter. You can imagine, then, how legit music snobs with a greater body of knowledge than a ten-year-old Whitney Houston fan must have regarded them at the time.

I can safely say I didn't think of Hall & Oates once for the duration of the '90s, and I doubt anyone else did either. The next time they entered my stratosphere was in 2005, with the launch of the Internet series *Yacht Rock*.

If you have somehow gotten to this point in your life and haven't seen *Yacht Rock*, Google it right now. You won't be sorry. The series creators staged lo-fi mockumentaries following the faux history of a genre of music they dubbed *Yacht Rock*: smooth pop hits from 1976–1984 by a loose Los Angeles collective of artists, including Steely Dan, Michael McDonald, Kenny Loggins, and, of course, Hall & Oates. The songs are all perfect for lite rockin' while sailing on a yacht in Southern California (see: Christopher Cross's "Sailing"), but the artists — who are all from a music scene that was largely ignored by the music press — are recast in fictional reenactments that confound expectations and exaggerate the personalities. For example, in *Yacht Rock* episode twelve, Oates becomes a hyper-aggressive, ninja-kicking ball of anger who trash-talks everyone around him and abuses Hall, which is ironic because Oates is commonly known to be silent. In the finale, a fight breaks out, with Loggins and McDonald taking on Hall and Oates, only to be soothed by the smooth sounds of Christopher Cross playing the aforementioned "Sailing." The extreme interpretation of all these characters whose real personalities went unexamined in the music press during their heyday is very funny.

Yacht Rock garnered a limited Internet audience but became a cult hit. *Yacht Rock* artists began turning up in pop culture much more often, which explains why a forgotten band like Hall & Oates was suddenly back in the popular consciousness. The show inspired live reenactments by the creators and the featured players, *Yacht Rock* karaoke nights, and a *Yacht Rock* tribute episode of *Late Night with Jimmy Fallon.*

In the *Seattle Weekly*, John Oates credited the *Yacht Rock* phenomenon with revitalizing their career, saying, "I think *Yacht Rock* was the beginning of this whole Hall & Oates resurrection. They were the first ones to sort of parody us and put us out there again, and a lot of things have happened because of *Yacht Rock*." Things like the inclusion of "You Make My Dreams" in a song-and-dance scene in the movie *(500) Days of Summer* and a controversial 2009 Grammy nomination in the Best Pop Performance category for a live performance of the then thirty-four-year-old song "Sara Smile." Naturally, they lost again that year to those bastards the Black Eyed Peas. The duo have, to date, never won a Grammy and are not in the Rock and Roll Hall of Fame, although they are eligible. Even suggesting Hall & Oates for Hall of Fame consideration before the emergence of *Yacht Rock* would have gotten you laughed out of the room, but now it seems inevitable.

Yacht Rock made Hall & Oates (and possibly Steely Dan, but we'll get into that shortly) cool. It cemented a tacit agreement among music snobs that Hall & Oates wrote some damn good songs that we all liked while shoving them in the spotlight again for the masses. A key part of their return was that acceptance among a select crowd first. The word of mouth generated among people who could be considered influencers ensured they

would be cooler this time than they were in their first go-around as pop icons. This is true because the masses are driven by the lowest common denominator: whatever the least (educated, cultured, knowledgeable) among the masses likes is catered to by corporations in order to make the most money. In some instances widely popular music can be good, but in other cases you get throwaway music like Justin Bieber (and the Backstreet Boys before him and New Kids on the Block before them, and the Monkees before them, etc).

There's a credibility to liking what music critics (who are often also music snobs) endorse, and that is why the return of Hall & Oates in 2005 as a trickle-down phenomenon steered them out of guilty pleasure and into just plain well-liked. It also introduced a new generation to Hall & Oates and recast the aspects that were originally uncool about them (like their terrible haircuts) in a humorous light. If you never had to witness the embarrassment of their '80s mullets or live through Michael Jackson rendering their blue-eyed soul outdated, they seem like pretty okay dudes.

Yacht Rock didn't have the same sort of effect for all the bands it name-checked. There hasn't been much of a groundswell of support for Steely Dan, whose tunes are arguably just as smooth as Hall & Oates', although certainly not as soulful. I once met a guy at a friend's holiday party who was interested in my musings on using "Beatles vs. Stones?" as a pickup line, which you can read about elsewhere in this book. He Facebooked me the next day to ask what I thought it said about a man's sexual agenda if he were to use, "So, do you like Steely Dan?" as a pickup line. I told him the best reason I could think of to do such a thing was as a coolness litmus test to see if the girl he was attempting to pick up had

seen *Yacht Rock*. If she hadn't, then he could seem cool and share it with her. If she had, then they'd have that in common to chat about.

He protested, claiming it could just be that some people (like him) grew up listening to Steely Dan and called *Yacht Rock* babbling idiot music. I grew up with a mother who listened to Linda Ronstadt, but I won't be using that as a pickup line. Ever. At any rate, music fans clearly aren't going to conspire to resurrect the career of Steely Dan, in spite of their endorsement of *Yacht Rock*. This sort of thing only works some of the time for some of the people. The next band this is going to work for is Electric Light Orchestra, who'll be the Hall & Oates of 2010–2020. Mark my words.

As a rule, popular music is rarely cool but often catchy, like the fine work of the Pussycat Dolls and Steely Dan — two bands you never thought you'd see in a sentence together. The conundrum presented by popularity is that it has the power to shame music into being uncool. You might find this force pulling some of your favorite bands from cool into the mainstream (which is how a guilty pleasure is born). That is when you have to decide what you are: loyalist or elitist.

One instance of such shaming went down between the Shins and the Zach Braff movie *Garden State*. I have to preface this story by telling you: I knew about the Shins a million years before you did. Or at least it feels that way.

This is how the music industry works: someone hears a promising new sound and then calls everyone in their network phone tree to give them a heads-up. Before long, you have 500 people in the industry abuzz about some new band. If you've ever wondered how Arcade Fire or Vampire Weekend happened, that's a pretty

good summary, minus some boring marketing plans that got drawn up after the initial "Hey, these guys are awesome" phone calls were placed. Not one story about the surprising rise of either of these bands ever mentions that they're both managed by powerhouse music-industry stalwarts who could pick up the phone and call just about anyone they wanted to get their bands listened to. Who you know really is important, but it's also possible to make things happen in this industry by sheer force of personality (please refer to Andrew W.K., R. Kelly's whole *Trapped in the Closet* saga). Obviously the music someone is standing on the mountaintop shouting about should be worth shouting about, but that's the only caveat.

I got a promo of the first Shins album, *Oh, Inverted World*, in the little white sleeve that Sub Pop used to send CDs in. I still have it, but it's too scratched to play without skipping. As soon as CDs with artwork were available, I asked for a case of them so I could personally hand them out to my coworkers at MTV. My God, I was in love with the band, and I was going to the mats for them. I wasn't just spreading the word at work. I made dozens of friends buy this album. This band . . . well, saying they changed my life would be the sort of overly dramatic thing that makes you want to vomit, but I was madly, badly in love with them.

The Shins came to New York for the *College Music Journal's* (CMJ) annual conference in 2003, circa the release of their second album, *Chutes Too Narrow*. Sub Pop's general manager, Megan Jasper, and I were talking about how we might all get together. I forget exactly whose idea it was, but we decided we would take the Shins and the esteemed cofounder of Sub Pop Records, Jonathan Poneman, to get pedicures. Poneman fell asleep in the massage

chair and the Shins singer James Mercer had each of his toenails painted different colors. They all had hideous, hairy man toes. It was the most memorable spa treatment I've ever had.

By the time this second album came out, the slow but positive word of mouth on the Shins' first album had taken hold and people were actually starting to care. MTV2 played their video, McDonald's used "New Slang" in a commercial, and the band played on an episode of *Gilmore Girls*. It felt like music everyone was starting to know about, but in a good way. Then, in the fall of 2004, *Garden State* was released.

You know what happens next: that scene where a dog humps Zach Braff's leg, Natalie Portman tells him that "New Slang" will change his life, and then they stare at each other while he listens to it for about fifteen seconds. It is the most jaw-dropping moment of music and film merging in recorded history.

When this movie came out, the characters and music were a revelation. There were other contemporary filmmakers who had captured our ethos and aspirations — Richard Linklater, Sofia Coppola, Wes Anderson, even John Hughes — but no one had ever done what Zach Braff did. No one had crossed the line between placing cool music in a movie and actually using dialogue and characters to tell the audience what music to like. Molly Ringwald never turned to the camera to explain that *Pretty in Pink* was so titled because she'd played the Psychedelic Furs' songs for Hughes and he thought it was cool. It was simply understood that what we were hearing was cool because we trusted the source. We now live in a world where using music to make you feel something while watching a movie, TV show, or ad has been de rigueur for decades. No one even notices anymore, much less thinks of it as

selling out on the musician's part. Hell, we take it for granted to the point where music snobs will decide a cheesy soap opera like *The O.C.* is cool based largely on how great the musical cues are.

The proclamation from Natalie Portman's character that the Shins would change my life was exciting at first, but when it became apparent the movie would be a mainstream success, I became increasingly annoyed. This is nonsensical to the average person, but any indie-rock fan will know this feeling. It's insane to dislike something because more people know about it, but being the first person to find a band in indie subculture feels extremely important. Considering all the effort I had put into telling people about the Shins up until then, it probably seems counterintuitive to be irritated by something that accomplished exactly what I wanted, doesn't it? I promise it wasn't just that I was immature and jealous, which I certainly was a little. It was the way the film went about it — like the world needed to be bludgeoned over the head with the importance of this band. Leaving it in the background and letting people discover their own connection to the song would have been a move we all respected. The shout-out was just too much, and now every Pussycat Dolls fan and soccer mom who saw every rom-com showing at their local mall were on to the Shins — and worse yet, thought our band would change their life.

When the floodgates opened and mainstream culture came to collect the Shins, the indie-rock subculture had to let go of exclusive custody, but they didn't have to disavow them. Nevertheless, before long the Shins were being derided in the indie-music press, along with Death Cab for Cutie and Sufjan Stevens, as yupster music. That's yuppie + hipster, if you managed to miss the ridiculing types who coined the phrase and publicized the trend. The

term was meant to characterize toothless indie rock with mass appeal that was fit to be endorsed by "alternative" parents and "edgy" coffeehouse consumers. It was also meant to knock indie-rock bands down a notch or two, by associating them with an unappealing, and much larger, demographic. The more yupster music was painted as mainstream, the more shameful listening to it became — and the bands unfortunate enough to earn the moniker started to decline into guilty pleasures.

The yuppie–indie music debate has raged on with rock critics, as many deride the placid tones that some more successful indie bands — from the Shins to Grizzly Bear to Feist — have embraced. In my book these bands don't qualify as guilty pleasures because the majority of the music-listening public still has absolutely no idea who they are. The Shins write hyper-literate lyrics and their music has broad appeal. The whole genre of music they represent is becoming part of the mainstream, and it's a shame the catalyst for their exposure had to be a blowhard moment in film. I cannot, however, agree with the idea that making music accessible to the masses is the same as making bad music. For those who just want to rail against the perceived complacency in yuppie indie music, I have a few Black Eyed Peas albums you need to listen to while you get in touch with true mediocrity, because your insular worldview has become drastically skewed.

Depending on which demographic you fit into, the Shins could be seen as either uncool or extremely progressive. If your record collection is full of obscure artists, they might be the most mainstream thing you own; if you're less of a record-collecting type, they might be the most out-there album you own. Unless you're into teenage music full time, that is — then you will

probably never like them, because they aren't nearly good looking enough for the genre and are an epic fail at dance routines (unlike YouTube sensations OK Go). If someone tells you they don't like the Shins, I would suggest asking them since when. It could be an interesting harbinger of their loyalty to you.

Maybe you have perfect taste in music and like all the right things, all of the time. I love the Shins, no matter how uncool pop culture attempts to make them, and I like the Pussycat Dolls, no matter how slutty they act. If you say you have no guilty pleasures, I think you're a liar. And as Shania Twain, another of my guilty pleasures, would say: That don't impress me much. Yes, I like Shania Twain. You secretly do too. She is awesome.

GUILTY PLEASURES PLAYLIST

THE BLACK EYED PEAS, "Let's Get Retarded"

SISQÓ, "The Thong Song"

THE PUSSYCAT DOLLS, "Stickwitu"

THE PUSSYCAT DOLLS, "Buttons"

THE PUSSYCAT DOLLS, "Beep"

DEVO, "Through Being Cool"

SID VICIOUS, "My Way"

MÖTLEY CRÜE, "Girls Girls Girls"

CHRISTOPHER CROSS, "Sailing"

HALL & OATES, "You Make My Dreams"

HALL & OATES, "Sara Smile"

R. KELLY, "Trapped in the Closet"

THE SHINS, "New Slang"

THE SMITHS SYNDROME

YOU KNOW WHEN you like music (and when you hate music), and you know your own record collection well. You have a good idea what songs to put on when your heart's been broken, when you need cheering up, when you need motivation to exercise, when it's raining out — you know what works for you. But how much thought have you given to what your music choices say about you to other people? Boys who love records (and let's face it, at some point we will all date a boy who is a little too into his records) are totally obsessing on what music you like when they meet you. They're using it to figure out how crazy you are before they get involved. They're using it to figure out what songs to include on a mix tape to demonstrate how into you they are. They're using it to figure out how much they're going to have to teach you about really "good" music. They are quietly sussing out what kind of person you are and how they should relate to you by taking a peek at your iPod.

True story: One night at a concert I met a boy who grabbed my iPod out of my hand and scrolled through it for the express purpose of judging me. He got to the Hs before giving me the nod of approval and making a move on me. That's not to say he wouldn't have tried to make out with me if he thought I had shitty taste in music. He would have. But our conversation the rest of the night

would have been very different, without our shared musical taste as an anchor. As it turned out, he worked at an agency that places songs in commercials, and I started getting loads of IMs from him when he was fishing for suggestions to fit projects he was working on (and, you know, for hints about when we could make out some more).

There is a lot to be gleaned about a person by finding out what bands they like. I can guess a lot of things about your personality and what your life has been like (or what you wish it had been like) based on the music you listen to. When I compress all the mental data I've compiled about what my ideal partner will be like, I find I have one unbreakable rule:

NEVER DATE A GUY WHO LIKES THE SMITHS TOO MUCH.

Boys who fall under the thrall of what I refer to as Smiths Syndrome are my must-avoids. Years upon years of friendships, crushes, and relationships, coupled with immense public embarrassment at the hands of love, have taught me that ardent Smiths fans are simply not the right guys for me. Some of my closest guy friends are now or once were overly enthusiastic Smiths fans, but there is a damn good reason I've never kissed any of those guys. Romantically we are peanut butter and tuna fish: two great tastes that are a disaster together.

Before I delve further into how I think the music of the Smiths has been ruining the minds of men, please allow me to point out that this is a conversation specifically about men who like the Smiths *too much*. I don't mean the casual fan or person in the throes of heartbreak, but your everyday Smiths-loving enthusiast.

The Smiths were a group of working-class boys (singer Stephen Patrick Morrissey and guitarist Johnny Marr, along with drummer Mike Joyce and bassist Andy Rourke) who grew up in Northern England and formed their band in 1982, at the height of Thatcher's Conservative rule over the country and during a period of widespread unemployment. While there was a general sense of discontent among the youth of the country, Morrissey suffered his own particular kind of anguish. As an intellectual, a vegetarian, and a man questioning his sexuality, he was an outsider in Manchester. I find that people who actually share his background take a different view of Morrissey's lyrics, so my theories generally only apply to American Smiths fans. (The British fanatics are still a bit pathetic, but at least many have a firsthand understanding of the malaise surrounding Morrissey in his youth.)

Men who are afflicted by the Smiths Syndrome tend to embody his angst in an unfortunate way, which is made all the worse if they also decide to rock his '80s haircut (always dire). The cursory Smiths listener who owns some albums and enjoys the band is a dude I keep one eye on if we date, but I won't write him off immediately. The overzealous Smiths fan, however, will never ever be my boyfriend. He is the sort who travels long distances to see Morrissey in concert, knowing that he's as likely to cancel as he is to play the show. This ultra-fan has probably taken a trip to Manchester specifically to visit the band's childhood homes and pubs they may have played in and will show you pictures. He embodies the particular brand of emotional wreck that I can't deal with.

You might feel the same about another, equally troublesome, band. My friend Sara's deal-breaker band is the Jesus Lizard. Sara loves the Jesus Lizard, but has said that after years of dating guys

who liked the band as much as she does, she realized they were all the same type of guy: druggies who wanted to *be* the guys in the Jesus Lizard but lacked the ambition to start their own band.

I have more of a love/hate relationship with the Smiths. Sometimes their songs are just perfect for a foul mood or a clever moment. Sometimes they exasperate me to the point where I consider poking out my own eardrums with a Q-Tip. If you think on it long enough, you'll probably find that you have your own points of contention with guys who like Pulp or Leonard Cohen or Nick Cave. It doesn't mean *you* don't like those artists. It just means those guys are in your emotional no-fly zone.

THE HORRIFYING POETRY OF LYRICS

If you ask a man who his favorite musicians are and he starts naming people you don't know well, the first thing to do is check out their songs, right? I urge you to listen to the lyrics closely; they can be telling. Most guys I know claim to listen more for the music than the words, but if they really love an artist, you can bet they'll know the lyrics sheets up, down, backwards, and inside out. So, if you listen to someone's favorite music and hear references to gruesome murders, painful breakups, and intense feelings of isolation, then you would presume this man is a bit of a sad bastard, would you not?

Every obsessive Smiths fan I've ever met was also obsessed with serial killers. Usually there is a specific serial-killer story that captures his attention above and beyond the others, but he inevitably knows the histories of all the major players. From "Suffer Little Children" and "Cemetry Gates" to the references in "Reel Around the Fountain," the Smiths don't shy away from writing

songs about murder and other grisly deeds. This gruesome interest springs from Morrissey's own fascination with the Moors murders, in which two sociopaths abducted and killed kids from his child-hood neighborhood in Manchester. It is the creepiest preoccupation a Smiths fan can have and is oddly universal among them. I'd rather not date someone who's going to make me watch Son of Sam documentaries. If you disagree with my disdain of this particular quirk because you also have an appetite for the morbid, we can chalk it up to a difference in taste.*

Some of the Smiths' songs might give you pause about the sexual orientation of a dude — as they should. When it comes to carnal proclivities, the Smiths are a haven in the storm for the undecided. The often gender-neutral and almost always snide lyrics in Smiths songs give those with questions about their sexuality room to breathe by taking the spotlight off their bi-curious nature and putting it instead on your closed-minded notions of acceptable behavior. They make listeners feel that someone empathizes with their fickleness. I think it's fair to want to know whether your boyfriend likes boys before you jump in the relationship pool with him.

If ever sexual ambiguity in music took a true form (since we all know David Bowie was faking it for the press), it was in Steven Patrick Morrissey. He was never much of a social butterfly, but upon his entry into the public arena, UK music magazine NME began quizzing him about his sexual preferences. And with good reason: for someone who wrote so many songs about being broken-hearted, he wasn't known to go out on many dates. He famously

* Although I now think you are much creepier than I did when we started this conversation.

declared his asexuality in the '80s and presented himself to his fans as an untouchable pop star who was (like Jesus) above sexual idolization. Although it's now well accepted that he's gay, he continues to evade the question. And all along he has taunted the world by playing the pronoun game with his song lyrics (inserting a he where you expect a she, and vice versa).

I'm equally disinterested in the guys who have realized that Morrissey's public discussion of his celibacy made the world infatuated with him as a potential conquest. There will always be people who are drawn to what they can't have. I know I was when I was in my twenties. But as I get older and wiser, the idea of chasing the ungettable-get loses its charm. The split second when straight guys realize that feigning disinterest in sex makes them more attractive to women and thus begin using it as a way to get laid is the exact instant they turn into douche bags on par with that moron who invented *The Game*.

Equally problematic in my mind: guys who subscribe to the idea that they are too delicate for a relationship. Much of the Smiths' catalog gives lonely boys without much experience in love a license to tell themselves that they choose to be alone, and they wear their solitude as a badge of sensitivity; they are just too special for the trials and tribulations of a real romance. In actuality, they should get out and date so they're not spending the best years of their lives as emotional illiterates.

Case in point: A close friend of mine is a recovering Smiths devotee. He was more introverted when we were in college and had a big crush on the girlfriend of one of his housemates. She idolized the Cure, so you know already the crush was doomed to fail — that much gloom in one relationship simply creates a black

hole. His housemate and the girlfriend had a tumultuous relationship and tended to break up and get back together often. My Smiths-loving friend moped around for a solid year, complaining widely that he was sure this girl would be happier with him if she would just give him a chance. We had endless discussions about whether he should confess his love to her. The result was heartbreaking but expected: he didn't do anything and dropped her as friend because it hurt too much. I still think this stupidity is a direct result of the brainwashing that comes with excessively listening to "There Is a Light That Never Goes Out" and "Please, Please, Please, Let Me Get What I Want." The protagonist almost never gets the girl in Smiths songs (though he does sometimes get the boy). Half the time he realizes he doesn't even want the girl (see "Pretty Girls Make Graves" or "Girlfriend in a Coma"). My Smiths-loving friend never actually made a move, but he was still utterly heartbroken because rejection was the only imaginable outcome in his mind.

Given the circumstances, the alternative was for him to declare his unbidden love to her. We know how that story goes: Shy guy suddenly opens up and is stunned when the girl, having been given no prior indication that he liked her in *that way*, doesn't quite know how to react and is flustered (and maybe a little freaked out) by his expectation that they'll suddenly be recreating the movie-script ending to a Woody Allen comedy. The third option, that she might actually reciprocate his feelings, was way too far-fetched for him to consider. It didn't seem a remote possibility to him, so he chose to get a step ahead of the rejection his unhappy mind anticipated. The moral of the story: Smiths fans are self-defeating. You could spend your whole life trying to convince one that you like

them and they may never believe you. Not the greatest use of your time.

In the land of Morrissey, women exist to torment the modern man. Think of Summer from the film *(500) Days of Summer*. She is roundly regarded as a bitch simply because she doesn't fall madly in love with the movie's protagonist, Tom (who most certainly suffers from Smiths Syndrome). We are all constantly getting our heart broken and getting over it. That's life. If we didn't feel the intense pain that comes with a broken heart, we could never feel the euphoric happiness of falling in love. But if you find yourself dumping a Smiths fan, you can rest assured he'll never get over it and will hate you forever. He may even twist the knife with some brutal mix tapes about what a jerk you are. If you're wondering how to avoid this, here's a piece of advice: Don't date guys who like the Smiths too much.

SMITHS NATION

Most bands have their place in pop culture, but bands with deeply devoted fans develop a culture of their own. Think of the Grateful Dead or Justin Bieber (whichever you are more familiar with will do). Their fans share a common slang, tribal customs, and even a communal life philosophy. The thing they have in common is the music they all love. If you're not down with the traveling, dirty, hippie lifestyle, then you don't date Deadheads (or whatever people who like Phish call themselves). If you're not down with adamant, screaming teenage girls, then you don't involve yourself in Bieberworld. If you don't want to date a guy who thinks he's better than you and has a venomous disdain for mainstream culture, then you don't date Smiths fans. People whose love lives are soundtracked

by John Mayer or Van Morrison will never understand the exclusive nature of loving a band like the Smiths any more than people who love the Smiths could ever understand buying a John Mayer record. I love guys who love underground music. I can't say, however, that I love the ideology adopted by Smiths fans.

The Smiths fan's embrace of the counterculture is meant to hint at a worldliness he might not possess. Morrissey himself came to his values without actually leaving Northern England, just as a lot of boys I knew came to the realization they loved Morrissey (or were Anglophiles) without ever actually leaving the various small towns in America they hailed from. As a younger woman I found this unbearably sexy, because it reflected my own outwardly worldly but realistically inexperienced tastes and opinions. All the knowledge Smiths fans pick up about 1980s political and social culture in the UK makes them seem very clever indeed. But then you realize they know little about any other historical period and their interest in current politics is nil. They've been so busy immersing themselves in that era to better understand the Smiths that they don't get around much else.

A true Smiths fan will dive deeply into Morrissey's inspirations to understand what makes the man tick. (It is always Moz he adores and never Marr, because Marr was too into '60s and '70s hippie/funk music, which is anathema for anyone who wears head-to-toe black on the outside to express how black he feels on the inside.) He studies the range of Morrissey's idols from whom he cribbed his schtick, including James Dean, Oscar Wilde, and the New York Dolls. From there the fan will likely follow Moz's footsteps and give himself a James Dean pompadour until someone explains that he looks ridiculous (or a rockabilly band member offers

a compliment — always the kiss of death); attempt to read Oscar Wilde but find it a little too boring for his tastes; and buy some New York Dolls vinyl only to eventually discover (usually when he gets older and falls out of the Smiths' thrall) that the '60s girl groups the Dolls were emulating have much, much better songs than the Dolls.

Moz and Marr both considered the Smiths a singles band, in the style of '60s British musicians they idolized, but unlike their contemporaries in the Cure, Depeche Mode, or R.E.M., the Smiths never had that one hit single that broke them through to the mainstream. "How Soon Is Now?" is as close as they came, but the buildup to making that a highly recognizable song spans more than a decade — it was not an instant smash on the singles charts.

They were signed to one of the most staunchly independent record labels in the UK, Rough Trade Records, which meant they operated on a limited marketing budget. They had to be cajoled into making videos in an era when MTV was making British bands famous to American audiences, and they rarely toured outside their home country (which is the surest way to keep your band obscure). To cap it all off, after five years they broke up at the height of their popularity, before anyone in the band had even turned thirty.

The Smiths epitomized indie culture, and they designed the template for all the great bands who followed them, like Pavement and Radiohead, for attaining success while maintaining credibility. Or at least that's the perception. Dig a little deeper and you'll find that just before the band broke up, they were planning to leave Rough Trade and Sire Records and make a move to EMI

Records, home of another famous British band called the Beatles. Their credibility was saved by an early breakup, compared to their contemporaries who went on to mainstream success tinged with underground disappointment. These facts will be conveniently forgotten by elitist Smiths fans, who prefer to remember them as kings of the underground.

If pop music is for the lowest common denominator, indie music speaks to those who consider themselves intellectually superior and appreciators of art. To understand the mind-set you're dealing with when it comes to male Smiths fans, you have to get the importance of social standing and hierarchy to boys. Dr. Louann Brizendine, author of *The Male Brain*, has some useful info for us. (It's not your usual light bedtime fare, I know, but at one point I intended to study cognitive science; while that plan was blown to hell, my fascination with neuroscience remains). Boys start mentally ranking each other based on traits such as who is toughest, strongest, or most dominating — *Planet of the Apes*–style — when they're as young as kindergarten age. If that's the case, what's left for those less-than-alpha five-year-old boys? If they can't dominate through brute strength, they must find another realm where they can rule. As they get older, record collecting and music fandom come into play. Those guys who will argue with you about B-sides or take the time to memorize what year every record was released and on which label. They're the alpha dogs of their world, and their giant record collection of import-only singles is all the brute strength they need.

The sort of dudes who dig on the Smiths are the sort who have created their own little pop-culture universe, filled with eccentric

interests from highbrow to obscure. You'll have to prove your cultural bona fides to even start a conversation with these guys, but if you're deemed worthy (or hot), they are masters of interesting discussion. For all the things Smiths fans may be, they are certainly never the dumbest kids in class. This sort of mind-set leads to a fetishizing of rare singles, and live and demo recordings. The Smiths, as a cult band with a limited catalog of releases, provide a music-culture refuge where these dudes can be insiders.

Ultimately, this is what music snobbery is about: someone arguing that their taste is better than yours and that they have more stuff than you do. If you date a Smiths fan, it's unlikely you'll ever win a debate about whose record collection is better. A lot of girls are cool with that and let their boyfriends shape their taste in music. For me, it's a deal breaker. The only thing less appealing is a guy with mommy issues.

Back when American women got married for social standing and because it wasn't just our job but our duty to have babies, there was a much stronger economic incentive to partner off with someone, as a business venture of sorts. Of course, it wasn't ideal if your husband was emotionally distant or if you found yourself saddled with a hellish mother-in-law, but it was by no means going to stop to you from marrying him. These days women are economically liberated; most of us now have the luxury of choosing to marry for love. In fact, we don't have to get married at all if we don't want to, because we can support ourselves. We're also not necessarily expected to have kids (except by nosy parents who want grandkids) and we can have careers instead — or in addition, if that suits us.

By their twenties, most men have finished their struggle to separate from their mother. This process is so important, because it

will impact a man's ability to commit to a mate. If he doesn't develop his own sense of self, he's just not going to let you in. As should be clear by now, the guy who identifies with Moz past adolescence will be a huge pain in your ass. And if he has an uncomfortably close relationship with his doting mother, you can bet she will be a pain in your ass too.

Because little Stephen Morrissey was passionate about books, like his librarian mother, he got perhaps more than his fair share of her attention as a child. He was quiet and shy and not known to spend a lot of time playing with other kids, let alone chasing teen romances. Morrissey's parents got divorced when he was seventeen. In the wake of the dissolution of her marriage, his mother devoted all her attention to her son and daughter. Moz lived at home well into his midtwenties, developing a codependent relationship with his mother, as he drifted from one menial job to another and mostly lived on the dole, while he waited for his destiny as a pop star to come find him. Most mothers would have put their foot down and kicked their loafing children out, but not Mozzer's mom. She felt Stephen needed to be coddled and taken care of, and who better than she to do it. To say that she encouraged his separation issues would be an understatement. Quite frankly, it sounds like we ladies are lucky Morrissey is asexual/gay, because his mother would probably be the archetypical nightmare mother-in-law.

In his controversial biography of the Smiths, *Morrissey & Marr: The Severed Alliance*, Johnny Rogan recounts stories of Moz hiding at his mother's house after doing something dastardly, such as canceling another Smiths tour or firing a manager. When the people at Rough Trade would call to talk to him about it, she'd

refuse to put him on the phone, enabling him to avoid receiving any scoldings or taking any responsibility for the bad spot he'd put his band in. Yes, even after becoming a pop star, he still hid behind his mother's apron strings. That is a special sort of spineless. At one point when the Smiths were between managers, Moz went so far as to put his mother in charge of accounting for the band, despite her utter lack of credentials. She was, very simply, one of the only people he trusted to manage his day-to-day affairs and still let him get his own way as often as possible. You can see how he would be a nightmare to be in a band with, let alone date.

As Smiths fanatic Mark Simpson says of Moz's relationship with his mother in his book *Saint Morrissey:* "Romantic love can be an eternal disappointment after true maternal love." For the men who feel that way, the resentment toward romantic love that Morrissey writes about is an absolute truth. They do believe that "Pretty Girls Make Graves" is as truthful about women as "Please, Please, Please Let Me Get What I Want" is about their ever-unhappy relationship status. You will never be as wonderful as their beloved mother, and they will always disappoint you. You will both end up with broken hearts.

There are dozens of bands who raise my eyebrows. Some of them are bands I dearly love but still see as red flags. The National has perfected lyrics about a certain kind of urban angst that I find lovely, but I have trepidations about dating boys who think they're genius. There is no chance I want to date someone whose idea of culture is Asbury Park, New Jersey, but there are still some amazing Bruce Springsteen albums. I like LCD Soundsystem, but I'm already over guys of a certain age who still want to go out every

night and wonder why all the hipsters look so young. I'm into Prince for dance parties, but I can't take you seriously if your idea of romance is "I Wanna Be Your Lover." But I'm willing to allow for the possibility that any of these guys could be a catch. Smiths fans, however? You can forget it. I will never be your girlfriend.

THE SMITHS SYNDROME PLAYLIST

THE SMITHS, "Heaven Knows I'm Miserable Now"

JESUS LIZARD, "Mouth Breather"

THE SMITHS, "Suffer Little Children"

THE SMITHS, "Cemetry Gates"

THE SMITHS, "Reel Around the Fountain"

DAVID BOWIE, "Ziggy Stardust"

THE CURE, "A Night Like This"

THE SMITHS, "There Is a Light That Never Goes Out"

THE SMITHS, "Please, Please, Please, Let Me Get What
I Want"

MAZZY STAR, "Fade into You"

THE SMITHS, "Pretty Girls Make Graves"

THE SMITHS, "Girlfriend in a Coma"

NEW YORK DOLLS, "Personality Crisis"

THE SMITHS, "How Soon Is Now?"

LCD SOUNDSYSTEM, "I Can Change"

PRINCE, "I Wanna Be Your Lover"

give it to me for free

FREE IS THE best price for most music. Rarely am I willing to buy a full album without having heard all or most of it in advance, unless I truly love the band and would follow them anywhere. I expect most bands to have phoned it in and try to collect my $9 to $25 on the strength of two to four songs. It's a musical bait and switch, and I'm not willing to chance it. Conveniently, many artists make their full albums available online to stream before they're released. NPR, AOL Spinner, and MySpace have become weekly must-visits for me to listen to what's new.

In the summer of 2010, NPR changed everything I thought about Arcade Fire. I cannot stand Arcade Fire. As a general rule, I consider them overhyped and self-important and find their verbal and musical bombast obnoxious. I am not only *not* a fan, I actively dislike every aspect of this band. When their album *The Suburbs* was released, the buzz was, as always, out of control. The album was immediately awarded *Pitchfork*'s Best New Music. It was written up by every press outlet in my Twitter feed, and no accolade was left undeclared. I don't care how many music and culture writers expound on their genius, these people

are all wrong. Nothing they say is going to make me give my money to a band whose music I am certain I do not like. However, I noticed when *The Suburbs* was released, it was available as a free stream on several websites before its release, including NPR. This album is the kind of slam-dunk cultural event that a music fan must hear to be part of the conversation, right?

I knew damn well that I wasn't buying this album, but I never want to be the ignorant jerk who rags on a band without actually listening to them. I like to be informed about what I'm hating, because it's the intellectually honest thing to do. So I began streaming it. Only fifteen minutes into the album, I had to admit that this was actually pretty good. To my great surprise, I didn't hate it. At thirty minutes in, I realized I was going to buy a copy of this album because what I'd heard deserved further consideration. I kept listening to the full more-than-sixty-minute-long album. That's a really long run time for an album in general and an extremely long time for me to spend with a band that fifty minutes earlier I'd been absolutely certain could break up without my shedding a tear. I'm not ready to say this will be the turning point in my relationship to the Arcade Fire's music, but now I know I like this album and I want to listen to it more. This was all quite shocking. No amount of publicity or press was going to get me to buy this album, but they got my money—and a second chance—by giving it to me for free first. It was no great surprise to anyone, but they ended up with the top-selling album in the country that week. You win this round, Arcade Fire, but we will tussle again.

ARE WE BREAKING UP?

THEY SAY YOU want most what you can't have. When the curtain goes down on another failed relationship, I often find the old saying to be true. I've been waiting my entire adult life for a guy to play Blur's "To the End" at some point in the course of our breakup. It's the loveliest end-of-the-affair song ever written, with that Hammond organ running up and down the scales, matched by a bit of vibraphone and the elegant-but-tragic good-bye tenor of the lyrics. Of course, to even have a breakup song requires a long, drawn-out event, and to have this particular song played implies it's the sort of ending in which neither of you want to part but you both know it's for the best.

Then, amazingly, this actually happened. And it sucked. I'd imagined it happening as part of a noble good-bye, the sort of good-bye that is bittersweet and the product of circumstances beyond anyone's control, like terminal illness or a cross-country move to accept a dream job. Instead it came from someone I didn't want to break up with at all — perfectly fitting, given the song lyrics. A guy who we'll call Mark e-mailed me a YouTube link to that particular song during a drunken back-and-forth after I'd issued the pronouncement that we were ending things. We had only been dating for five months, but we'd been friends for more than three years and already knew each other well. Throughout much

of our relationship I had been on the fence about getting involved with him, but after he hit me with that song, I wondered if he was, in fact, the ideal guy for me.

In return I sent him an e-mail with the dramatic breakup song that I insisted better spoke to our parting (it didn't): "Ciao!" by Lush with Jarvis Cocker. It's a call-and-response duet that outlines all the ways two people can be happy to be finished with each other, from both the male and female perspective, and it's full of spite. It was meant to be an extra twist of the knife because he loved Jarvis's band Pulp and had, on occasion, done a fantastic karaoke version of them to impress me. I had been listening to the song on repeat in an effort to wrap my head around our relationship's implosion, but it's too over the top to be anyone's breakup song.

From our dueling song selections that night, which was nothing short of a musical YouTube battle taking the place of a real fight, I could see that we were in different emotional places about this breakup. He was sad, while I was still angry. It was going to be a long march through the stages of grief to pull myself away from this relationship, and I wasn't ready for "To the End" yet. I was still too annoyed-bordering-on-angry to be sad, and listening to a very sad song like this made me realize that I would eventually come to the final stage of grief — acceptance — and I'd get over him. But I didn't want to get over him yet; I wasn't done fighting and listening to angry songs. How was he already on to the sad song, bordering on acceptance?

Musical selections during a breakup mirror the Kübler-Ross model stages of grief: denial, anger, bargaining, depression, and finally, acceptance. In both music and Kübler-Ross, you can skip

some stages entirely, jump around out of order, or have to repeat them over and over again before you reach acceptance. The musical stages of getting through grief are a little bit different and look more like this:

1. **ANGRY**—including: vindictiveness, songs that involve a woman screaming, and any song with themes of emasculation

2. **SAD**—including: sad bastard, bittersweet, any song that makes you reminisce over love that's now dead, and any song that makes you curl up into a ball and cry

3. **BEGGING**—including: asking for one more day, wishing for another chance, and anything that makes you feel like you've utterly given up on having any sort of pride

4. **KISS-OFF**—including: gleeful songs about freedom, independent-woman anthems, and anything expressing a "thank God that's over" sentiment

ANGRY

Very few of my breakups have inspired loud, repeated playing of Björk's "Army of Me." I save such truly pissed-off songs for egregious-dumping situations: the cheaters, the users, the guys who hid from me their love of the Smiths. Just the same, even mundane breakups have their angry moments, if only for the injustice of having spent time — sometimes a significant amount of time — getting to know someone, only to find that person is utterly wrong for you.

The end of a relationship tends to bring out a more irrational side of me, and I know I'm not alone in this. I'll admit to some

seriously crazy behavior when I'm in the midst of breakup, but I have never ever let anyone, not even my closest girlfriends, who know how to talk sense into me when I'm veering off the rails of the crazy train, see how truly nutty I become during a breakup. There are so few times in life when you can allow yourself to become unhinged, and I find that putting on a few pissed-off songs helps me abate the impulse to compulsively check and comment on my ex's Facebook status or send inappropriate, annoying e-mails about every little feeling I might experience.

In those times, I've been known to turn to music that makes that bitter Lush song seem like Celine Dion. I absolutely require that all of the angry songs be exclusively from female artists. I don't want to listen to a man when I'm full of inner turmoil about why a breakup is happening, what it says about me, if I'm a terrible girlfriend, if I'm just not girlfriend material at all, and a million other stupid and insecure thoughts. When I'm alone, behind closed doors, I put on my headphones and I spew lyrical venom. At a high volume. I'm particularly fond of songs about how unsatisfying a guy was as a lover (see Lily Allen's "Not Big" and the Yeah Yeah Yeahs' "Bang"). It doesn't matter if there's truth in that sentiment, because we all know it's the cruelest thing you can say to a guy. And if you broke my heart, I'm aiming to at least knock your ego down a notch or two. I want to listen to songs where girls sound legitimately pissed off. Perennial favorites include Fiona Apple, Hole, and Sleater-Kinney. They don't even have to be pissed off about relationships — any sort of rage will do.

These songs express the things I never say out loud, both because it is ungracious to be a bad sport when departing a relationship and because there is a social stigma that goes with being an

angry woman. I get my anger out through repeated yell-alongs to my favorite tracks so that when it's time to talk to the guy I'm breaking up with, I can maintain my composure. In fact, I want to be so detached that the guy starts to doubt I ever liked him. I want to win the battle of who could care less. I may feel like I've lost all control of the situation on the inside, but they don't need to know — that's between me and my iPod.

Female anger is not unprecedented in pop culture, but musically, an angry woman was something you rarely heard before the 1990s. Some '70s punks, like Poly Styrene of X-Ray Spex, had combative tracks about the injustices of being a girl, and Heart did a few outraged songs about jerky guys before they became a hair band. In the '80s you might happen across the odd pissed-off song from Pat Benatar or Debbie Harry on the radio, but they were the exception and not the rule. Overwhelmingly, being sad was the only marketable breakup emotion available to women in music. You could be Nancy Sinatra and talk about your boots walking all over your latest failed relationship, as long as you didn't roar above a pout.

Then, in the 1990s, someone finally realized there was an audience for pissed-off, ranting songs by women. Unbridled female rage in music started out as an underground thing, with riot grrrl bands like Bikini Kill, Babes in Toyland, and Bratmobile, but by the middle of the decade, angry women were mainstream. Pissed-off hit songs from Poe, Alanis Morissette, Garbage, PJ Harvey, Björk, Tracy Bonham, Hole, L7, the Cranberries, Veruca Salt, and even No Doubt were constantly on the radio. It was becoming socially acceptable to call guys out on their deplorable behavior. These women were singing with fervor and not shying away

from the dark undertones of fury. This acceptance of angry girls came in the midst of my formative dating years and informed my ideas about acceptable levels of female rage — namely, that it was allowed publicly. I'm still timid about letting my rage flag fly for ex-boyfriends to see, but I certainly feel a bit freer to spew some venom their way instead of playing the brokenhearted Kewpie doll whose feelings have the depth of a baby's pool. Unfortunately, that moment has been muted in music, and now we're back to the Britney Spears–ification of music: You can pout sexily when you're vexed *if* you dress in revealing clothes, but please don't ruin the fantasy by expressing anything as unattractive as anger.

During my breakup with Mark, my songs of choice were obtusely angry: Berlin's "No More Words," Glasser's "Mirrorage," Kelly Clarkson's "Since U Been Gone" (a first, I swear, and it felt so right). Kate Nash's "Dickhead" got a lot of play as well. And of course, there was Fiona Apple. Every breakup eventually leads to Fiona Apple. Which album I choose is directly related to the cause of the end of the affair. If it was something humiliating (like cheating or an unexpected dumping), I opt for *When the Pawn* . . . If it's just the everyday disappointment of not getting along with someone, I tend to go with *Extraordinary Machine*. Breakups and rejections in my college years were often scored by repeated listens to *Tidal*. There are songs on that album that I might still pull out, but on the whole it's too melodramatic to resonate with me these days. If you put that album on, it will take you to a place when every heartbreak was a huge devastation. My Fiona Apple dirge of choice for breaking up with Mark was "O' Sailor." It encompasses a form of restrained, almost detached, anger that's more directed at love itself than at the man Apple writes the song about. She

spends the verses of the song talking about herself, while the choruses are directed at him, and that suited my breakup with Mark well — I swear I spent as much time talking to myself about it as I did to him.

SAD

So many sad songs have been written in the history of music that you can easily find a hundred to suit the end of any relationship. While angry songs make me feel satisfied and proactive, like I'm shaking the bad feelings out, sad songs are reserved for when I'm feeling self-indulgent and want to wallow in my unhappiness. This is some of the ritual behavior I engage in during my sad-songs period. Some girls put on their headphones and go for a run or eat a pint of ice cream. Some girls go through all the stuff their ex gave them, sorting through what to keep and what to throw away. I usually find myself inspired to write a devastating breakup letter that recaps my feelings, either about our last fight or the relationship as a whole. If I'm moved to write the letter, I always send it. These letters have been known to bring men to their knees with their crushing logic and emotional depth. (Okay, that has never really happened.) They have inspired some frank dialogue, though, which helps close the book on bad relationships for me. I always compose them while listening to incredibly sad songs, the songs that become representations of my feelings about ending things with these exes. While writing a possibly record-breaking eight-page letter to Mark, I listened to Bat for Lashes' "Moon and Moon" and El Perro del Mar's "Change of Heart" on repeat. Both are woeful songs about the breakups you don't want to have but can't avoid, so they were perfect for this situation.

Over the years I've realized that I rely on the same artists and songs for the feeling-bummed segment of my grief parade. While every breakup is different, the feelings I have are the same and have been since the first time I fell in love. When I was fourteen, the Cure released *Wish*. It was the soundtrack (minus "Friday I'm in Love," obviously) to my heartbreaks throughout most of high school. Listening to that album now makes me feel the depression of unrequited love, the sting of rejection, and the very lowest of romantic disappointments, because it was the soundtrack to my first taste of those experiences. Even today, I cry when I listen to "A Letter to Elise." When I feel disgusted by love, I put on "The End." When I feel hopeless, I put on "Apart." Every song by the Cure is the most. Dramatic. Thing. Ever. Every emotion is exaggerated, every feeling overexamined, every rebuff turns the world upside down. It's the perfect reflection of the mind of a teenage girl. I bought this album on CD five or six times because I kept wearing it out from overuse. A few years ago I met Robert Smith while he was taping an episode of *Unplugged* with Korn (a career low for him). Meeting him was disconcerting, because he was this self-conscious, awkward person wearing loads of bad makeup — like the fourteen-year-old version of me — and I had absolutely no idea what to say to him. How do you thank someone for soundtracking the worst disappointments of your most awkward years?

In my twenties, when I made more stupid decisions about relationships than I care to admit, it was Death Cab for Cutie that played in the aftermath. I picked songs off *We Have the Facts and We're Voting Yes*, *The Photo Album*, and *Transatlanticism* to score the bitterness that accompanied my romantic miscalculations. Eventually I would meet and become friendly with the guys in

Death Cab. In fact, at one point I had a conversation with their bassist, Nick Harmer, about breakup albums in which he told me all about his devotion as a young man to the Cure's *Disintegration* as the only answer to his heartbreaks. There has to be some sort of psychological symmetry at work there. I suspect that Ben Gibbard, Death Cab's singer, and I must have spent our early twenties doing the same things: dating people who didn't like us as much as we liked them, getting dumped, feeling really bitter about it, and enacting revenge scenarios with a pen: his dedicated to song lyrics, mine to blistering postmortem e-mails after being dumped. I spent many nights lying in my bed in various crappy New York apartments listening to Death Cab albums and trying to figure out why Ben and I were so unlovable (or maybe so awful at being in love).

A few years later I got involved in what can only be described as a series of romantic disasters with a guy who was friends with Gibbard. I had no idea they knew each other until the guy drunkenly tried to introduce us one night, not knowing we already knew each other. My Death Cab records were soon retired from sad rotation. It felt too weird to listen to them once I actually knew the band, and even weirder after messing around with one of their friends; the universal experience of listening to their songs was ruined. It felt like listening to your brother write love songs about a girl — it's nice and all but there's something kind of creepy about it.

BEGGING

I don't do begging songs. I break up with determination to stay that way and subscribe to the school of thought that says, "It didn't work out, you can die now." I almost never learn my lesson. On

111

occasion I've been known to feel a twinge of regret after breaking up with someone, but I still wouldn't beg them to come back. I have only once sent someone a playlist of songs about how I'd change, how things could be different, or how I've learned my lesson. It didn't work. That's the bleak truth of a begging playlist: If you actually send it, there's a fair chance you'll get the thumbs-down. You're taking your ego in your own hands if you try to woo someone back with music.

However! There are situations when begging becomes the only recourse at your disposal: If you cheated on someone; if you deeply regret breaking up with someone, because you weren't really ready to break up but the other person called your bluff; if you did something generally unfair to drive him away, like blowing him off on his birthday. To find the right come-back-to-me songs, look beyond pop music. If you have to beg, you'd better do it right: with soul and R&B songs. The ultimate in baby-please-come-back songs is Otis Redding's "Just One More Day." If you're making a mix tape for someone you did wrong, that'd better be the first song. If you haven't heard it, put the book down and You-Tube it right now. The second song on your mix should probably be the Exciters doing "Tell Him," to get across the message that you will never ever again let that man doubt you adore him. The last song on the mix has to be Sam Cooke's "Bring It on Home to Me," in case he does change his mind and take you back. Somewhere in there you have to have the Temptations doing "Ain't Too Proud to Beg."

I don't know what it is about soul music that imbues it with this perfect longing for the one thing you've lost; perhaps it's the genre's roots in gospel music, which is filled with begging for God's

attention and forgiveness. Maybe it's the way the singer needs the response from the chorus so the song as a whole makes sense, in the same way you need his reply to your mix tape. Maybe it's the inherent vulnerability in soul; these singers expose themselves in a way that pop singers can't seem to replicate. Soul musicians just sound more sincere, as though their hearts are truly on the line. If you really want someone to believe you're desperate to have him back, you have to go with the old soul classics. Just be really sure you want him back before you make a begging-songs mix and give it to a boy. This is serious business. And no matter how soulful the mix, there's a good chance the response will be, "No way."

KISS OFF

Entering into a romantic partnership with someone is like going into therapy. You slowly start telling the other person everything about yourself. Eventually you find yourselves settling in together, building a rapport, and slowly changing each other's behavior. But what do you do when, after you've agreed to be someone's girlfriend, you come to realize you don't actually want to be with that person? There are relationships that end neatly, when both parties realize it isn't going to work out, and you mutually decide to part and wish the other person well. And there are breakups when you kind of hope the other person gets hit by a bus so you don't have to go through with the breakup. Or the awkwardness afterward of trying to be friends. In the past, I've dumped guys because I literally couldn't stand to be around them any longer. I actually hid from a couple of guys, hoping they would dump me so I wouldn't have to do it (that even worked once, but it took forever).

When I was younger, it was easier to just break up, because

guys were like buses: If one departed, another one would come along. I had the time to burn. These days I find myself wondering more and more often whether it's time to settle down with Mr. Right Now or face dying alone. Every girl who has watched an episode of *Sex and the City* or read a *Cathy* cartoon has been trained to fear spinsterhood and the day your cat eats your wrinkly, old face. In my opinion, though, even worse than dying alone would be retiring with no money. If I were independently wealthy, I would never think about how much easier things might be, and I might dismiss the idea of marriage entirely. But retiring with no money is one of my biggest fears, so Mr. Right Now with a Good Job sounds pretty good when I'm feeling emotionally nihilistic.

The apex of kiss-off songs has to be the Beatles' "Think for Yourself" (although "I'm Looking Through You," also on *Rubber Soul*, is also pretty damn good). It manages to imply both that the person has some hope to fix his mistakes and that he's an idiot all at the same time, while making it perfectly clear that he's being ditched. There's a callousness to the song that makes it obvious that reconciliation is not an option — and that is really what you want in a kiss-off song, because in this phase you are at high risk of slipping back into the comfort of a relationship you don't want to be in anymore. If you listen to the right songs, you can keep yourself from backsliding. The only mix you'll make about this guy is a playlist for yourself. These songs are your reminders when your confidence waivers — and it will. Unless the guy you've dumped is a total loser, leaving the warm cocoon of a relationship is incredibly difficult! You'll have moments when you miss him, or if not him, then the comfort of a relationship. It's hard for me to dump

a guy even when I dislike him so much that spending one more night with him makes me want to dry-heave. I always feel a little mean, knowing I'm going to hurt his feelings. The right kiss-off songs always help me when I feel cold feet coming on in the face of a breakup.

You're most likely to listen to sad or angry songs as a reaction to having something done to you, when things spiral out of your control. You listen to kiss-off songs to capture a vision of how much better your life will be once you've moved past the bad situation you find yourself in. There are loads of options, like the Replacements' "Unsatisfied," for those instances when you know you've been settling and what you want is something more than what you have with this person. Scandal's "Goodbye to You" suits a particular feeling, when you're crazy about him but can't stop fighting and it is obvious you won't work together, but you keep having dramatic fights and long entanglements. Or it could be Elvis Costello's "You Belong to Me," which, contrary to the song title, is about not wanting to belong to anyone or be in just any relationship. It's the "I'm not settling" anthem of my life.

While I was still breaking up with Mark, I went out on a date with another guy. He was the type of guy who started planning date two before date one was over. I just couldn't commit myself to a second date, because he was a Mr. Right Now. I am always eager after a breakup to move on and stop thinking about it, but it was undoubtedly too soon to be dating anyone at that point. If you try to rush things, you'll likely find yourself regressing — moving

backward through the cycle of breakup songs, repeating sad to angry to relieved to angry to sad . . . in an infinite loop. The day after my date, I felt so depressed that I hid in bed all day and listened to Kate Bush. The only thing to do in that situation is resign yourself to being on vacation from love for the moment, until you've completely worked your way through the stages of musical grief.

ARE WE BREAKING UP? PLAYLIST

BLUR, "To the End"

LUSH (FEATURING JARVIS COCKER), "Ciao!"

BJÖRK, "Army of Me"

LILY ALLEN, "Not Big"

YEAH YEAH YEAHS, "Bang"

BERLIN, "No More Words"

GLASSER, "Mirrorage"

KELLY CLARKSON, "Since U Been Gone"

KATE NASH, "Dickhead"

FIONA APPLE, "O' Sailor"

BAT FOR LASHES, "Moon and Moon"

EL PERRO DEL MAR, "Change of Heart"

THE CURE, "A Letter to Elise"

THE CURE, "End"

THE CURE, "Apart"

DEATH CAB FOR CUTIE, "For What Reason"

DEATH CAB FOR CUTIE, "A Lack of Color"

OTIS REDDING, "Just One More Day"

THE EXCITERS, "Tell Him"

SAM COOKE, "Bring It on Home to Me"

THE TEMPTATIONS, "Ain't Too Proud to Beg"

ELVIS COSTELLO, "You Belong to Me"

THE BEATLES, "Think for Yourself"

KATE BUSH, "Never Be Mine"

THE NEXT MADONNA

YOU'VE BEEN WITH MADONNA through triumph. Through scandal. Through questionable hairdos and fashion disasters. You, along with the world, have idolized her as she reinvented herself, pushed the boundaries of acceptable behavior and femininity, and redefined what a female pop star could accomplish. And on August 16, 2013, you, along with Madonna, will celebrate her fifty-fifth birthday. You've probably noticed that around the year 2000 the music press began the hunt for the Next Madonna. The original has had a solid thirty-year run as arguably the most successful female pop star in the world, but now the world seems ready for a newer model.

When all this Next Madonna chatter began, a young upstart named Britney Spears seemed primed to take the crown, but a series of public missteps involving exposed lady parts and a shaved head halted her ascent. More recently Lady Gaga has been the favorite contender as the Next Madonna, with approval coming from music journalists, Kanye West, Jonas Åkerlund (a Swedish video director who helmed "Ray of Light" and "American Life" and came out of retirement to shoot Gaga's "Telephone"), and a great swath of music writers. For those who haven't been named as candidates for the throne, there is always self-nomination, an option that Miley Cyrus, Rihanna, and Avril Lavigne have all

embraced. But this raises some important questions: What does it mean to call someone the Next Madonna? How will we recognize the Next Madonna when we see her? And what is the old Madonna to do when we force her to retire?

Most people associate Madonna with sex. While she's partly responsible for that (and I'll get to that later), so too is the world of music writing. Pick up any mainstream music magazine or blog and look at the staff list. You may see one female editor, but the rest of the editors will be solidly male. The gender ratio of writers will lean male as well. The voices of men, from Nick Hornby to Chuck Klosterman, have dominated music writing, resulting in a decidedly male slant to music coverage: Van Halen's guitar chops are treated with a level of seriousness on par with the return of Christ, and Madonna's evolution as a songwriter goes unexamined, but her body does not. If a female musician is profiled in a magazine, the odds that she will also be photographed in a state of undress are high. Unfortunately, Madonna exploited this angle from the start, putting her sexuality at the forefront to get a reaction from the press. After all, press sells records, and salaciousness gets more press, especially if you're an attractive woman. Throughout the 1980s, no matter where you turned, you heard Madonna talking about being like a virgin while dudes obsessed over how hot she looked. This worked for Madonna because the teen girls who were her core audience and the kind of guys who become music writers have a key commonality: They are obsessed with female sexuality and are not entirely sure how it works.

Teenage Madonna fans in the '80s were interested in her sexuality because we were just then learning the potential power of our own sexuality. Madonna became a role model for us in learning

what this new sexual power could accomplish, and she wrote the book on how to wield it for maximum effect.* Male music critics were interested because, well, duh — boobs and the vague promise of sex hold pretty much any straight guy's attention.

A long line of young female pop stars have embraced the legendary Lolita fixation to get some easy publicity. But that sort of attention alone can only get you so far — as my friend Russell pointed out to me, isn't it weird that none of Prince's lady protégés, a list that includes Sheila E., Wendy & Lisa, Vanity, Apollonia, and Sheena Easton, ever broke beyond one or two hits, even with the Purple One's backing and sexy songwriting? It takes more than sex alone to create a Madonna.

That said, sex did help Madonna steal our attention away from the pop world's top dog at the time: Cyndi Lauper. Back in 1983 Cyndi's debut album *She's So Unusual* was outselling Madonna's self-titled debut by a wide margin. The albums were released in the same year, and Lauper's racked up major hits like "Girls Just Wanna Have Fun," "Time After Time," and "She Bop." Cyndi is the quirky one, the outsider who touched a nerve that everyone could relate to. Her videos were in constant play on MTV, and she attracted a wide fan base with her kooky hairstyle, female-friendly anthems, and out-there sense of style that Madonna later admitted to biting. Cyndi scored four *Billboard* top fives in 1984 and by March 1985, her album had gone platinum four times over — that's four million copies in the United States alone. While Cyndi's album took just six months to go platinum, Madonna's took over a

* This is exactly why it is dumb for musicians to claim not to be role models. At the very least they are influencing social behaviors, more so among young fans. That is a big deal, no matter how ardently they may dismiss it.

year. Madonna was a well-known pop artist, but she was no Cyndi Lauper.

With the release of *Like a Virgin* and Madonna's performance at the 1984 MTV Video Music Awards, everything changed. Lauper had racked up eight nominations to Madonna's one. In what should have been Cyndi's moment to shine, Madonna stole the show. Her now-iconic performance of "Like a Virgin" paired the song, which winked at the virgin/whore imagery that would become a cornerstone of her appeal, with images of a lingerie-clad Madonna writhing on the floor and unintentionally flashing the audience. The act she put on that night convinced a lot of us that we shouldn't just buy in to her image, but that we wanted to save up our allowance to buy a copy of her newly released second album. And it's the moment most often discussed when we talk about the history of the VMAs. Though Cyndi went home with the Moon Man for Best Female Video, Madonna made 1984 all about the "Material Girl," *Desperately Seeking Susan*, and her self-proclaimed status as a boy toy.

Like a Virgin was certified platinum six times over by the Recording Industry Association of America a little over a year after its release. Her hyper-sexualized persona did a lot to drive our interest in her, but she sustained it by remaining front and center, while Cyndi took 1985 off to write her next album. Cyndi released *True Colors* in '86. It had a massive hit in the title track, but none of the follow-up singles charted. By the time she released her third album in 1989, it barely even registered with the pop audience.

When Madonna released *Like a Prayer* in 1989, she was as ubiquitous as Pepsi, so it seemed only fitting when she struck a sponsorship deal with them that caused a sensation not just in the

pop world, but in the marketing world as well. It was Madonna's first major endorsement. *New York* magazine quoted an unnamed source close to the deal at the time: "Now that everyone from Michael Jackson to Whitney Houston has endorsed either Coke or Pepsi, it's become a rock 'n' roll status symbol." In the midst of a brutal cola war between the two soda giants, Pepsi was incredibly lucky to land Madonna, whose popularity and of-the-moment legend was second only to Michael Jackson's.

After Pepsi featured her and "Like a Prayer" in a two-minute commercial that premiered during the Super Bowl, Madonna released the track's accompanying music video, and a shit storm of drama rained down. The video was an interracial love story that ended with her kissing a black Jesus. The Catholic Church actually issued a condemnation against her, and Pepsi killed their contract with the superstar immediately, yanking the spots off the air. Madonna reportedly kept the multimillion-dollar fee she'd been paid and walked away amid the whirl of controversy, garnering major press attention and all of the bad-girl reputation rumors she could handle (not that any of those were bad things in her world). Pepsi came out looking conservative while Madonna's actions played into our perception of her as a maverick.

Throughout her rise, Madonna has been at the center of a range of criticism, from disapproval for the negative social impact of her blatantly sexual image to allegations of lip-synching and studio fixes to enhance her vocals. Her fans, however, could not have cared less. We just wanted to be part of the spectacle. Her ability to put on a live show that's nothing short of an extravaganza has been a vital part of her appeal and her reputation. And she's come a long way. In the early '80s, she could be found lip-synching and dancing

to tracks in clubs, with her brother and some girls as backup danc-
ers. Her first major tour, 1985's Virgin Tour, didn't veer too far
from the club routine. By 1987's Who's That Girl tour, Madonna
was already trying the push the envelope in creating a multime-
dia stadium experience, but the result was little more than a fairly
faithful recreation of her music videos with some Warholian pop-
art–inspired costumes and visuals. It was the 1990 Blonde Ambi-
tion tour that forever changed audience expectations for pop con-
certs. Even if you didn't go, you're probably familiar with that tour
from its infamous on-the-road documentation in the movie *Truth
or Dare*, which gave us a raw, behind-the-scenes look at Madonna,
who came across as kind of a monster. Every Madonna tour since
has been a massive production, requiring so many set changes that
the crew and transportation needed would be unthinkably taxing
to any but the richest and most sponsorship-bankrolled pop stars,
but they're also among the most profitable — and entertaining. She
has twice broken the record for the top-grossing female tour ever,
according to *Billboard* magazine. With her Re-Invention, Confes-
sions, and Sticky and Sweet tours commanding $350 a ticket, she
has likely priced out many of her teenage fans.

Which brings us back to Britney Spears. From the start, Brit-
ney busted sales records for a solo female artist, selling fourteen
million copies of her debut album, . . . *Baby One More Time*, in
the United States. Her cumulative thirty-two million album sales
to date still pale in comparison to Madonna's sixty-four million,
though it's worth noting that Britney's debut has sold more than
any single Madonna album. It's not unthinkable that as Britney's
album was flying off the shelves in '98 and '99, and Madonna

was seeing comparatively slow sales for *Ray of Light*, the original Material Girl might have felt threatened.

In 1997 the RIAA reported a boom in music purchases by female consumers, which accounted for more than half the market share for the first time in the decade. A large chunk of that uptick can be credited to the boy-band and girl-power pop of the late '90s and early 2000s, and Britney was at the center of it all. She hit the touring circuit opening for *NSYNC in 1999, and by the time she headlined her own tour in 2000, she had one of the top-ten highest-grossing concerts of the year (behind, among others, *NSYNC and Metallica — 2000 was a weird year in music). She was in high demand, from both her fans and the media, who couldn't get enough of the "Is she or isn't she a virgin?" game.

And though neither would admit it, Britney and Madonna became subtle competitors. Britney talked to the press about idolizing Madonna, while Madonna talked to the press about loving Britney. Everyone else, bloggers and journalists alike, was ready to declare Britney the next Madonna. In the face of this youth-quake, Madonna used a clever business maneuver to inject herself back into the center of the conversation: She staged a takeover. In the business world when a smaller company begins taking attention, money, or customers away from a corporation, the corporation's most prudent move is to buy them and eliminate the competition. For Madonna, the takeover would be sealed with a kiss.

When Madonna kissed Britney on national TV during the 2003 MTV VMAs, even the celebrities and jaded music-industry types in attendance were shocked. It was, naturally, followed by a round of thunderous applause. This was my first year working

at the VMAs for MTV, and the feeling in Radio City Music Hall that night was electric; we were watching a moment that everyone would be talking about the next day. And our collective gasp was warranted — the kiss still makes top-ten lists of the most shocking VMA moments, hottest girl-on-girl kisses, and scandalous events in either Britney's or Madonna's history. In an instant, Madonna reclaimed the full attention of the press and used the public's fascination with Britney to change the conversation around their relationship from one of competition to one of collaboration. And she reinforced her own sexiness and youth appeal, after making such a spirituality- and mommy-oriented album (read: grown-up) like *Ray of Light*.

In the public-relations aftermath, it wasn't Britney who appeared on Oprah. It was Madonna. She used the opportunity to promote her latest album, *American Life*, while directing all controversial attention and eyes back on herself. She feigned surprise that the world was so shocked and interested in the kiss, as though it hadn't been a perfectly executed publicity stunt. Britney may have thought she was getting a big-sister figure or pop-icon mentor in the only living person who could identify with what she was going through. In retrospect it seems obvious that Madonna was using their relationship and the public's fixation on Britney to bolster her own image. She did not hesitate to cut all ties after the bloom rubbed off Britney's flower during Brit's unraveling in the public spotlight. In any case, Britney began defining what it would mean to be the Next Madonna, which entailed more than being a blonde pop star who hints around about sex. She made us see that for the old Madonna to be replaced, we would need someone

who could capture the public's attention in the same scandalous-but-likable manner, while providing us with that special pop-star sparkle.

Since those halcyon days, the idea of Britney as the Next Madonna has faded out of favor. It's become obvious she lacks the drive to sustain her career. She is surrounded by a crack team of marketers, but she appears to have no artistic vision of her own, nor a keen-enough business sense to pull off pop-stardom for the long haul (we're talking the fifty-year long haul here, not the "while I'm young and convincingly sexy" haul).

Regardless of whether you like Madonna's music or not, you have to have some respect for her tenacity and cultural intelligence compared to the pop stars who have come after her. She manages to deftly pull together a variety of artistic influences and cultivate them into a persona that engages people. Her name-checking of Marlene Dietrich and tribute to her in "Vogue" is perhaps more responsible for contemporary awareness of this actress than any of the movies Dietrich actually starred in. Britney, on the other hand, probably couldn't tell you who Madonna's artist friend Jean-Michel Basquiat was, let alone work him into a song's lyrics.

Britney has had no problem captivating the public and the press in good times or bad, but her coming undone has provided us with a different sort of spectacle — and it's not at all what we expected. In 2007 I was working at the VMAs in Las Vegas when she gave her absolutely frightening performance of "Gimme More." It was a complete disaster and a cultural phenomenon. Looking as if she'd spent ten minutes getting ready, Britney took the stage. She might as well have fallen right off it for how badly she flopped. She

stumbled listlessly around in a Vegas showgirl-style outfit, appearing dazed and most certainly not fully there. This was not the confident pop star we knew, but some broken doll, too weak to say no to what turned out to be an exploitive performance that would only further her decline. It was shocking that a star of Britney's stature would appear so sad and out of control in public, let alone as the opener of the VMAs. Madonna would never be caught on stage in anything less than full control, whereas Britney's performance that night gave the impression that she was too feeble-minded to know she shouldn't have been there in the first place. Everyone who suspected she was a puppet had further proof after that night.

In my opinion, her neutered return to the VMAs in 2008, when she'd cleaned up and was ready to collect her awards with decorum, was just as bad as "Gimme More." The public was ready for her redemption, but Britney seemed just as vacant and noncommittal as she had the year before.

It requires a special kind of self-possessed mind to look into the face of iconography, understand how universally adored you are, and continue to function at all, let alone maintain your humanity. Britney couldn't handle it.

Madonna, in her own struggle with control, freaked everyone out in 1992 with the dual release of *Erotica* and the *Sex* photo book — not because we were scared of her sexuality, but because we collectively felt this was too blatant and lacked depth or emotion — but the idea that she might atone for any stir she caused never crossed anyone's mind. Every track on *Erotica* brought a Madonna with a different look. She assumed a disco persona in a nod to Edie Sedgwick for "Deeper and Deeper," rocked a black-haired pixie cut (a first for her) in the "Rain" video, and got

Christopher Walken to play her guardian angel in the "Bad Girl" video. However, the *Sex* book, with all its unabashed and sometimes tasteless kinkiness for the sake of shock, grossly overshadowed any sort of stylistic ambition she tapped into with *Erotica* and undoubtedly had an impact on how poorly it sold in comparison to her previous albums. The naked pictures of her with Vanilla Ice in *Sex* didn't do anything to help her cred in music circles. And the release of *Body of Evidence* in 1993, the notoriously awful "erotic thriller" that was neither erotic nor thrilling, only further pushed along her reputation in pop-culture circles as a pantheon of the tasteless. And not a bit of that matters in the long run, because even if she marred her reputation, everyone was still obsessed with her every move. Separated from the firestorm of controversy at the time, most music critics consider *Erotica*, in retrospect, one of Madonna's most important releases. She made us love her even when she was a badly behaved outcast. And she did it on her terms.

Madonna maintained her sense of humor and sense of self beautifully for many years after that lapse, doing the sort of things we all do. Getting married and divorced, having kids, making stupid mistakes, finding spirituality: in short, growing up. And she incorporated all of these stages of life into the music she created, so her fans could follow along. As she gets older and the urge to stay youthful through high-intensity workouts and plastic surgery becomes irresistible, even her most adoring fans have to admit there is every chance she could slip into that same dark downward spiral. From 1983–1999, however, she had her shit firmly together and was the model female pop star. Which is probably why Lady Gaga is trying so hard to be her.

Christopher Walken to play her guardian angel in the "Bad Girl" video. However, the *Sex* book, with all its unabashed and sometimes tasteless kinkiness for the sake of shock, grossly overshadowed any sort of stylistic ambition she tapped into with *Erotica* and undoubtedly had an impact on how poorly it sold in comparison to her previous albums. The naked pictures of her with Vanilla Ice in *Sex* didn't do anything to help her cred in music circles. And the release of *Body of Evidence* in 1993, the notoriously awful "erotic thriller" that was neither erotic nor thrilling, only further pushed along her reputation in pop-culture circles as a pantheon of the tasteless. And not a bit of that matters in the long run, because even if she marred her reputation, everyone was still obsessed with her every move. Separated from the firestorm of controversy at the time, most music critics consider *Erotica*, in retrospect, one of Madonna's most important releases. She made us love her even when she was a badly behaved outcast. And she did it on her terms.

Madonna maintained her sense of humor and sense of self beautifully for many years after that lapse, doing the sort of things we all do. Getting married and divorced, having kids, making stupid mistakes, finding spirituality: in short, growing up. And she incorporated all of these stages of life into the music she created, so her fans could follow along. As she gets older and the urge to stay youthful through high-intensity workouts and plastic surgery becomes irresistible, even her most adoring fans have to admit there is every chance she could slip into that same dark downward spiral. From 1983–1999, however, she had her shit firmly together and was the model female pop star. Which is probably why Lady Gaga is trying so hard to be her.

I first met Gaga in 2008. Back when her "Just Dance" video was newly in rotation on MTV, the powers that be at Interscope Records set up a meet-and-greet with Gaga. She was still a new artist at the time, and we didn't yet understand that she embodied the Gaga character 24-7. She came into our conference room wearing no pants — this was during her leotard phase, which was followed by the hair-as-hair-bow phase. Needless to say, Gaga had the theatrics angle nailed down before most people even knew she was, and she clearly has a big artistic vision for herself.

Gaga has evolved the elements of style and costuming on her character, but she remains firmly entrenched in shock-value pop-art performances, both live and in music videos, as the big carrot to pull an audience in. And she's not ashamed to lean heavily on Madonna's style to do it. In the '90s, when Madonna was in the zone as a pop icon, she did an amazing job transforming herself and her look into several vastly different styles. She kicked off the decade playing a serious brunette who kissed a black Jesus, morphed into a Marilyn Monroe look-alike who costarred in *Dick Tracy*, became a cheesy kinkologist with the *Erotica* album and the *Sex* book, toyed with being a respectable movie star in *Evita*, and wrapped up the decade by recounting her experiences becoming a mom and finding Kabbalah on *Ray of Light*. Those were more than evolutions. Madonna inhabited entirely different characters at breakneck speed. As of the writing of this book, Gaga is just releasing her second all-new album. She has certainly switched out fashion accessories quickly, à la Madonna, but it's too soon to tell whether her sound or lyrical subject matter is going to evolve as well. This isn't to say that Gaga doesn't have musical tal-

ent to go with her outfits, but it must be said that Gaga's songs are not as good as Madonna's. At least not yet.

Amidst all this reinvention, Madonna — and now Gaga — are constantly accused of ripping off other artists' style, music, and looks. The wide variety of people Madonna has been accused of borrowing from is too long to list in one book but includes people as far-reaching as '70s girl punk band the Slits, Marilyn Monroe, and photographer Guy Bourdin, whose estate actually sued her in 2003 over the claim that images in her "Hollywood" video were plagiarized copies of his famous photographs. (She settled but acknowledged no wrongdoing.) Gaga faces a chorus of rip-off references to David Bowie, Grace Jones, and, of course, Madonna. My thoughts on this matter swing toward the Ecclesiastes* quote, "There is nothing new under the sun." All artists pull from those who came before them. Some do so more heavily than others. However, in a world where Girl Talk can be considered a talented artist for doing nothing more than mashing a bunch of song samples together, when a Gaga or Madonna brings aspects of their lesser-known influences to the mainstream, it's hardly worth crucifying her over. Bear in mind that most of Gaga's fans hadn't even been born yet when Bowie and Grace Jones put on the live shows she visually references. If she inspires kids to Google those earlier artists and discover their music, I don't see a downside. Obviously, she'd be a lot cooler if she were more original, but in music what is critically lauded is rarely popular, and the most-popular performers are rarely important to the critics.

* Yes, I just quoted the Bible. I am as freaked out about it as you are.

When it comes to her relationships with corporate America, though, Gaga may have surpassed Madonna. She has the expected tour sponsors and music-video product placements, but she's also struck a deal with Polaroid to act as a creative director on select projects. Judging by the product placements in Gaga's video for "Telephone," the creative influence is hardly one-way. Neither party has laid out the exact details of their collaboration agreement, but it's a highly sophisticated product-integration deal that brings the commercialization of art to new levels. In her creative-director role, Gaga will potentially affect actual design, marketing, and presentation of new products for the camera company, a role relatively unheard of for a pop star.

This is where Gaga loses people who think that the mixing of corporations and artistic endeavors is a bad thing. You either appreciate the ingenious integration of Gaga into the Polaroid company and reciprocal integration of Polaroid products into the Gaga brand or you find tasteless the idea of corporations using art to sell products.* Either way, as sales and profits in the music industry weaken and advances and marketing budgets shrink, more artists are relying on corporate underwriting. Essentially, the bar Madonna set for pop-star performances created a financial barrier to entry for every pop starlet who wants to follow her. Gaga is using connections with business to help her generate enough capital to create the giant spectacle show she requires to top Madonna and support her pop performance-art vision. Between her blatant nod to Madonna's looks of the past and her aping of Madonna's basic economic strategies (even if she does do it on an advanced

* Or you are 100 percent apathetic.

level), Gaga is just following the template that Madge established decades ago. If the Next Madonna is truly as inventive as the first Madonna, she'll look nothing like her. She'll be someone no one can see coming.

When she launched her career in her twenties, there was no way Madonna could have known she would still be making pop music in her fifties. Aside from Cher and Barbra Streisand, who are in a very different world, it's unprecedented for a female pop star to be such a cultural phenomenon for so long. In the last decade, Madonna has tried desperately to hold on to a youthful audience and she's faltered. As she chases her next hit, her evolution as an artist seems to have stalled. It's hard to get behind an album like *Hard Candy*, where her thighs are the main feature of the album art, every song is stacked with weirdly cold beats, and guest appearances by Justin Timberlake and Timbaland feel like a weak attempt to remain relevant to teenagers. Not only is she losing her original base, but she's out of touch with the younger audience who are looking to new idols like Gaga and another Next Madonna contender, Maya Arulpragasam, aka M.I.A.

If you were at all tapped into music-blog culture in 2004, then you first heard M.I.A. when music blogs went batshit crazy for "Galang" and Maya's massively leaked first album *Arular*. Maya is a woman of the world. She's originally from Sri Lanka, where her family was heavily affected by the civil war. Her father helped found the Tamil militant group EROS, which sought to create a separate Tamil state in Sri Lanka. EROS was later taken over by the Tamil Tigers, a militant group that wasn't shy about employing terrorist tactics in their fight. Her father wasn't a Tiger (she would tell you he was), but M.I.A. didn't shy away from using Tiger

imagery and references in her music, which led to her labeling as a terrorist sympathizer by some members of the press. She lived in India for a period before her family relocated to London, where she met singer Justine Frischmann of the band Elastica, leading to her appearance on M.I.A.'s debut album. From the jump, M.I.A.'s music has been a crazy mix of hip-hop/grime, reggaeton, Bollywood, and pop. Her lyrics are very political, not always well-informed and, by extension, controversial.

Lynn Hirschberg of the *New York Times* was among the first to acknowledge M.I.A. as the potential successor to the Material Girl's throne. In her controversial feature on the singer in May 2010, she noted, "in fusing style, music and controversy, Maya evoked Madonna." Hirschberg then went on to call Maya out for being uneducated about the political groups she purports to support, accused her of using shock tactics to get attention, and said she co-opts the talents of male producers and songwriters to bolster her own rise to fame. These mirror accusations that were flung at Madonna in her early career, substituting lectures on morality for accusations of terrorist sympathies. But it seems fitting in a post–9/11 world that the next Madonna would take up the issue of terrorism as her focus for shocking everyone. Madonna used the intersection of sex and religion to provoke us, and now there's very little left in that arsenal. That's a big part of why no one was especially taken aback by Lady Gaga's "Alejandro" video, which rehashes the tools of Madonna's trade from nearly twenty years earlier. Religious intolerance and xenophobia in the West — issues at the center of the current global political divide — are Maya's playground. It doesn't even matter what she says, whether she has actual or exaggerated ties to the Tamil Tigers in Sri Lanka, or

whether she actually cares about the third world or lives an incredibly privileged life. It just matters that she uses an extreme point of view to shock everyone into listening to her. Madonna and Maya both know the first trick is to get the world's attention. And once you have it, you can push that button for decades.

Put nose to nose, "Paper Planes" holds its own with "Like a Virgin." It's hard to argue that the video for M.I.A.'s "Born Free," where redheaded white people are rounded up into a concentration camp, isn't as misguided and muddled an attempt to disconcert us as "Like a Prayer" once was. Maya may lack the live performance spectacle, telling Hirschberg in the interview for the *New York Times* exposé that she's most uncomfortable in that arena, but in every other way she's a more natural evolution of what a twenty-first century Madonna should look like than Britney or Gaga.

As a fifty-something woman trying to embody the role of sex kitten, Madonna is no longer an aspirational figure to me. In a lot of ways, I've outgrown her. When I was young I wanted to have her self-confidence. I wanted to mock everyone and rule the world while I did it. But one-time Madonna fans like me no longer need a teen idol to talk to us about sex. We have grown out of being all-consumed by the desires of youth and have graduated to the next life stage. We've mastered our sexuality. Madonna fans now have mortgages to pay, kids to raise, and the business of everyday life to get through. Our interest in her golden thrusting crotch is escapist at best and nonexistent most of the time.

According to the 2009 SoundScan figures, some of the biggest-selling albums of the year were released by Susan Boyle, Barbra Streisand, and Michael Bublé — all artists whose success was credited to an older audience, people who actually buy albums.

This is not to say Madonna has to neuter herself or her sexuality to remain successful. If anything, it would be even more revolutionary if she used her station to create a new vision of what middle-aged female sexuality could look like. But she seems to be leaving that task to Jamie Lee Curtis (also born in 1958) while she sets about having enough plastic surgery and sequined costumes to outshine every Miley, Rihanna, and Swedish pop star who tries to be her. If she had simply evolved into the Next Madonna in the twenty-first century, instead of devolving into the '80s Madonna, her story would still be going on, and all these wannabe Madonnas could go dream their own little dreams of pop stardom. Madonna created the opening for a crowning of the Next Madonna herself.

THE NEXT MADONNA PLAYLIST

MADONNA, "Ray of Light"

MADONNA, "American Life"

LADY GAGA, "Telephone"

CYNDI LAUPER, "Girls Just Wanna Have Fun"

CYNDI LAUPER, "Time After Time"

CYNDI LAUPER, "She Bop"

MADONNA, "Like a Virgin"

MADONNA, "Material Girl"

CYNDI LAUPER, "True Colors"

MADONNA, "Like a Prayer"

BRITNEY SPEARS, ". . . Baby One More Time"

MADONNA, "Hollywood"

MADONNA, "Vogue"

BRITNEY SPEARS, "Gimme More"

MADONNA, "Deeper and Deeper"

MADONNA, "Rain"

MADONNA, "Bad Girl"

LADY GAGA, "Just Dance"

M.I.A., "Galang"

LADY GAGA, "Alejandro"

M.I.A., "Paper Planes"

M.I.A., "Born Free"

INTERLUDE

music blogs are just dadaist conversation

IF THE INTERNET'S an unlimited universe of knowledge, then music blogs are the little corner of that universe where people have the sort of conversations that would be unacceptable in mixed company. Not because of blue content, but because the writing is both so nerdy and so obtuse it can be difficult to wade through. Music blogs are proof that the Internet represents the ultimate democracy for information. Some of my favorite blogs are written by people I wouldn't otherwise interact with, writers from random small towns in Florida and Minnesota. And some of the most popular ones, like Stereogum, are written by people I once walked by every day: namely, my former coworker Scott Lapatine, who jettisoned his cubicle around the corner from me when his blog, Stereogum, took off. Talk about living the dream. And while some music bloggers are functional members of society whom you could easily go out and have a drink with, others are stereotypical, socially awkward geeks. There is a famous quote, often attributed to Elvis Costello, that says writing about music is like dancing about ar-

chitecture. For all their differences, these music bloggers are all dancing their hearts out.

The only way to find your way among the boiling tar pits of information that are music blogs is to jump in face first. Finding music via blogs is advanced music searching that caters to niche audiences. There are blogs dedicated to specific cities, specific decades, specific sub-sub-subgenres of music. A handful of blogs whose taste matches your own can become one of the most useful tools for finding new music, but they tend to come and go quickly. I can't give you a list of my favorite music blogs, because by the time you read this book they may be abandoned, start to suck, or be bought and "renovated" by a corporation. Blog culture, however, is here for the long haul. If you haven't been out there finding your blogs of choice already, now is the time.

Often the way bloggers describe music will make no sense, as they attempt to contextualize music in a seemingly Dadaist stream of words. These brave souls have taken on a challenge by starting music blogs. Very few of them have any professional experience writing about music. They are making it up as they go, so many blog writers will hit you with a blurry picture of a half-naked person or a cloudy sky and then follow it with a nonsensical verbal spew about the time a storm hit the Carolina coast and how this song reminds them of the swirling trash on the beach. It's very much about their experience and won't necessarily make any sense to you at all. A person could lose her mind—and her way—in this mess. If you want to really delve deep into the musical blogosphere, there are three proven ways

you can penetrate this world without going completely insane, while increasing your collection of free and semi-legal music.

OPTION 1: BE METHODICAL IN SEARCHING FOR THE RIGHT BLOGS.

There is no shortcut to finding music blogs you like. You're going to have to sit down and read a bunch. Most discerning people start by going to the one or two music blogs they trust and checking out the blog roll—it will include both bloggers they are friends with (because in blog culture, cred is all about who you know) and, more important, people who write about similar music. If you're starting fresh, with no music blog experience at all (who are you and what do you do with your time on the Internet?), start by visiting a site called Hype Machine and searching for the names of a few of your favorite bands. It will return a list of blogs that have featured whatever band you searched for. Read the ones whose names sound most interesting to you. Yes, this is sort of like picking a bottle of wine based on the label. Wine snobs will find that annoying, but for the novice, it's as good a method as anything. After reading a few dozen and listening to the MP3s they've posted, you'll come across the right blogs for you. Eventually it will become just like reading the daily news or your Twitter feed—you'll have an order, a method to your blog madness. Keep in mind that you may have to rely on some obtuse descriptions by bloggers whose writing abilities are questionable at best in order to get a sense of what you're downloading. You'll find the pattern that suits you best, whether you read them once a week or every day, and then you'll find all the tracks you can handle. And you'll do it with all killer, no filler.

OPTION 2: FIND EVERYTHING.

If you're the sort who's afraid to miss anything, someone who is so trend-centric that you'd actually consider rocking acid-washed denim if it rolled down the runway in a Marc Jacobs show, then you'll want to set up an RSS feed and put every single music blog you can find on it. And I mean everything: the good, the bad, the really terrible. Then download every single track that every one of them posts (obviously excepting repetitions of tracks posted on more than one blog, but certainly not excepting all remixes of a song). The biggest hassle with having it all is finding the time to listen to it. Putting aside an hour a day or several hours on the weekend will allow you all the time you can bear to listen to your new music. On the plus side, there's no need to try and read what any bloggers are writing because you're going to download everything you find anyway. You can completely skip trying to decode what someone else thinks it sounds like and just figure it out for yourself.

OPTION 3: HIT THE HEADLINES.

You only read CNN. In fact, you actually only read CNN's Breaking News feed in your Twitter stream, because they're your trusted news source but you don't want all the pratter of the less-important CNN stories. All you need are the top five most-popular music blogs. Make your list, download everything they post, listen if and when you feel like it. Your slightly ignorant bliss will be the envy of all your overachieving friends.

OUR SONG, YOUR SONG, MY SONG

My college boyfriend, Charlie, had an outstanding record collection. It was top-notch beyond my comprehension at the time, heavy on jazz and swirling psychedelic rock. I had never heard 90 percent of it. In the years since we were together, as I've learned more about obscure and cult music, I've gained a keen appreciation for his records. They reflected both his taste and the massive amounts of pot he smoked. Charlie was the first person to get me to listen to experimental Brian Eno records, the first to play me John Coltrane, and the first to introduce me to Mercury Rev.

By default, Charlie almost always dictated what music we listened to because we spent most of our time at his apartment in the presence of his substantial collection. Based on the "my house, my records" rule (always fair, I say), we would listen to whatever he had pulled out that day. When we were driving somewhere, he would pick four or five CDs for the trip, even if we were just going a few blocks to Whataburger. He was trying to expose me to music that he thought was better than the second-rate music I was listening to, but we had very different taste, so it was an uphill battle. He enjoyed telling and retelling the story of an old girlfriend who got him into the Velvet Underground, whose album *White Light/*

White Heat inspired him to join his first band. It's worth noting that almost every single one of the miniscule number of people who actually listen to Velvet Underground records, from the Pixies to at least one random dude you've dated, will tell you that exact same story. I don't remember the first time he played me Mercury Rev, but the first time I noticed was in the car when he put on track 99 of Mercury Rev's 1991 debut album, *Yerself Is Steam*, and smirked at me.

If you don't know this particular Mercury Rev album already, let me explain: There's left of the dial, and to the left of that is where you'll find *Yerself Is Steam*. Historically, it is filed by music critics under the shoegaze genre. I suppose this is because the band used a lot of the same guitar tones as shoegaze outfits from the same time, but it was really a bit too psychedelic to fit the genre. It's not easily accessible if your ears are more attuned to the pop end of the spectrum, where most shoegaze lives. Mercury Rev is clever, but they avoided writing hooks or melodies on this album. Except for the hidden bonus track 99, "Car Wash Hair." Charlie might have played me every song on that album dozens of times, but the only one I remember is "Car Wash Hair." He played it repeatedly. Every time we were in the car. Every time I went over to his apartment. He put it on with no commentary, aside from a smirk, until I finally acknowledged his little musical joke about my car-wash hair.

Before continuing, I should tell you that I have naturally curly hair that gets very poofy in humidity. Exploding-off-my-head poofy. Needless to say, humidity is a fact of life in Texas, which led to some very big-hair days while I was growing up. I should also tell you that the chorus of "Car Wash Hair" goes: "Wanna ask

but I just stare / Can I run my hands through your car wash hair?"
It's lovely, poetic, charming, sexy — in short, nothing like the rest
of the song, which tells the story of a man riding in the back of a
band's decrepit tour van. While the chorus was about me and my
hair, I always thought the rest of the song was about Charlie, who
was a member of several bands about town. In fact, we met be-
cause I had been writing terrible things about the Houston music
scene that summer for MTV's now-defunct local website. He sent
me an e-mail to take issue with my proclamations that Houston
was a cesspool devoid of decent entertainment, and he included
lists of bands he thought I should be listening to. We ended up
hanging out so he could play me records. Next thing you know, we
were dating. I still think he was wrong about the music in Hous-
ton. Nothing I saw that summer was particularly impressive, with
the exception of a band called the Fatal Flying Guilloteens, who
all dressed like the Lone Ranger and put on aggressive punk shows
to captive audiences of fifteen people.

Back to the point: "Car Wash Hair" got played a lot that sum-
mer, and I started thinking of it as Our Song. Although I am ab-
solutely certain Charlie started playing it to tease me, the song
touched on truisms about both of us. For the rest of my life, hear-
ing that song will always take me right back to being silly with
Charlie in the summer of 1997. Other guys have, amazingly, tried
to play this particular song for me since, and I always stop them
and explain that Charlie beat them to it. It's already my song with
him. Recycling it would be creepy and wrong.

What I took away from this experience with Charlie was that
it's really easy to turn something into an Our Song. It can happen
accidentally or romantically, or it can spring from an inside joke.

Making an Our Song happen is an incredibly powerful thing, though, so I would advise using this power carefully. Songs may be sullied forever if things go badly.

One function in life absolutely demands an Our Song: a wedding. I am fascinated by stories of how people picked their wedding song. If you haven't stumbled across (or staged) one by the time you're engaged, it's not going to happen organically. You'll have to have a debate that will undoubtedly involve months of playing each other songs, melding your musical tastes, and generally driving each other nuts with unbearably sappy music. Charlie, the aforementioned ex from my college days, once told me a story of two friends of his who walked down the aisle to the Moody Blues' "Knights in White Satin." This song is both hilarious and corny — an epically funny choice for a wedding song. I should have asked him whether this song was something they'd chosen specifically for the wedding or whether it was a well-worn Our Song for them. Charlie tried to convince me that the selection was very romantic. All he managed to prove was that we all have our lapses in musical judgment.

One of the most fun weddings I've ever attended was my friend Josh's. It was a chance to reminisce with old friends I didn't see very often while we drank too much and danced just the right amount. Josh and his lovely bride, Connie, had their first dance to U2's "All I Want Is You." When I heard the song, I was immediately suspicious. I have never heard Connie talk about U2. I'm certain that when it comes to U2, her interest level could best be classified as ambivalent. Josh and his best man, however, were huge

U2 fans. So I asked Josh what inspired him and his wife to choose that particular song for their first dance. He was quick to confirm my suspicions that his wife had little to do with it. "It was an amazing and perfect song with the perfect lyrics. It meant more to the best man and me than anyone else, I think. It was essentially for me."

What you need to know is that Josh is not a music snob or a music nerd. He is a Music Nazi. As long as I've known him — well over a decade now — he's wanted to control the music that's playing wherever he is. I can totally relate. We are Music Nazis because we believe we have better taste in music than everyone else. Letting us control what you're listening to is entirely to your benefit, and it would be great if you could just trust us about this. In addition to single-handedly picking their wedding song, Josh also picked all the music that played at the reception. I don't want to say his charming bride wouldn't have been allowed a say in the selection of the first-dance song if she'd cared to object, but Josh did tell me he picked that song when he was in high school, long before he had even met Connie.

From watching those *Bridezilla*-type reality shows about weddings, I've noticed that women seem to spend a lot of time trying to interest the groom in participating in the wedding decisions. Connie planned everything else, so if Josh's area of interest was the music, then, hey, that's a collaboration. Here's what strikes me as really hilarious: I asked Josh if "All I Want Is You" became a thing for them after the wedding, thinking that maybe that moment gave it a sense of enduring romanticism and turned it into their song. Actually, what I asked was, "Have you ever had a romantic moment with the bride involving that U2 song? Do you

ever just put it on to reminisce?" He wryly replied, "Do you see a
dress on me?" Okay, point taken. Then he admitted that when the
song comes on, he does mention it, but the romance is muted be-
cause Connie keeps forgetting what the wedding song was. Some
songs will not be forced into being an Our Song, but I'll always
think of Josh and his best man when I hear that U2 ballad. I may
also imagine them slow-dancing together, for my own amusement.

That track couldn't make the jump to Our Song status for
Josh and Connie because it wasn't *their* song. It was Josh's roman-
tic ideal song that soundtracked his teenage dreams of love. It's
charming to think he chose a grandiose love song as the repre-
sentation of romantic love back when he was a kid, but a real Our
Song is often much more pedestrian. U2's "All I Want Is You" is
way, way too over the top for Josh and Connie to sit around listen-
ing to. It is so romantic, it might be too romantic to be anyone's
Our Song.

John Sellers, author of *Perfect from Now On: How Indie Rock
Saved My Life*, tweeted: "'Better Man' by Pearl Jam is stuck in my
head. Kill Me. Please," I wrote back that the song reminded me of
boys I rejected in high school. He replied that he was glad I had
rejected them. This is because Pearl Jam is a mediocre band and
we both knew it, no matter how many millions of albums they sell
or how many Target-commercials-turned-music-videos Cameron
Crowe shoots for them.

The full story, in more than 140 characters, is that there was
a specific boy I rejected while the song "Better Man" was play-
ing. He was the manager of our local McDonald's when I was in

high school. One evening he hit on my friend Kaye and me while we were enjoying some french fries at his fine establishment. Kaye made it very clear she was not interested, and then, just to mess with him, told him that he was my type. The cruelty of youth, right? This led to us catching a ride with him back to her car in a nearby grocery-store parking lot. During the drive, that goddamn Pearl Jam song came on the radio. It was synchronicity. The universe was trying to tell him not to ask either of us out, but he wasn't listening to the soundtrack of his failure as it blasted in our ears. He ignored the Pearl Jam song on the radio, a song that was far too apt for the moment, and he asked for my number. Our brief relationship ended when I declined to go on a date with him and he asked if it was because I was gay. Seriously, the stupidity of youth. After that beguiling interaction, I never talked to him again, but for the rest of my life when I hear Pearl Jam's "Better Man," I will think of him. It is his song, whether he wants it or not.

Your songs don't always come out of romantic disaster, or romance at all. My freshman year in college I lived next door to a girl named Jill who introduced us all to the magic of Simon & Garfunkel's classic "Cecilia." She never explained where her love of this random song originated. She just put it on one day when a group of girls were hanging out in her dorm room, and it was such a "WTF?" moment that the song stuck. She played it so often and danced so cutely that it became Jill's song. When she later joined a sorority, it joined the canon of songs associated with all those girls because they insisted on playing it at all their parties for Jill (mostly because the way she danced around in circles to it when she was drunk was so effing adorable you could just die). She knew it was her song too. It got to the point that everyone would shout out for

her when it came on, and wherever she was — at the campus pub, a house party, or a dorm room — her friends would make her get up and do her sweet little spinning-around dance to it. Years later I don't as much as keep up with Jill on Facebook, but every time that song comes up on shuffle, I think of her and chuckle.

You should also give serious consideration to your go-to karaoke jams. These inevitably become Your Song in the minds of those who witness your glorifying — or horrendous — performance (really though, the worse you are at karaoke, the better it is for everyone else, so don't hold back). My friend Leah does the most amazing, gutting rendition of Phil Collins's "Against All Odds." A lot of people karaoke this song because the emotionality of it makes for a good performance, and the song itself is easy to sing. Leah, however, generally ends the song rolling on the floor in agony, inserting a few choice profanities to elevate the song's emotional impact. It is impossible not to laugh, because it's Phil Collins. But the trick is done, and whenever I hear "Against All Odds," Leah immediately pops into my mind.

I have an affinity for difficult men, but for one shining moment of good emotional decision making, I decided to try dating against type and went out with a nice guy we will refer to as Noel. I've never dated anyone with fewer possessions. When we met he had recently moved to New York from Seattle and was working for a nonprofit. He owned zero actual records, just a stack of unlabeled burned CDs. I started making him mixes and playing him music by bands I thought he would like, because I felt it was my duty. Every guy I had dated before him had done the same for me. Among

the things I gave him was my own personally chosen selection of Elvis Costello's greatest hits. Noel took an instant and enthusiastic liking to Elvis Costello. When I broke up with Noel a few months later, I was overwhelmed by the thought that if I couldn't make it work with a nice guy like him, I must be destined to die alone. At the end of our relationship, Noel got Elvis Costello, and I got a guilt complex for breaking up with such a genuinely good guy. It's a little bit illogical, but it hurt to see Elvis newly added to his favorite-artists list on Facebook. Elvis is *mine*. Knowing Noel might be out there somewhere consoling himself with my favorite breakup songs made me feel violated. Thousands of people probably use Elvis Costello songs for that sort of comfort, but it was unsettling to think someone might be listening to the really pissed-off or really sad Elvis songs and thinking about me. Once a song or artist becomes wrapped up in the experiences you had with someone else, it is not just yours anymore.

Introducing Noel to my favorite Elvis Costello songs was probably the most intimate interaction we had, but he had no idea, because music didn't mean as much to him as it did to me. I spent a lot of time thinking about what it means to share your music with someone when you're in a relationship, and it dawned on me: This is why guys are always bitching about their girlfriends' not knowing anything about music. It really hurts to give someone music that means a lot to you and have them react with lukewarm acceptance. It hurts more to realize you don't like someone anymore, but they've taken a shine to your favorite records. When guys make us mix tapes and play us songs, they aren't just showing off. They're trying to tell us some truth about themselves through the sounds and words of an intermediary. This realization has made

me appreciate all the mix tapes I've ever received all the more. It's worth noting that the meaning and feeling put into those mixes can lead to some prime possibilities for an Our Song, though I should warn you that attempting to sow the seed for an Our Song via mix tape can go awry. Sometimes it doesn't take. The worst is when you pick something he doesn't like. The second-worst is when you pick something that was already an Our Song for him with someone else, because he may feel compelled to tell you all about it.

There is one other time in life where the need for a My Song arises: your funeral. Is it morbid to plan what songs will be played at your own funeral? Absolutely. Do I think it would be worse to die and have my parents (or more terrifying, my sweet grandmother who loves church hymns) pick out songs for my funeral? Double absolutely. I love the scene in *High Fidelity* when Rob talks about his top-five funeral songs and says he had always dreamed some mysterious, beautiful woman would come to his funeral and tearfully demand that Gladys Knight's "You're the Best Thing That Ever Happened to Me" be played. It's a great illustration of the point of divergence between a Your Song and a My Song — he wants a beautiful woman to associate him with that Gladys song, but for himself he chooses Bob Marley's "One Love," Jimmy Cliff's "Many Rivers to Cross," and Aretha Franklin's "Angel" — all much more somber in tone, and a reflection on his (fictional) life. The funeral is pretty much your last chance to express any commentary on your life, unless you believe in the afterlife and are planning to stick around to haunt people. (I hope for revenge.) If this

is your final say, you should probably plan ahead and get the message right.

When I was in the ninth grade a kid in my class died in a car accident. At his funeral the Eric Clapton song "Tears in Heaven" was played by his parents, which makes perfect sense, because Clapton wrote it about the death of his own young son. It was a tearjerker that perfectly expressed his parents' grief but said nothing at all about him. I've never forgotten it and always thought it was exactly what I don't want to happen at my funeral. I really cannot bear the thought of a church full of people crying about my untimely demise while a song I don't even like plays in the background. If everyone is going to cry, it might as well be because of a song that meant something to me, right?

I've given it some serious thought, and at my funeral I would prefer that the following songs be played:

1. SPIRITUALIZED, "Ladies and Gentlemen We Are Floating in Space"

This song speaks for itself. The idea that all we want in life, as we float around on this rock in outer space, is love is a fairly complete summation of the human experience. In fact, this song should probably be mandatory at everyone's funeral. It is my own little way of saying I love you one last time after the ultimate breakup.

2. PJ HARVEY, "Good Fortune"

I lived in New York during the September 11th attacks on the World Trade Center. I don't like to talk about it, mainly because I don't know what to say. It was unfathomable. And absurd. What happened then, how my friends and I acted and lived and carried

on with our day-to-day lives, is beyond anything I could express in words. *Stories from the City, Stories from the Sea,* the PJ Harvey album, which came out in 2000, got a lot of play for the rest of that year and into 2002 on my Walkman. It went with me pretty much everywhere, because it embodied the feeling of angst that came with being in New York City at the time, and it simply and accurately suited the way it felt to live there, both before and after the attacks. PJ Harvey wrote the songs while living in New York and having a love affair, and the way she talked about it tapped into this universal feeling that described not just my life but the lives of everyone I knew. All my friends had a copy of this album and loved it. They will know exactly why I picked this song and will immediately reflect on that very particular point in our lives and our shared experiences.

3. ÉDITH PIAF, "Non, je ne regrette rien"

I think all us hope that at the end our lives, when we take stock of all we've done or left undone, we'll have no regrets. For most people, that's unlikely. I can think of dozens of things I've done or decisions I've made that, given the chance, I might do differently. For example, I often suspect that if, as a child, I had stuck with ballet and tap lessons instead of changing to piano lessons, I could have been a world-class dancer. It is highly unlikely, as I'm well known to be the sort of woman who trips simply walking down the street in a pair of ballet slipper flats, but in my imagination it's the road not taken down which I could be graceful and much, much thinner. But, as it is, those piano lessons made me more of a music nerd and I ended up here, so *non, je ne regrette rien* all the scabs on my knees or the bottles of wine that put them there.

4. ROD STEWART, "Young Turks"*

I may change my mind about this one. I find myself weirdly obsessed with this song, and I can't help thinking it would break up the tension of a funeral with its bizarrely upbeat, new-wave–esque sound. And, of course, Rod Stewart is an unexpected choice. I have to think there are very few people who think any Rod Stewart songs are appropriate for their funeral. I happen to be one of them, but I can't think of a way where "Maggie May," which I have always unironically loved, is at all appropriate. Instead, my funeral party of young Turks will find themselves admonished to be free tonight.

In some situations you can control and program what becomes Your Song or an Our Song. As with the funeral song, you have to take control of that situation for the sake of posterity. But sometimes songs can take on a life of their own. As often as I feel tempted to try and slip songs into the background to see if people pick up on them, it doesn't feel nearly as satisfying as when the universe anoints someone with a song. At the same time, there's also something satisfying about making an Our Song happen. I mean, what's the point of knowing so much about music and loving so many songs if you can't drop them like little emotional bombs in peoples' lives?

* It was difficult not to include a multitude of inappropriate song choices that I think would crack my friends up, like Nouvelle Vague's cover of "Bela Lugosi's Dead" or Johnny Paycheck's "Take This Job and Shove It." You can't take the irony out of a Gen Xer, I suppose, even in death.

OUR SONG, YOUR SONG, MY SONG PLAYLIST

MERCURY REV, "Car Wash Hair"

THE MOODY BLUES, "Knights in White Satin"

U2, "All I Want Is You"

PEARL JAM, "Better Man"

SIMON & GARFUNKEL, "Cecilia"

PHIL COLLINS, "Against All Odds"

ELVIS COSTELLO, "Lipstick Vogue"

ELVIS COSTELLO, "Everyday I Write the Book"

ERIC CLAPTON, "Tears in Heaven"

SPIRITUALIZED, "Ladies and Gentlemen We Are Floating
 in Space"

PJ HARVEY, "Good Fortune"

ÉDITH PIAF, "Non, je ne regrette rien"

ROD STEWART, "Young Turks"

THE DEATH OF THE RECORD COLLECTOR

THERE'S AN IMPORTANT distinction to be made between people who collect records and record collectors. The former are well adjusted and include people like you and me with our haphazard directories of MP3s downloaded on impulse, stacks of CDs we bought in college that we now kind of regret but hold on to for the memories, and crates of vinyl that we picked up along with those really cute bangle bracelets at a flea market — all in addition to the bits of our record collection that we bought with purpose. The latter, on the other hand, carefully weigh each record purchase, hunting for the perfect albums to round out their deliberately crafted collection, which they will play only rarely, so as not to risk damaging them. The former will expect you to look through their records the first time you go back to their place. The latter won't even let you touch the sleeves of their records with your bare hands. I'm kidding . . . sort of.

Very few of us are true record collectors. Those people are one step away from hoarders in their slavish devotion to finding and buying music. Their format of choice is vinyl, especially of the obscure 78-rpm variety that was from the original label's limited pressing, was made valuable by mistakes in the pressing, or

includes rare deleted tracks. Their adherence to the rules of collecting is off-putting — like the irrational need to collect every Chess Records original single and organize them in order of release number, not because they love and plan to listen to the records, but simply to possess them. Most of us just build a collection of what we like. The real record collector looks with disdain on the randomness of our "collections."

But the way we listen to music is evolving, and the rules are changing for everyone. Rarities are released as promotional MP3s, so an import-only B side that you previously would've hunted down for weeks is now given away for free for a limited time. As record labels begin clearing their back catalog and making everything available for purchase on the Internet, the idea of music as rare or unavailable has become a thing of the past. You can still dig through the stacks at your local record store, but know that someone else is one-click-buying it online. Record collecting by today's standards might entail buying every release from little pockets of artists you're fanatical about and only downloading random tracks from everyone else. It could mean you keep that embarrassing New Kids on the Block cassette tape from 1989. It certainly means that there is a diversity to your music that only makes sense to you. All the reasons you have for including music in your collection, especially the very embarrassingly bad records, are incredibly personal. That is the modus operandi of a music lover. If I asked a record collector to show me his albums, he would take me to a cabinet with his prized records impeccably stored. Assuming you aren't a record-collecting purist, what would you show me? Shelves of CDs? Your iTunes? A milk crate of vinyl? All of these? It isn't just the formats of available music that have

changed — everything about the way we listen to and consume music has changed as well.

Over the last few years there has been a movement among my friends and colleagues to digitize their CD collections and get rid of the physical CDs. Many of them live in cramped apartments in cities where space is at a premium. And some of them are so attached to their iPods and laptops that these have become the device of choice for playing music. I don't have a problem with embracing the *Star Trek*–like future where everything you want, from music to books to magazines, is on a shiny hard drive instead of collecting dust on your shelves. In fact, I'm actually quite partial to it.

However, a fairly equal share of people I know feel very adamantly that you don't truly own an album unless you possess a physical copy. Digital is too transitory and doesn't count, in their opinion. Some of these people have valid (and nerdy) reasons for their point of view, like concerns about the audio quality of MP3s or fear of a simultaneous hard drive and external backup drive crash that would result in the catastrophic loss of their entire music library. I used to assume this was the sort of worst-case-scenario hypothetical that could never happen to me (or anyone for that matter). It made it hard to take the idea of actually losing all my digital music seriously. And then, mere minutes after I finished my first draft of this book and celebrated with a glass of wine, catastrophe struck. I knocked the wine onto my computer, destroying the hard drive.

Lucky I had saved the book draft onto my external hard drive

just before the liquid disaster occurred, and while I was doing that, I thought to myself, "It's been about six months since I backed up my music. I should do that tomorrow." I didn't lose everything, not even the majority of what I owned, but I lost everything I'd bought or downloaded from blogs over the last six months. This was only a small portion of my music, but I felt totally lost. Songs I wanted, songs I'd been listening to lately because I'd just gotten them were gone. I was able to rip some songs from my iPod back onto my hard drive, but for months I kept discovering at the most inopportune times that random tracks and albums had gone missing. It was a solid six more months before I felt like my digital record collection was back to normal. The loss of my entire collection would be an event so extremely devastating that I don't know how I would recover.

That concern aside, the reason some of you continue to buy physical albums is because having the actual album in your hands that makes you feel secure, because you are traditionalists. The record collector asks, "If someone comes over to your house and can't browse through the shelves of albums you've bought in your lifetime, how could he possibly appreciate the time and money you've put into collecting music?" And for some, there is joy to be found in organizing and reorganizing your records according to your own systems. But that thinking is antiquated. The first thing I do when I want to get to know someone is scan their iPod. It gives me an instant, if not necessarily complete, idea of the music that's important enough to them that they must have it with them at all times. This is the music that really matters to them, not the music they've arbitrarily collected, and it's the music that's more important to me in learning about them.

Even as our shelves of records languish in favor of our hard drives, the things we love still function as shorthand for describing ourselves, particularly in various online social media profiles. Anyone can look at my last.fm profile to find out what I'm listening to. Or my Goodreads profile to find what books have lived on my bookshelf at some time, even after I've disposed of the physical book. They can friend me on Netflix to get an idea of what movies and TV shows I like. They can friend me on Facebook or subscribe to my Twitter feed to see the thoughts and ramblings I want to broadcast, which are often pop-culture related and convey my likes and dislikes.

I no longer have to wait to be invited over to someone's house to see their record collection. I hardly even have to wait until we're closely acquainted to connect with them and snoop into their life. This is true even in the realm of dating. I made a profile on the music-dating site Tastebuds, which required little more than giving the site access to my last.fm profile to get started. It populated a list of my favorite artists, based on what I've listened to most. I can go back and fill in the blanks or not. This list is enough for the boys who are a little too into their records and are interested in a girl who is as well. Before I've even met these guys, they're judging me, and I them, based on the music we say we like. In certain cases (like if he loves the Smiths), it saves us the bother of an inevitably disappointing relationship.

For a long time, I was among those who believed that an album didn't count in my collection unless I owned a physical copy. This was an appropriate stance to take while working at a job where I got a huge number of albums for free, though there were always plenty that I'd buy from very small labels or self-released

from New York bands. It was easy to hold on to everything when the biggest move my record collection made was from Queens to Brooklyn. My attitude began to change when I was facing a cross-country move from New York to Los Angeles. My CD collection then numbered around a thousand. This became the limit of what I could manageably store in my small NYC apartment, and moving it, along with all my other stuff, was not going to be fun. To make it easier — and lighter — I moved all of my albums out of jewel cases and into individual plastic folding CD sleeves. At that point, I also decided to rip all my music onto my hard drive. All this was a time-consuming pain in the ass, and as I sifted through album after album, I realized I hadn't pulled the majority of them off the shelf in years. I tend to listen to the new stuff and a group of core albums repeatedly (of course including Elvis Costello, whose albums I would never get rid of on any format).

Why did I need to keep ten boxes of CDs, when, in the years since I'd moved, I haven't been able to find a shelf I like enough to store them on and rarely ever look at them? It's no joke: my CD collection has been neatly packed in boxes for more than two years now. I don't even own a CD player, other than the one in my computer, and I haven't for years. Still, the idea of giving away all my albums makes me uncomfortable. They've been with me all this time, and I like knowing that they're there for me if I want them. It's a function of developing an attachment to your physical belongings, I suppose. It does happen, now and then, that I'll realize I've deleted something from my iTunes that I thought I wouldn't listen to again, and I have to dig out the CD. I especially appreciate their existence when it's something hard to find, like the Old 97's and Funland split EP they cover each other's songs on.

It might be on Amazon or it might not. I'm not even sure whether the Dallas record label that put it out is still in business, but when I'm inclined to take a little mental trip back to the late 1990s to listen to what everyone I was friends with in Dallas held precious, the Old 97's cover of Funland's "Garage Sale" is the thing I want to hear. If I discover it's fallen off my iTunes, I'm happy to go on a box-diving adventure and dig it out.

Our collective dependence on the Internet has increased in recent years — even my luddite grandmother joined Facebook. So it's no surprise that the MP3 has become an increasingly valid and popular form for collecting music. Digital album sales have grown fast and furiously, hitting a high in 2009 and accounting for 40 percent of all music purchases. So what sort of person is collecting digital music? Almost everyone — with the exception of the curmudgeon-audiophile holdouts and those who are scared of computers. While I was visiting my family over the summer, my stepdad asked me to help him rip his CDs onto an old iPod I gave him. He had been trying to do it himself, but somehow kept importing CDs without any metadata, so all the albums and tracks were unnamed. I fixed his settings, and when things were working correctly, he immediately stopped making himself mix CDs and started making playlists. He's not going to start buying tracks on iTunes anytime soon, but at 57 he took the first step into the digital landscape.

While there may be a generational divide between those who do and do not buy digital music, there doesn't seem to be a divide between the sexes. More than any other factor, it comes down to whether you're a pragmatist or a nostalgist. Some people are unable to let go of the idea of the album as a physical object. The

ritual of going to a record store to buy CDs; the packaging, from the artwork to the liner notes; the smell when you open a record for the first time — for some people, it's an experience that's not so different from sexual fetishism. Studies have shown that music has an effect on people not unlike the effects of sex or food or money, causing euphoria and craving. When you listen to music, the brain releases dopamine at your peak emotional arousal, which is a sci-ence-y way of saying that listening to music gives your brain a lit-tle chemical reward of pleasure that can manipulate your feelings. And like people who enhance their sexual euphoria with a little kink, some people get more musical pleasure from the obscure and the rare. The fetish aspect makes the act that much more gratifying.

Luckily for the fetishists among us, a format whose popularity unexpectedly rose starting in 2005 is vinyl. So they can have their cake and get a spanking too. In 2011, Nielson SoundScan reported that vinyl sales broke existing records for the format in the history of SoundScan sales tracking (which isn't really saying too much since sales records only go back to 1991). In 1977, when Fleetwood Mac was selling two million copies of *Rumours* in the first week, and vinyl was the dominant music format, more vinyl records were purchased than are even available today. Still, in 2009, vinyl re-cords saw the most growth of any segment of music sales, and by Record Store Day in the spring of 2011, they had already bested sales for all of 2010.

Considering the power of this resurgence, it's worth looking at how the experience of listening to music is different on vinyl. I cued up Vampire Weekend's *Contra*, album two of *The Beatles* (aka the White Album), and Elvis Costello's *My Aim Is True* to put

my finger on what makes listening to vinyl so special. The first thing I wanted to do after dropping the needle on the Vampire Weekend album is put on headphones. I could be hooked into the biggest, best sound system in the world, and I'd still want to pop on headphones to listen to vinyl. It comes from an instinctual desire to make listening an intimate experience. Putting on a vinyl album feels personal, not like blasting a CD so all the neighbors can hear.

My copy of the Vampire Weekend album is brand new, never played by me or anyone, but it crackles in my headphones like I've had it since 1979. This is the warmth people describe when they talk about listening to vinyl. It makes a new album sound like a worn-in old friend. I realize two songs into Vampire Weekend that I need to go to the bathroom, but it's so inconvenient to pause an album on this record player that I decide it will be easier to wait until side A plays out and then take a break before flipping to side B. It's weird to listen to something released so recently on vinyl, because it was not mastered to be played on that format, so the point is moot. But people do it; five of the ten top-selling vinyl albums of 2010 were released in the previous two years. The other half of the top ten were released before 1985 — mostly in the 1960s.

So I head back to a piece of vinyl from a 1960s band to compare. My copy of *The Beatles* (the White Album) is a significantly older, original-issue copy from my parents' record collection and not one of the remastered re-releases. It was warped when they bought it (the unlucky result of not inspecting the vinyl for lumps and scratches before purchase) but has been played by my parents that way for years. So it makes a little funky noise here and there that doesn't belong but that makes it distinctly the album I've been

listening to since childhood. Even a bumpy version of the White Album feels better than the vague emptiness of listening to a digital transfer of the album to CD. The crackles on my album add something to the songs, and they feel sanitized when you strip them away. I always imagine that I'm listening to the album in the way the Beatles and producer George Martin expected I would, and I like the way "Revolution 9" sounds on vinyl.

Finally I put on *My Aim Is True*, an album I know from side A to side B. I browse my Twitter feed for news while listening to the album, headphones still on, and immediately have to fight off the impulse to pause the music to watch YouTube movie trailers, listen to another song that sounds interesting, or watch a collection of video clips that mash up Cee-Lo's "Fuck You" with movie scenes. Going back to vinyl makes me realize how often I become utterly distracted when I listen to albums on my computer. It's so easy to stop a digital album at any point, and because I'm a real multitasker when I'm in front of my laptop, I'm easily pulled away from the music by one of the other five things I'm working on. I hadn't thought of this behavior as disruptive, but I'm beginning to doubt that I've listened to more than handful of full albums straight through since 2004. When I listen to vinyl, I want to go full analog and feel tethered to one experience at a time. I feel like I should step away from the computer, close my eyes, and focus on the music. I become singular in focus and zen in execution, because hopping on my laptop and doing fifty different things doesn't fit the experience. The format forces me to be more reverential about listening to music. I'm also less likely to obsessively listen to a song I love on repeat (yes, I mean you, "Alison") when I'm playing vinyl, because it's a hassle to reset the needle, and I'm

frankly more than a little scared of scratching the hell out of this beloved record. Instead I let the album play out and end up hearing it as Elvis Costello intended, instead of dictating my own experience. For him I am willing to do that. For artists I'm less attached to, that willingness fades. I find I'm more than happy to tinker with the experience I have with their music and make it suit my whims.

Just as there's a tactile heft to getting out a piece of vinyl and playing it, there's a superfluousness to downloading MP3s from blogs to sample a few songs before you buy an album — mostly because they're free and thus have less value. There are few albums that I know front to back these days, but I have countless beloved singles that I obsessively listen to on repeat and build playlists around. The singles culture has been promoted by digital music, playlisting, and the iPod's shuffle function. *Billboard* magazine found this to be true, reporting that in 2009 only twelve albums sold more than one million copies. In 2006, thirty-five albums reached that benchmark. As we become more culturally accepting of digital goods, it gets harder for us to have a universal cultural experience with an album. When the Eagles released the *Greatest Hits* album, they sold twenty-nine million units — one in every three people owned a copy. These days an album can be a financial success without reaching the million-copy mark if one of the singles sells fourteen million copies.

Equally interesting to me is the breakdown of the top-selling artists in digital vs. vinyl. The ten best-selling artists in digital music for 2009 included Lady Gaga, the Black Eyed Peas, Michael Jackson, and Taylor Swift. The only overlap with the ten top-selling vinyl artists that year is Michael Jackson. That list is instead filled with artists like Radiohead, Bob Dylan, and Animal

Collective — the kind of things that serious music heads buy but the masses are not so apt to pick up. What sells on vinyl makes it very clear who owns record players, and it's not your twelve-year-old cousin. And the absence of the hottest top-forty artists on this list makes sense. What would be the point of owning a Lady Gaga album on vinyl? It is produced specifically to sound best playing from a digital source on the radio or on your iPod. It isn't meant to be more immediate or personal, and it's difficult to imagine having a warmer, more intimate experience with Gaga's albums. This music is not suited to a turntable. It's the stuff of arenas and your computer speakers.

Because of artists like Lady Gaga, there's an increasing number of singles I can't see the point of owning as part of an album. The songs' production shows no real consideration for the album as a thoughtfully crafted musical experience. There are some notable exceptions, but most albums (and I'd go as far as saying this applies to nearly all albums released before 1964 and after 2004) are collections of singles with a smattering of throwaway songs in between. The last time I heard an album truly take advantage of the CD format was the self-titled first release by Owen.

This is an album that's probably owned by fewer than 10,000 people, the majority of whom live in Chicago. It is the work of Mike Kinsella of Cap'n Jazz, American Football, and Joan of Arc fame. Owen is his bafflingly named solo project, and his initial album came out in 2001. It was recorded in Kinsella's old bedroom in his mother's house, suggesting he had a certain intimacy in mind in creating it. I can't imagine listening to it with another person. The way he produced it, each song bleeds into the next with rhythmic patterns and lyrical moments that holler back at

something you heard in the last song or even five songs ago. After all these years I still have no idea which lyrics go with which song title. This is remarkable, because I live to memorize that sort of useless information. An album like *Owen* fully takes advantage of the full-length-playing digital-recording process that was promised with the advent of the CD.

In 2009 digital track sales broke the one billion mark for the second year in a row. People want to buy individual tracks, especially from bands whose music they consider disposable. As far as I can ascertain, most bands package together a series of songs that may or may not have a common thread (or as musicians with artistic aspirations like to call them, a "concept album") and call it a work of art. If the growing number of digital downloads of singles is any indication, then I'm not the only person who is highly suspicious of the idea that the consumer is expected to buy an artist's full album and hope it isn't 75 percent filler with a few hit singles. That is not to say that there haven't been albums I've enjoyed from front to back since *Owen*, but the ease of skipping around on digital recordings has encouraged my habit of being a person who knows her favorite songs and readily jumps to them for repeat listens.

In the end, nothing will stop our progress toward a digital culture. It is so much more convenient, and the loveliness of getting rid of your clutter cannot be overstated. Plus, the number of people who are downloading without buying is swelling. Whether you're paying or not, it's a whole lot easier to get music from your living room. In some respects it's a shame: Everyone should have the opportunity to listen to the epic albums from the '60s and '70s in the way they were meant to be heard, with that special something that

comes in the flip from side A to side B that was incorporated into the way they were sequenced. Or to hear CDs that are mastered specifically for that format without the three-second break iTunes wants to insert between tracks. Or to appreciate the superior audio quality of both vinyl and CDs over MP3s played through your crappy built-in computer speakers. But I suppose it's time to get rid of the boxes of CDs that are three deep on the floor in my walk-in closets and replace them with a few external hard drives. I'd like to tell you I'll miss those albums, but with a few exceptions, I'd be lying.

THE DEATH OF THE RECORD COLLECTOR PLAYLIST

MUDDY WATERS, "Got My Mojo Workin'"

NEW KIDS ON THE BLOCK, "The Right Stuff"

ALEXANDER COURAGE, "Where No Man Has Gone
Before (Theme from *Star Trek*)"

THE SMITHS, "This Charming Man"

OLD 97'S, "Garage Sale"

FLEETWOOD MAC, "Second Hand News"

VAMPIRE WEEKEND, "Diplomat's Son"

THE BEATLES, "Revolution 9"

CEE-LO GREEN, "Fuck You"

ELVIS COSTELLO, "Alison"

THE EAGLES, "One of These Nights"

MICHAEL JACKSON, "Billie Jean"

RADIOHEAD, "15 Steps"

LADY GAGA, "Poker Face"

OWEN, "Declaration of Incompetence"

INTERLUDE

adventures in second life

I FIRST HEARD about Second Life from my friend Gina. She told me she was thinking of opening a virtual pet store to get away from the stress of her real life. I had no idea what she was talking about, so I turned to Google. The first hit was a seemingly preposterous story about a woman who earned a six-figure salary in real money selling virtual real estate. There were also a few stories of people (most of them British) who divorced their spouses over love affairs between two avatars. This was clearly the wild west for computer nerds and the socially awkward. I mean, I was into chat rooms in the 1990s, but this was like a chat room on steroids.

If you're not already familiar, Second Life is an online virtual world where users interact with each other via avatars. They play games, buy and sell virtual products, and build things. From Japanese shopping malls and laundries to underworld sex dungeons and vivid recreations of Tim Burton movies, users draw on their own experiences and imagination to create whatever sort of world they want. By 2010, the virtual land created was reported to equal the size of the actual Rhode Island.

In 2007 MTV launched some virtual worlds of their own, and

I was put in charge of music programming for one called the virtual Lower East Side. This 3D world would recreate a four-block radius of the Lower East Side of Manhattan with clubs you could duck into and watch music videos, digital clothes you could buy from American Apparel, and mean streets to walk in a permanent twilight. I needed to learn more about virtual worlds, so I created a Second Life avatar named Astrud Sands. I immediately began virtually shopping and visiting places like Morocco and 1920s Paris, where I could walk around as though I were a tourist on vacation and take pictures of my avatar to be e-mailed as postcards.

Let's pause for a minute before you judge. You or someone you know probably spent real money today on something virtual to use on Farmville, Mafia Wars, or Sorority Row on Facebook. And it was probably nowhere near as cute as the outfit I bought to visit virtual Casablanca in Second Life. Exploring SL was fun but lonely, because most of the places I visited were empty. In the hunt for actual life forms, I found that the most popular activities seemed to be role-playing (steampunk, vampires, and urban death matches in the spirit of *Fight Club* were the most popular), shopping hunts where you went to a series of stores to get the next free item and ended up with a lot of ugly free stuff, and dance parties at European-style techno clubs.

I started visiting virtual music clubs to see what people listened to and got deep into research for my job. Based on the number of times I heard them played in SL, Buckcherry's "Crazy Bitch" and Hinder's "Lips of an Angel" were the two biggest songs of the year. This, coupled with the crazy European techno I stumbled upon at every turn, disappointed me.

This place seemed full of people who liked music I wasn't interested in. But then someone told me about a place called Umbra Penumbra.

Umbra was the first indie rock–themed place in SL that I came across. Umbra was known for its re-creation of the famous mural from the cover of Elliott Smith's *Figure 8,* surrounded by a decor of urban grime and graffiti. The main attraction was the dance club, where DJs played every night. The avatars who DJed there played some really great indie rock. Everyone dressed like a hipster, some with more than just a nod to goth, but all with sophisticated avatars decked out in studded leather bracelets, hoodies, and skinny jeans. I started spending most of my time there, and soon I found a whole world of indie clubs, including the Doublewide (a white-trash trailer park for rockabilly and alt-country fans) and the Velvet (for snobs who liked indie rock and rarely acknowledged n00bs). Once I discovered these places, the whole secret kingdom of indie rock in Second Life threw open its doors for me. It reminded me of late-night underground clubs in New York, where you have to be pretty damn in-the-know to figure out they exist and then you have to become a regular to find out when something new is happening. The indie kids in Second Life really make you work for it, which is so indie rock of them.

Some would characterize Second Life as a place for losers who spend all their time online and can't get laid. However, a 2009 Harris Poll found that adults aged twenty-five to forty-nine are spending seventeen to eighteen hours a week on the Internet, so let's not pretend we aren't all spending a large portion of our time at home in front of the computer not getting

laid. Sure, there are a lot of stereotypical gamers in the SL community, but it's great for record collectors, too.

I read music blogs to stay current and download the free tracks that sound interesting. I do this alone in front of my laptop. Finding new music these days can be a very lonely endeavor, but this wasn't always the case. Just look at the popular representation of teenagers and music over the last half century. Back in the (allegedly) good old days, *The Honeymooners* would gather around their radio to listen to the new Elvis Presley song or around their TVs to watch the Beatles on *Ed Sullivan*. By the '70s, teenagers were inviting their friends over to listen to the new Bay City Rollers vinyl (or Kiss, depending on how you rolled) and smoke pot. In movies in the '80s and '90s you could find kids hanging out in record stores,* but there were also plenty of kids sitting at home alone, calling in requests and dedications to their local radio DJs.† By the time Napster came along in the late '90s, the image of a teenager finding music was best represented by a lone figure sitting in her dorm room in front of a computer screen with university broadband.

Digital availability has turned many of us into gluttonous collectors with no discretion, so actually listening to and curating all the music we find is a time-consuming affair. I often find myself with a boatload of new music and nothing to do with it. At this point it should be apparent to you that I didn't quit Second Life when my research was complete. No, I am only marginally embarrassed to admit that Astrud Sands got totally sucked in and

* See: *Pretty in Pink, Empire Records.*
† A young, attractive Christian Slater heavily inspired this; see *Heathers* and *Pump Up the Volume.*

stayed. I stayed long enough to become an indie-rock DJ in SL. Suddenly I had somewhere to play all this music I'd been collecting for no reason. I stayed long enough to start several fights about Beatles vs. Stones during the course of conducting research for this book. At one point if my avatar walked into an indie club, the DJ would immediately put on a Beatles or Stones song, and the debate would commence. I earned the nickname the Professor, due to the little lectures and random nuggets of information I couldn't help dropping during my DJ sets. The best part has been having a place to talk to other people about music. For me, SL is like a music blog and social-networking site all mushed together with the option for totally cute digital outfits.

ROCK 'N' ROLL CONSORTS

IF YOU CHOOSE to be with a rock star, you're either a groupie or a wife. "Wife" is a broad phrase that includes all forms of committed relationships, since rock stars are not necessarily inclined to do such pedestrian things as enter into a legal union with their partner. For this discussion, "girlfriend" and "wife" are interchangeable terms, though it should be noted that neither one implies monogamy unless this is specifically brokered when you set the terms of involvement. Even then, you're likely to be disappointed. "Groupie" is the random girl in Topeka or Columbus or L.A. that a rock star sleeps with on tour. It used to be that groupies were exalted figures, known for their sexual prowess. These days they're anyone who isn't the wife or girlfriend. If you live in his house and are typically not invited on tour: wife. If you only see him when he's on tour: groupie. If a rock star has his manager call you in case of an emergency: wife. If he makes you mix tapes that start with the Velvet Underground's "Femme Fatale": groupie.

It's probably your natural inclination to be one or the other. As is probably obvious, I'm not so supportive of the groupie scene. In fact, when I finished reading *I'm with the Band*, a memoir by the ultimate groupie, Pamela Des Barres, I felt as though I had just banged my head repeatedly against a brick wall. It's not because of all the shocking sex with all the outrageous rock stars. That was

hardly surprising. It's the way she talks about the men she's chased. Every crush becomes an imagined fairy tale in which she is a princess in need of rescue at the hands of some big, rich guitar god. She details going out of her way to please them, as if their happiness is more important than her own. She worships the ground these rock stars drag their amps across and devalues herself so completely that she doesn't set any boundaries, emotional or physical. A series of men including Jimmy Page, Mick Jagger, Keith Moon, Chris Hillman (bassist for the Flying Burrito Brothers), Noel Redding (bassist for Jimi Hendrix), and Waylon Jennings all screw Pamela. Physically and mentally. And she doesn't just let them, she chases them down and practically begs for it. After most of her encounters, Des Barres writes of feelings of loneliness, of being unable to pay her bills, of despondent crying, of promises of visits and plane tickets that are rarely kept. She starts chasing rock stars before she turns eighteen and by the time she reaches the ripe old age of twenty-five, a new pack of groupies are on the scene, stealing her men and calling her an old lady. While it's laughable to be called old at twenty-five, they're right. Once you hit twenty-five, you're too old to put up with the bullshit rock stars dish out.

I can't wrap my brain around why she spent so much time throwing herself at men who are clearly interested only in using her — for sex, for inspiration, for distraction, for sport. How is it possibly fulfilling to be the proverbial extra baggage and, even worse, to get into the middle of other people's relationships, playing the role of late-night entertainment when the wife isn't around? Most of the time she isn't even the mistress, just the sad little one-night stand with about as much meaning as a slice of cheesecake. I wanted better for Pamela Des Barres. I wanted to show the 1960s

version of her how to take charge of these aimless relationships that break her heart. I've since learned that you should be careful what you wish for. Dating a rock star never turns out how you imagine it should because they're one big ball of ego and unexpected secrets.

HOW IT STARTED

I met a guy who happened to be in a band. A mutual friend posted to our Facebook walls that we were soul mates. When I told our friend that I don't believe in soul mates, she replied, "Neither does he! See how perfect you are for each other?" This is the sort of infallible logic girls use on each other, and it almost always works. I tried to restrain myself from initiating contact, but that's an impossible task when someone has been deemed your soul mate. The curiosity absolutely ate at me. I caved and messaged this Soul Mate to find out what he was all about. We talked about our matchmaking friend and the books we liked. We spent a lot of time comparing what we wanted to read, whose writing we liked, and what each of us recommended for the other. We didn't overtly flirt. We twinkled at each other from behind our book stacks. We lived thousands of miles away from each other on opposite coasts, so we started making plans to hang out at the South by Southwest (SXSW) music conference in Austin that we would both be attending in a few months.

WARNING SIGN: ROCK STARS WHO CARE ABOUT YOUR BRAINS

When Marianne Faithfull first slept with Mick Jagger, she was still married and had a very young son, but that situation didn't suit her at all. She'd been hanging out with the Stones because they

shared a connection through manager Andrew Loog Oldham, and for over a year, she had been deflecting Jagger's advances. Oldham was the man who famously locked Jagger and Keith Richards in a room, refusing to let them out until they wrote a song. The result, "As Tears Go By," was too sappy for the Stones at the time, so Oldham gave it to Faithfull. It became her first hit single.

As the story goes, Faithfull went to watch the Stones at a show where Ike & Tina Turner opened. At the end of the night, a roadie drove off in her Mustang, so she, along with some others, stayed at the hotel. After an evening of drugs and a Roman Polanski film (a harrowing combination) people began leaving the room in pairs, until it came down to Jagger, Faithfull, and an Ikette (one of the Ike & Tina background singers) waiting it out to see who'd stay the night. It was like a game of sexual chicken. Faithfull claims she didn't give up and leave because she was too stoned to move, which is possible, but more likely it's just a coy retelling of events on her part. Eventually the Ikette realized it was not going to happen for her, and she took off. Jagger and Faithfull started chatting and went for a walk as the sun rose. Yes, this face-off took so long that by the time they were left alone, the sun was coming up. She tried to get to know him before they hooked up and asked him a series of questions about the King Arthur fable and where he thinks the Holy Grail is. According to her account, he gamely answered all the questions and then asked her, "Am I going to pass my A-levels, Marianne? What do you think?"

Charming, right? I am a sucker for verbal sparring. Faithfull tried the same thing with Keith Richards, with whom she later had an acid-trip sex romp after her adventure with Jagger. Richards

asked her if she was still tripping on acid and then went right back to the seduction. He had sex with the girl his mate Jagger fancied, and at the end of their night together, he told Faithfull that she shouldn't pursue him because Jagger was into her. Straight and to the point. Faithfull wasn't up for chasing after Richards then, so instead she coupled with Jagger and began a four-year relationship that led her straight into the comforting arms of a heroin addiction for which no one ever suggested she seek help. Even the guy you don't know you want can win you over if he's got any sort of charisma, because by her own account Faithfull was madly in love with Jagger in no time flat.

Your average rock star is romantically hapless. He won't try to engage you with a conversation about your collection of books or the history of King Arthur. Not once did that happen backstage at a Mötley Crüe concert, as *The Dirt* (the legendary story of the disgusting and amazing inner workings of the Crüe) reveals. We certainly never hear Tommy Lee wax about being in love with Pamela Anderson's mind. In fact, other than Pamela, I don't think any of the women mentioned in *The Dirt* even have names, let alone brains. Most rock stars are about flat-out seduction via the music and then getting busy in a Burger King bathroom. Or at the local Hilton. Or in your roommate's bed. Rock stars like Jagger, who could pass the A-levels and literally charm the pants off you, are the guys who will do your head in. They make you feel special. But then, on tour, they're banging Pamela Des Barres. When you find out, they will write you an unbearably romantic song to suck you back in. The rock stars who are excited about your intellect are inevitably the ones who will turn up into down, confusing the

issue until you don't know who you are or where you stand with them. At least Mötley Crüe was honest about why you got a backstage pass.

The Soul Mate and I met in person in Austin at the hedonist spring break for the music industry that is SXSW, where people party as if they were the rock stars they work with and stay drunk all day every day for a week. His band played an insane — but not out of the ordinary — ten shows in five days, so his free time was at a premium. After months of back-and-forth messages, we were both overflowing with excitement to meet one another, but we were also nervous and awkward. Our first night together was an intimate evening . . . that we shared with fifteen other people, including his entire band. We all went to grab drinks and check out a weirdly awesome Asian pop band. We stared at each other from across the room for a while. I waited him out; my one truly girly move is to make the men come to me. It seemed fair that he should make the first move and start our awkward first-meeting conversation. As we chatted, we shifted back and forth on our toes and looked around the room — anywhere but at one another. Two drinks later we were in a knock-down, drag-out battle of wits over Gertrude Stein. I'm the kind of girl who usually gets bored with guys after six months, but he was the kind of guy I could imagine talking to forever.

By the end of SXSW we still hadn't managed to spend time together without a cast of dozens getting in the way. Apparently even marginal rock stars can't travel without an entourage. We planned

to have a coffee the last morning we were in town. I got up early — no small feat considering how late I had been out drinking the night before — to put on my game face, but then he texted me that he couldn't make it because his band wanted to go to Target. Seriously, Target. There isn't a proper response to that kind of mundane blow-off, so I went with the nuclear option. I texted him back that he was a sucky soul mate. I went home and told the boy I was dating that I was ready to get serious. I dropped my sucky soul mate and his band's EP out of rotation from my iTunes.

WARNING SIGN: BROS BEFORE HOS

This is a moment that occurs in nearly every wife-of-the-rock-star story. At some point, usually when the relationship first hits the rocks, girlfriends and wives are banned from joining the tour. Any variety of reasons might be given for this directive, but the reality is that it gives the musicians the opportunity to drink copious amounts of liquor, boink groupies, and act like bad little boys with no one keeping score. It is actually a pretty understandable phenomenon. The road is full of strange hotel rooms, permanent midnight, and groupies who will do anything for a piece of their favorite star. If every day brings offers of no-strings sex with someone who only wants to please you, it can be difficult to keep saying no.

That alone can become a pretty serious threat to your relationship, but what happens when you find it's not the groupies getting in the way, but the band? Or the business manager? Or the personal assistant? When a third party manages to wedge their way between you and your rock star, it's only a matter of time before you find yourself exiled. Your rock star knows it's happening. In

fact, he's most likely using the interloper for cover to avoid whatever it is about your relationship that needs avoiding.

Angela Bowie should have seen her problems coming when she proposed to David, couching their union as a business venture so as not to give her heart away. His reply was, "Can you deal with the fact that I'm not in love with you?" She should have ended it right there by walking away. Instead, they got married. By the end of their eight-year marriage, Angela was unable to get past David's fanatical personal assistant to speak to him, at David's own direction. Divorce via personal assistant is on par with being dumped by text message. This had to have been an especially hard blow to a wife who purported to be as creatively invested in her rock-star husband's career as Angela did.

Deborah Curtis, widow of Joy Division's Ian Curtis, paints a similar picture in her memoir, *Touching from a Distance*. In the very short life of Joy Division, Ian banned all women from their practices and tours, and after Deborah gave birth to their child, he wouldn't allow her to come to any of the band's shows. He used the creative process of writing songs, which was sacred time with the band, as cover for an affair. The stress of juggling both relationships triggered an increase in epileptic episodes for Ian, and after months of leading a double life, he committed suicide at the age of twenty-three. We'll never know why he took his own life. His untimely death wasn't due to any one thing, but likely a combination of feeling torn by his adulterous affair, his lifelong struggle with epilepsy, and the pressures that came with the increasing attention for the band.

This sort of dramatic ending doesn't just happen to underground band wives. One of the most famous rock-star wives in

history, Priscilla Presley, was barred from Elvis's tour after the King's 1968 Vegas comeback. The next thing she knew, they were living separate lives. In her memoir, *Elvis and Me*, Priscilla paints a picture of herself as a child bride who had been under her husband's thumb since she was fourteen. When he forced distance between them, she found a sense of independence by taking crazy new-age classes — the two of them were pretty divorced from reality by the time they split — and developing her own interests. Elvis's "no chicks on tour" mandate ended up working against him when Priscilla asked for a divorce.

It's easy for rock stars to build up layers of people around them as insulation from the outside world. It's even easier to hide behind obligations to the band. And if the wife protests too much, she'll start hearing choruses of "Yoko Ono." The only way out of this hell is divorce — preferably one in which you take everything.

That summer I started to miss our conversations, and because I'm a glutton for punishment, I started e-mailing the Soul Mate again. He told me about the temp jobs he was taking while his band tried to make it. I told him about the book I wanted to write, which turned out to be the one you're reading right now. My relationship with my boyfriend was already flailing, but I was loath to be the one to instigate our breakup. When the Soul Mate came back to New York in August, I went to see his band. I watched their show. Immediately I was a goner, and my hormones were to blame. At the same time, I started representing his band at MTV because they were the sort of band I often got behind. It was expected. Their first album was about to be released, and it was already clear it was going to be big. I was excited to work on a project that promised to be a success, thereby earning me brownie points

at work as a genius trendsetter. I consciously refused, at the time, to consider just how fraught mixing business and pleasure could be.

As our e-mails continued and his band started to take off, he told me how weird it was to watch their audience expand to include people who were radically different from them, and not necessarily in a good way. I told him Kurt Cobain once felt the same way and that becoming bigger meant becoming more detached from the audience for the sake of your own survival. He was struggling to reconcile his band's reputation and who he wanted to be with the people they were becoming. There's a degree of selling out that inevitably accompanies success, and most bands don't realize it's happening until it's too late. It's a short jump from the conversation we were having to realizing your audience is made up of frat guys with whom you wouldn't want to have a conversation.

WARNING SIGN: YOUR UNIVERSE GETS SUCKED INTO HIS EXPANDING STAR

The Soul Mate and I didn't have to face the problem of our egos facing off because I had my own work and aspirations that weren't wrapped up in his musical career, but I would be remiss not to address it.

It's a problem that was acute for many wives of '60s and '70s icons, and Suze Rotolo, Bob Dylan's paramour who appeared with him on the cover of *The Freewheelin' Bob Dylan*, is a prime example. In her memoir, *A Freewheelin' Time*, she talks about her distaste at being cast by Dylan's contemporaries as the girlfriend who was relevant only as a muse for his songs. She was hurt when she was publicly informed that Dylan was having another

relationship at the same time with Joan Baez, but she wasn't neces-
sarily shocked by his behavior then or by his eventual public snub-
bing of Baez. Rotolo writes, "Girls knew their place if they were
girlfriends. Even if they were folksingers working their way up just
like the guys, their position was not quite the same."

This proved to be prophetic commentary on how Dylan's rela-
tionship with Baez would play out. When Baez and Dylan played
live together in '63, on her tour and at the Newport Folk Festival,
she was much more famous than he was. They were in love, and
Baez felt it was her duty to put Dylan's music in front of the pub-
lic. He had the talent, and she helped give him the platform. By
the time they toured England together in '65, he had become the
voice of his generation and never once invited her on stage for a
duet, because he was at the self-centered-dick stage of his career.

Baez and Rotolo were both well-educated, talented, thought-
ful muses for Dylan. They helped advance his songwriting and
persona. In the end, though, the power of his sun was so great that
all the women orbiting him ended up burned to a crisp. His fame
spiraled out of control so quickly that the man even managed to
singe himself. By the time he turned up in Marianne Faithfull's
party-girl life in '65, he was a stoned shell of himself, hitting on
pretty little girls, interested only in their breasts. This is the prob-
lem of growing fame. It is impossible to remain unchanged when
you gain the adulation of millions, and it takes an incredible sense
of self to stick with anyone through the life-changing process of be-
coming famous. Only the most remarkable of partners can avoid
getting sucked into the orbit when the rising rock star becomes the
center of the universe.

Rotolo's ability to see what was going on in 1962 as Dylan started to gain acclaim was really impressive. Against his wishes, she ran off to Italy to go to college. She pursued her own ambitions and refused to remain a slave to his. Not many women can resist the excitement the world of rock stardom offers, let alone have the presence of mind to satisfy their own needs. As time marched on for Rotolo, however, she fell into the Warhol crowd, partly because Dylan hated them. She had to be rescued from her own bad drug decisions by Dylan well after their breakup (which had to have been at least a little humiliating, after all they had been through). Although she is, more than most rock-star wives, an exceptional person in her own right, she is still only as interesting to history as her most famous lover.*

The Soul Mate came back to New York with his band that fall. We texted pop-culture references back and forth for two days straight, starting the moment his tour bus hit the Lincoln Tunnel. He made sure I was coming to their show and the after party. I had broken up with my boyfriend, and I was in it to win it. I remember feeling so anxious about seeing him that I had to force myself to go talk to him at the party after the concert. When we finally did connect, it felt as if the room were on fire. We talked, we drank, and before I saw it coming, we were kissing. Then we were full-on making out. In the bar. In front of everyone: his band, the record label, my co-workers, and a bunch of way-too-cool strangers.

* During the editing of this book, in February 2010, Suze passed away.

I made a few fatal miscalculations. First, because he was in a band and I worked at MTV, I assumed that there was a power dynamic between us that ensured he would not dick me around. This led to my second miscalculation: I'd assumed he was single. I was wrong on both accounts. Not only did he have a girlfriend then, but he'd had a girlfriend when we met. He chose not to disclose this bit of information until a few weeks later, upon my suggestion that we try having a date when the band was back in my town.

My exact text in reply was, "ew ew ew we're done talking now." Then I threw the phone across the room.

WARNING SIGN: HE PUBLICLY EMBARRASSES YOU

By the time Pattie Boyd's famous husbands were all done with her, she had no idea who the real Pattie Boyd was anymore. Boyd started out as a model in London in the Swinging '60s. As an extra on the set of *Help!* she met Beatle George Harrison, who was so inspired by her countenance that he wrote "Something," one of the Beatles' finest songs. Within a year she became his wife. Fast-forward half a decade . . . and family friend Eric Clapton had become obsessed with her. In an effort to woo Boyd away from her marriage, Clapton wrote "Layla" and "Bell Bottom Blues." Around this time, Pattie learned that Harrison had been unfaithful. He started bringing mistresses to their house and even slept with Maureen Starkey, Ringo's wife, while Pattie was home. Who wouldn't leave all that for a little "Layla"?

Clapton wasn't quite the Prince Charming she had hoped for. Within a few years, she discovered that he too had been cheating

on her. In a childish move to fix it, he proposed. I suppose you could look at it as an apology by way of grand gesture. But Boyd later found out that Clapton had popped the question because an item stating that they were to be wed was scheduled to appear in the papers shortly — the result of a drunken bet with his manager. And so the two were quickly married in Tucson, Arizona. They skipped the honeymoon and went straight out on a string of tour dates. Sweet romance, right? It wasn't long before Clapton pulled the "no wives on tour" card, sending Boyd home and making room in his bed for a groupie who was nowhere near as beguiling as the woman who had inspired him to write "Bell Bottom Blues" — but was at least ten years younger.

Things got worse for Boyd. Clapton was an alcoholic. After seeking treatment, he fell off the wagon so hard that she finally left him. He talked her into coming back home. And then he told her he was in love with someone else. That someone else quickly announced she was pregnant and became the mother of his only son. To add insult to injury, Boyd had been trying unsuccessfully to get pregnant for years. By now she was in her mid forties and was approaching the point at which motherhood would be impossible.

A guy who will unthinkingly destroy you because he sees his own needs as more important than yours is a jerk. You wouldn't think that would have to be articulated, but since the concept of rock stardom first powered into existence, a substantial number of women have proven themselves more than willing to subjugate themselves to musicians' egos. A parting comment on this: If they do it once, they will do it again. If it happens to you, at least have

the courage of your convictions and stop yourself from going back for more.

Even after our series of infuriating texts, the Soul Mate wasn't done talking to me. He e-mailed the next day to apologize profusely and berate himself. For once, it was nice to have a guy own up to the epic-asshole level of his actions. He also made it clear that he was very much in love with his girlfriend and I shouldn't hold my breath waiting for that to change. I wasn't the wife in this rock-star romance; I was the groupie. If I had known all the facts in advance, things would have gone differently. We would have made lovely friends and nothing more.

Although I wanted to, I couldn't cut him completely out of my life. His band still had to do stuff with MTV, and I chose to see him at the little soirees in restaurants and concert halls that I was invited to when he played shows in my city. It would have seemed odd if I hadn't shown up, given our professional relationship, but every time I had to do something as small as schedule one of their videos, I had to swallow another chunk of my pride. Hearing their music when I went shopping or sat in a bar was the worst torment. Through all of this, he and I kept standing around at these little gatherings, talking about books and pretending we weren't completely petrified of each other.

Realizing I'd thought I was a wife but was really just a groupie was a worst-case scenario for me. It was humiliating. I was pissed off at myself most of all, because I was just as stupid and deluded as Pamela des Barres. It meant I was a dumb girl, a Penny Lane

who believed the fairy tale and didn't know how they really saw her: as a prize to be traded in a poker game when the tour was over. Just the same, I don't think I would want to be a rock star's wife, either. Rock stars only disappoint.

If I were more like Pamela des Barres, I would still be his friend even though he disappointed me. One thing that crazy groupie was always able to do was show up for the next concert with a smile on her face, no matter the circumstances. I'm working on mastering that skill to manage this rock star, but his band's music is permanently out of my rotation. I need my space.

ROCK 'N' ROLL CONSORTS PLAYLIST

THE VELVET UNDERGROUND, "Femme Fatale"

LED ZEPPELIN, "Whole Lotta Love"

MARIANNE FAITHFULL, "As Tears Go By"

IKE & TINA TURNER, "Proud Mary"

MÖTLEY CRÜE, "Dr. Feelgood"

DAVID BOWIE, "Rock 'n' Roll Suicide"

JOY DIVISION, "Means to an End"

ELVIS PRESLEY, "Viva Las Vegas"

JOHN LENNON, "Oh Yoko!"

NIRVANA, "Heart Shaped Box"

BOB DYLAN, "It Ain't Me Babe"

JOAN BAEZ, "Diamonds and Rust"

THE BEATLES, "Something"

DEREK AND THE DOMINOS, "Layla"

DEREK AND THE DOMINOS, "Bell Bottom Blues"

BEATLES VS. STONES

WHEN I WAS a newly minted twenty-one-year-old in Dallas, there was a cute but moody guy named Patrick who hung out with my group of friends when he deemed it worth his time. Patrick played guitar in a twee rock group and was renowned for being a total asshole who could pick up almost any woman. The other guys were dumbfounded by his skills. They didn't understand that his cocky attitude was a captivating siren's call for girls, especially girls who were young and self-destructive in romance.

One night Patrick and I were hanging out at a show. Out of curiosity about his oft-discussed abilities as a lady-killer, I asked him what his best pickup line was.

"I usually just go up to a girl and ask, 'Beatles or Stones?'"

"But what's the right answer? What do you want her to say?"

"If she says Beatles, then she's probably a nice girl and has good taste in music," he paused to smirk at me, "and if she says Stones, you know you can take her home and fuck her."

No joke, that is exactly what he said. I was completely taken aback. It's not that it wasn't obvious to me that sex and rock music go hand in hand, but it had never occurred to me that my sex drive would be subject to the snap judgment of random guys based on my preference in bands.

Patrick's pickup line stuck with me, and over the years I've

told this story many times. It almost always gets the same reaction. Boys are able to anticipate where the story's going. They tend to look sheepish, laugh, and say, "Well, yeah, but it's kind of true." Girls almost never see what's coming and are either horrified or say something along the lines of, "That explains why guys look excited if I say I like the Stones."

After this little chat, I spent years insisting my answer was neither Beatles nor Stones, but *Pet Sounds* by the Beach Boys. When it comes to sex, I like to be a woman of mystery. I could give you a list of reasons why that single album was better than anything either of the other bands ever released, but it was really just a dodge of what I felt was an unfair evaluation of what might be happening in my pants. You could be a conscientious objector, too, for reasons entirely your own, and choose the Who, the Kinks, the Supremes, or whomever, and that's fine, but sidestepping the question entirely is a cop-out. Choosing favorites in seemingly impossible situations is what music nerds do for fun. And I've grown to believe that you can avoid lecherous pigeonholing if you can support your choice with a considered explanation.

Even if I never admit it to the sort of guy who'd ask, after a thorough comparison of their bodies of work and the bands' histories I finally realized that I'm a Beatles fan through and through. My arguments for the Beatles are not entirely musical, but it's clear they never stopped being the world's greatest rock 'n' roll band and the Rolling Stones are pretenders to the throne.

NUMBERS NEVER LIE

By the end of 2009, the Beatles had sold over a billion records worldwide to the Stones 600 million. Let's take a closer look at

those numbers. The Stones released their first album two years after the Beatles' debut and have continued recording and touring in the years the since the Beatles broke up. Three of the Stones' most critically lauded albums were released post-Beatles (1971's *Sticky Fingers*, 1972's *Exile on Main St.*, and 1978's *Some Girls*), so they've been recording for about forty years longer than the Fab Four and have produced about fourteen more studio albums. (That number is debatable because, as was customary at the time, the Beatles released multiple albums with overlapping track lists.) Until very recently the Beatles' songs have not been available for sale as digital downloads. Despite having four additional decades of recorded output and more music available from more places in more formats, the Stones have sold some 400 million *fewer* albums than the Beatles.

On November 16, 2010, the Beatles' back catalog was finally made available for digital download exclusively on iTunes, accompanied by much press and a marketing campaign paid for by Apple to mark the event. In the first week they sold two million individual songs and 450,000 albums worldwide. Those are sales of tracks that have all been available and widely purchased on vinyl, tape, and CD by the general public over the last forty years. No new audio material at all.

Entangled by contractual and copyright issues, the Rolling Stones made their catalog available for download with various partners on a piecemeal basis, getting it all out there by 2005. However, they boast no comparable first-week sales numbers for either the big release of their ABKCO catalog or their later Virgin catalog release, despite big marketing pushes by online retail partners. It was news when their digital catalog became available, but

it wasn't the same kind of worldwide event as when the Beatles finally broke their status as digital holdouts.

It's questionable to say one band is better based on sales alone, because then you imply that commercial art is more valuable than other art, which I don't think is true. But it's not like I'm comparing Britney Spears and Bright Eyes here. If anything, the Beatles' later output is far more artistic and inscrutable than anything in the Stones' oeuvre. Given that these two bands took off commercially in the same decade, with similar recording, distribution, and promotion resources, it's reasonable to expect that the total sales would be in the same ballpark. Selling 600 million albums is nothing to sneeze at, but the Beatles' music has outsold the Stones by a 40 percent margin. In overall earnings, however, the Stones may have come out ahead through their massive tours in the '80s and their fondness for playing exclusive parties for monstrous fees.

WHAT'S REAL AND WHAT'S PUBLICITY?

If the Beatles obviously have it over the Stones in sales, the question remains: How did the two bands get cast as rivals in the first place? To understand how they became the biggest bands in the world, one right after the other, we have to go back to the 1960s and the beginnings of rock 'n' roll. Enter the Beatles, a group of long-haired guys from Liverpool, one of the UK's grittier cities. They started as lads in leather jackets and rockabilly hairdos with a Bill Haley & His Comets look (think The Fonz on *Happy Days*), and in their quest to get to the toppermost of the poppermost, they morphed into the more recognizable wholesome boys in matching suits that even mums and dads could enjoy. At this point, they weren't exactly the highly developed musicians they

would become after 1965. They wrote songs that capitalized on the interests of teenage girls, which is precisely why the early Beatles material was cheesy — those dudes weren't even trying. They were cashing in on teen dreams and candy-covered rainbows. Just the same, they managed to have a profound effect on the perception of pop music by the general public. Beatlemania awakened US advertising agencies to the phenomenon of youth culture and the emerging counterculture. And at the time, Americans under the age of twenty-five made up 40 percent of the population — it wasn't a demographic that could be ignored. To the ad world that amounted to an insanely large market with a loud, shrill, screaming voice.

Beatlemania opened the door for other UK bands to enter the US market. The Stones' manager Andrew Loog Oldham immediately cast them as the evil yin to the Beatles' yang. Their career was launched with Oldham's "Would you let your daughter go with a Rolling Stone?" campaign in 1965, though "go with" was later changed to "marry," because even in London's Swinging '60s, the sexual implications of "go with" were too tawdry for the public. The campaign was successful in making the parents of Britain extremely uncomfortable, and thus, a group of bad-boy teen idols was born. When the Stones started writing songs after their first few albums as a cover band, they got at the heart of hormonal teenage desires and '60s misogyny in songs like "Yesterday's Papers" and "Stupid Girl." Where the Beatles charmed schoolgirls by shaking their mop tops and slyly hinting at the darker side of life, the Stones put it all out there. They painted themselves as the dangerous types your mom had warned you about right from the start.

The Stones actually started out as a rather innocent bunch of

boys, save the slightly older Brian Jones, who really did impregnate girls, run off to do drugs, and live the life of a homeless vagabond musician. Keith Richards and Mick Jagger bonded over a shared love of underground blues records, which accounts for the more overtly sexual nature of their music as compared to the innuendo that was a staple of pop music at the time. Controversial press coverage of the band led to intense police scrutiny and some notable brushes with the law, including the legendary 1967 raid on Keith Richards' house, when Mick Jagger's then-paramour Marianne Faithfull was found wearing nothing but a fur rug. Jagger and Richards were both arrested on drug charges, and their very public trial highlighted the "us vs. them" tension between '60s youth and the Establishment. They were both heavily fined, and Richards was sentenced to a year in jail (later overturned). The rockers had evolved to embody the contrived personas that had been created for them.

After famously being introduced to marijuana by Bob Dylan, the Beatles too experimented with all sorts of drugs, including LSD, but this was rarely ever mentioned in the press and was virtually ignored by the UK police. The idea that the Fab Four were unimpeachable was so ingrained in popular culture that for years the police were willing to look the other way when the Beatles fell under suspicion. It wasn't until 1968 that Lennon and Harrison were finally busted for possession of cannabis resin.

Buying into the idea of the Beatles as "good" and the Stones as "bad" is to believe the hype. Oldham could never have contrived the early Stones' bad-boy image without the Beatles' good-boy one to play off. The imagined feud made excellent fodder for the press.

Both bands had their share of high-profile soap-opera moments, from John Lennon's desertion of his wife, Cynthia, and son, Julian, to Brian Jones's abuse of his girlfriend Anita Pallenberg, who then left him for Keith Richards. Not to mention their everyday, on-the-road indiscretions. In truth, there are no nice guys or bad guys here, just some images that were marketed for the tabloids and teenage girls.

WISDOM IN LYRICS

I have a theory: Women who prefer the Stones to the Beatles aren't slutty, as traditional guy wisdom suggests. They are women who like assholes. It's a phase many girls go through, some of us for longer than others. A whole lot of Stones' lyrics come from a very selfish place that's anti-relationship and anti-woman. (Hello, "Under My Thumb," I'm looking in your direction.) While the Beatles have more than their fair share of sweet love songs, the Stones spend a lot less time singing about being in love and focus more on sex as a weapon.

Nearly everything about the Stones is designed to make guys think about sex, from the band's ripped-off aggro-blues riffs to the lewd lyrics about spending the night together. Listening to phrases like "cocksucker blues" and "rocks off," guys start to think about all kinds of ways of getting it on. They see the cover of *Sticky Fingers* with Mick Jagger's exaggerated crotch or the Stones' famous tongue logo and think about blow jobs. Some of them will admit it. Some of them will say they appreciate how the Stones sing about "real" things that they can relate to; that's code for, "This song is about fucking!" Since the Rolling Stones so effectively make men

think of their carnal desires, and they assume the band does the same for you.

When a guy is looking to hook up, he may seek out a girl who prefers the Stones. Then he'll tell her up front that he's only down for sex, on the theory that any girl who's into "Under My Thumb" will be self-loathing enough to go along with it. He's hoping he'll get off scot-free because he told her it wasn't going anywhere from the start. It's a weak assumption, and those guys are wrong. The lyrics to Stones songs like "Under My Thumb" piss me off no end, but the music's so fantastic to dance to that I find myself unable to hate it.

For a woman, there is a complexity to liking the Stones, and they don't make it easy on you. On one hand, they hit you with a sweet, swoon-worthy ballad like "Wild Horses" that speaks with the voice of a sensitive soul who's been bruised by love. In the other corner, they come at you with a come-fuck-me song like "Rocks Off," whose lyrics read like a barroom challenge of the sexes. The Stones' lyrics cover everything from overthrowing conventional values on "Sympathy for the Devil" to spouting philosophy with a choir of angels for backup on "You Can't Always Get What You Want." This isn't the music for sluts; it's music for a woman who appreciates a complicated man, who may at times send mixed messages but keeps things interesting. Sure, he's a bit of an asshole, but you're never bored because you have no idea what he's going to do next. Being in a relationship with an asshole is like being an adrenaline junkie — the drama is addictive. It's the same reason some guys like crazy girls. And it's part of the overall allure of the Stones. We speculate about which woman Mick Jagger really

wrote "Wild Horses" for and accept terrible saccharine ballads like "You Got the Silver" from Keith Richards because he wrote it for his crazy German lover Anita Pallenberg. The songs themselves are good, but so too is the personal drama behind them that has become intertwined with our perception of their music.

IS IT BETTER TO BURN OUT OR FADE AWAY?

Even most Stones fans will tell you that there is an expiration date by which the band should have broken up. Few people would argue that their post–*Some Girls* (1978) material is necessary. The one thing we can all agree on is that by now the Stones are well beyond the point when they should have given up being an arena rock band. Their touring became a complete affront to rock 'n' roll for two reasons: 1) They're still playing songs in their sixties that they wrote in their twenties and thirties about sex, drugs, and fighting. This is unappealing because most younger people don't care to think about the sexual viability of a man the age of their grandfather who wears eyeliner and wants to be started up. That's gross. 2) The entire raison d'être behind their continued career as a huge touring band has become a series of cash grabs designed to maximize their income with the least amount of taxation on their time and creative efforts. That's selling out.

I suspect that if any of Mick Jagger's solo albums had been a success, he would have broken up the Stones immediately. But he flopped on his own, and so the Stones as a band and brand live on as a money-making machine. Their whole career followed the flow of the money, as was audaciously illustrated when they fled to France to dodge UK taxes while recording *Exile on Main St.* Their

greed was most recently displayed in their collaboration with Martin Scorsese to create the live-performance documentary *Shine a Light*, which is arguably one of the worst and most-bloated rock docs ever filmed.

Even their turn in one of the greatest rock docs ever made, *Gimme Shelter* — the story of the tragic events of the Stones' free concert at Altamont that became the defining musical statement on the death of '60s counterculture — was ultimately a case of the Stones' trying to make a buck. The now-legendary free concert was organized and headlined by the Stones after the manager of the Grateful Dead suggested a "Woodstock West." (Ultimately, the show would turn out to be such a disaster that the Dead turned around and left instead of playing the festival.) It was marketed to the public as a free holiday concert to cap off the US tour that reportedly earned the Stones over a million dollars — big bucks in 1969. The promoters working on behalf of the Stones and the Dead were unable to obtain the proper permits for their first venue of choice, San Francisco's Golden Gate Park. The owners of a second site, the Sears Point Raceway, wanted the rights to film and distribute the concert, but the Stones were already planning to use footage from the show as the climax of their 1969 tour film and would not agree to the terms. The disagreements and fallouts with venues led to repeated cancellations, followed by announcements that the show was still on. Twenty hours before the show was to begin, it was decided it would be at the Altamont Speedway, a gravel pit thirty minutes away from San Francisco that usually served as a demolition-derby track. The venue was shoddily set up, with no food or water, a dire lack of medical supplies, insufficient bathrooms, poor parking, and no provisions for crowd control beyond

the Hells Angels, who were paid $500 in beer to keep people off the stage.

The Stones were not entirely at fault for the events at Altamont, although their grandstanding during their performance, poor choice of songs, and irresponsible management of the venue have long been thought to have needlessly incited the already explosive mood of the crowd. Over the course of the day, the Hells Angels harassed the performers and crowd ruthlessly. As many as 850 people were injured, including several who were hit by cans of beer the Angels were randomly throwing into the audience, and Jefferson Airplane singer Marty Balin, whom members of the motorcycle gang attacked on stage. Four people died at Altamont. While three of the deaths were ruled accidental, the fourth was a homicide. During the Stones' set, as they played "Under My Thumb," the Angels stabbed and killed an eighteen-year-old black man named Meredith Hunter, who was seen brandishing a gun. *Gimme Shelter* captures the moment on film, turning what was supposed to be a standard tour documentary into one of the most notorious films of the twentieth century, nudging into first place because the other infamous Stones film, *Cocksucker Blues*, remains officially unreleased. *Cocksucker Blues* documents the band's first return to the United States after Altamont, along with some serious sex, drugs, and rock 'n' roll. It was not released because the Rolling Stones themselves decided the content was inappropriate.

I've always found it amazing that the Stones allowed the release of *Gimme Shelter*, because they come off as completely irresponsible and out of touch. But it was one more way for the band to get deeply in touch with your wallet. By partially financing the film and, some speculate, influencing how they were portrayed to

whitewash their involvement, they managed to capitalize on their negligent role in one of the defining disasters of rock history. By extension, both the Stones and the production company behind the movie have profited from exploiting the death of a young man alongside the inevitable demise of the Woodstock generation.

In the decades since this incident, the Stones have devolved into greedy old men of questionable creative talent. Every world tour, as the audience wonders who might break a hip on stage during this go-round, their legacy as the most dangerous band in rock 'n' roll unravels just a little more. Once you looked to the Stones and found the definitive rock band; look today and you'll find old men who are in it for a paycheck.

Finances become a problem for many bands, and the Beatles didn't escape such troubles. In the end, their disagreements over money management were a major factor in their breakup. The friction so often attributed to the presence of Yoko Ono had a lot more to do with the battle over who would handle the Beatles' affairs after the unexpected death of their longtime manager, Brian Epstein. Nor was the band's post-breakup asset management entirely without missteps; consider the notable period when they let go of publishing rights for their songs. Sony ATV and Michael Jackson picked them up, which resulted in both a falling-out between McCartney and Jackson and the infamous placement of "Revolution" in a Nike commercial. It could have been so much worse, though, if the Beatles had stayed together or, worse yet, had the opportunity to reunite. Too many bands of the '60s through the '90s are cashing in with reunion tours for nostalgic fans who will pay to see the performers well past their prime. It's embarrassing, and I'm

glad the Beatles did not partake. They will remain the 1960s versions of themselves in our minds forever.

NATURE VS. NURTURE

For some of you, this entire discussion is moot because you made your choice long before you even reached dating age. It's very likely that you grew up in a Stones or Beatles house. Your parents, TV, or radio introduced you to one of the bands first, and that early exposure greatly influences which one you prefer now. It's called sense memory — you probably identify one band with happy times or time spent listening to the music of a trusted parent or older sibling, and so you'll always be partial to them.

I grew up in a Beatles house. We listened to the White Album all the time. My personal childhood favorites were "Ob-La-Di, Ob-La-Da" and "Rocky Raccoon." I was also quite obsessed with *Abbey Road*. On weekends my stepdad and I would make mix tapes together from his record collection. I wasn't allowed to touch the vinyl, but I did get to pick the songs, and the Beatles were a perpetual favorite. Not at all coincidentally, when the time came to buy my own records to play on my Fisher-Price record player, the first thing I saved up my allowance to acquire was Julian Lennon's *Valotte*. I tried not to buy records my parents already had in their rather extensive collection, but when I moved out of their house, one of the first things I did was get my own copy of *Abbey Road*.

I was ten before I started recognizing Stones songs, largely on the radio, where "(I Can't Get No) Satisfaction" got excessive play on the local classic-rock station. Even at that young age, I thought

their songs seemed crass and immature, certainly compared to the more sophisticated Beatles songs I'd grown up listening to. At the time I was more into George Michael's "I Want Your Sex" than the Stones' "Beast of Burden," and Bette Midler's cover of that song didn't help the Stones earn any cred with me. The best Stones' songs do, however, have that magic X-factor that makes them amazing to sing along to while you're driving around with the windows down.

From age twelve on, I spent more time with current popular music than I did deep-diving in anyone's catalog, and didn't go back to listen to the Stones or the Beatles much until my twenties. Having been weaned on the Beatles, the Stones never stood a chance with me. Then again, if you ask me in five years, I might change my mind entirely and tell you that *Let It Bleed* is a grossly underrated work of genius. It is my favorite full-length Stones album.

And so, having spent some serious time contemplating which band I prefer, I leave you with three conclusions:

1. Comparing the Beatles and the Stones is stupid, because it's based on an outdated marketing concept from the 1960s.

2. Being a woman who likes the Stones is not the same thing as being a man who likes the Stones, and to make such an assumption is folly.

3. If you're asking, I prefer the Beatles.

Should guys try to extrapolate my sexual preferences, intelligence level, or any personality trait from my answer to the Beatles-or-Stones question? Absolutely not. Will asking this question lead to a very interesting conversation, giving two people a great excuse to flirt and talk about themselves? Oh, yes. In fact, I might start using it as my pickup line.

BEATLES VS. STONES PLAYLIST

THE BEATLES, "Tomorrow Never Knows"

THE ROLLING STONES, "Yesterday's Papers"

THE ROLLING STONES, "Stupid Girl"

THE BEATLES, "She's Leaving Home"

THE ROLLING STONES, "Under My Thumb"

THE ROLLING STONES, "Wild Horses"

THE ROLLING STONES, "You Got the Silver"

THE ROLLING STONES, "Rocks Off"

THE ROLLING STONES, "Sympathy for the Devil"

THE ROLLING STONES, "You Can't Always Get What You Want"

THE BEATLES, "Ob-La-Di, Ob-La-Da"

THE BEATLES, "Rocky Raccoon"

THE BEATLES, "Dig a Pony"

THE ROLLING STONES, "(I Can't Get No) Satisfaction"

GEORGE MICHAEL, "I Want Your Sex"

BETTE MIDLER, "Beast of Burden"

FINAL NOTE

down the music k-hole

MUSICAL DISCOVERY IS not just about finding brand-new music. It should also consider music that's new to you. A collector of any depth and range—especially one who wants to understand the abstruse reference points of critics who love name-checking other bands in a revolving game of "sounds like"—must know about the artists who influenced their current favorite bands. When I know what I want to hear but am burnt out on the current crop of music, I like to take a trip down the music k-hole.

If you're not a recreational drug user or a recreational user of drug slang, allow me to loosely define the k-hole: it is the dissociative state of mind one experiences after taking too much Special K. Many claim to have achieved enlightenment after their trip down the k-hole. I think of the musical k-hole as a similarly disorienting experience, where you explore music that you've never even thought about before and become so engrossed that you lose all sense of time and space. This is often a directionless exercise, but for the purposes of this book I offer you a guided tour. Our preferred map today is my Rhapsody subscription and AllRovi.com, the new site intended to replace

the All Music Guide (an online depository of biographies and al-
bum reviews).

First, identify what you want to hear. Let's say, for instance,
it's TV on the Radio. You like their sound, but you know their
albums inside and out and are bored with them. It's time for
something new. So you pull up their page on AllRovi and start
looking around.

**If you want to listen to a band that inspired TV on the Radio,
go to ONE.**

**If you want to listen to music that sounds like TV on the Ra-
dio, go to TWO.**

ONE

TV on the Radio's profile page includes some fascinating content in the "influenced by" section. The list of musical influences here may be among the top ten weirdest things you will read on the site. It includes a mish-mash of bands, from the Pixies and Funkadelic to Public Image Ltd. and Peter Gabriel. If you didn't already know what TV on the Radio sounds like, this list would make them seem insane. Your eye is drawn to Pere Ubu, because you've heard of the band but never really listened to them. You click through to their discography to determine which album is arguably the best. You can decide strictly by the star ratings or you can click and read a review to be sure you're getting the best match for what you want to hear. You see that the first two records from the late 1970s have been crowned their "masterpieces" that straddle the border of art punk and just plain punishing to the ear. You have the easiest time finding a copy of their second album, *Dub Housing,* on Rhapsody and opt to listen to that. This album turns out to be an excellent substitute for listening to TV on the Radio's *Return to Cookie Mountain.* It has all of the disjointed, dark music and vocal yelping that suits the sort of art-rock aesthetic you were hoping to find.

If listening to Pere Ubu put you in the mood for more post-punk, go to THREE.

If you'd rather get back to the present and listen to a band that's a contemporary of TV on the Radio, go to FOUR.

TWO

At the moment you want to recreate the feeling you get from TV on the Radio's music, searching for something similar but less familiar. You see David Bowie listed as an influence for their *Dear Science* album, so you Google him. It turns out Bowie produced a documentary on Scott Walker that looks interesting. To find out what Bowie, TV on the Radio, and Scott Walker have in common, you decide to pull up the Walker Brothers' *After the Lights Go Out: The Best of 1965–67*. Scott Walker has a dark, swirling voice and you're curious to hear more of the vocal blending that must have happened on albums with all three Walker brothers.* AllRovi tells you this album is notable for some excellent songwriting by John Walker, who never achieved the kind of successful solo career that Scott Walker enjoyed. A click-through to his full songwriting credits reveals he was in a death-metal band in the late '80s and '90s called Cancer, which is a fascinating jump from the soft rock he played with the Walker Brothers. You also see that the Walker Brothers performed "Make It Easy on Yourself," a classic Burt Bacharach/Hal David song that's been interpreted by hundreds of artists, from the Carpenters to Cilla Black to Rick "I Rickroll You Not" Astley. It's been recorded enough times that you could easily listen to it for two hours without listening to the same artist twice.

If you want to listen to death metal from Cancer, go to FIVE.

If you want to listen to "Make It Easy on Yourself," go to SIX.

* Incidentally, the Walker Brothers were not brothers or even actually named Walker. It is very the Ramones.

THREE

From Pere Ubu's AllRovi page, you click on "Post-punk" to get an overview of the key works in the genre. The first tier of the artist list is shockingly narrow, and you're familiar with everyone on it, so you go to the list of top albums instead. A few clicks farther down on AllRovi's list of definitive post-punk albums gets you to the Raincoats' self-titled album. You click to read more about the Raincoats and you notice a band called Sleater-Kinney listed as one of their "followers." This prompts you to Google "Sleater-Kinney and the Raincoats," and the first thing that comes up is a *Pitchfork* news item on Sleater-Kinney singer Corin Tucker's first solo album, *1,000 Years*. She names as influences for the album, "the Slits, the Raincoats, the English Beat, and Sinéad O'Connor's *The Lion and the Cobra*." After playing the title track from Tucker's album, you debate whether you want to listen to Sinéad O'Connor's debut album in full or listen to some other girl bands.

If you would like to listen to *The Lion and the Cobra*, go to SEVEN.

If you would prefer to investigate other all-girl bands, go to EIGHT.

FOUR

Back to TV on the Radio's AllRovi page. One band listed as an influence whose music you're not super-familiar with is Funkadelic. You pull up a few of their albums in Rhapsody, get your funk on, and find there is a tenuous connection to some of TV on the Radio's more jammy songs. You know the work of all of their other influencers, so go to **TWO** and start again.

FIVE

Wow. Bracing choice. This decision was a musical dead end for you. Go to **TWO** and start again.

SIX

Rolling through the various version of this Bacharach/David composition you happen across an R&B version by Jerry Butler. His voice is smooth. Very smooth. So you pull up a playlist of popular Jerry Butler tracks on Rhapsody and read his AllRovi bio, where you discover that his nickname is "The Ice Man" and that he was in a choir with Curtis Mayfield. Before long you are totally seduced by "Never Gonna Give You Up." You've heard the Isaac Hayes version before, but never Butler's original. You read that the song was written by the famous songwriting team Gamble & Huff, who were the architects behind the '70s Philly soul sound. Googling the two turns up a plethora of credits for both songs you know and songs you've never heard by singers you know. A quick Rhapsody search leads you to an album called *The Sound of Philadelphia* that looks reasonably interesting.

If you'd like to listen to *The Sound of Philadelphia*, go to NINE.

If all this soul put you inexplicably in the mood for some Prince, go to TEN.

SEVEN

It doesn't get much more definitively strong-female than world-class vocalist and slightly crazy person Sinéad O'Connor. As you begin listening to her stellar debut album, *The Lion and the Cobra*, you Google the title to find out what it means. Turns out it's a reference to Psalm 91 in the Bible. This brings to mind O'Connor's bizarre anti-papal outburst when she performed on *Saturday Night Live* in 1992. Hearing her voice reminds you that her biggest single, "Nothing Compares 2 U" was written by Prince, who has also fallen into a kind of weird, hyper-religious place in the last few years. You Google the story of how the hell Prince knows Sinéad O'Connor, and it turns out he didn't. "Nothing Compares 2 U" was written for the Family, one of his side bands, but was never released as a single and went more or less unrecognized for a decade until O'Connor covered it. It's always entertaining to compare different recordings of a song, so you hunt down O'Connor's version, the Family's version, and the versions Prince recorded after the song became a hit. But everyone knows you can't listen to just one sexed-up Prince song; they're like Pringles potato chips. You must have more.

All of this makes you want to listen to some more Prince. Skip to TEN.

EIGHT

You decide that if you're going to listen to a girl group, you might as well go with the most-successful girl group ever: the Supremes. Sure, Diana Ross is a bit of a ruthless egomaniac, but there are some amazing harmonies to be found in Supremes records. You do some reading and learn that the songwriting team of Holland-Dozier-Holland wrote all their biggest hits — that, in fact, the Supremes without this team is just the Supremes doing Beatles covers. You're fascinated by this symbiotic relationship, and you find yourself listening to all the Holland-Dozier-Holland compositions for Martha Reeves & the Vandellas to see if they stand up to the ones the guys wrote for the Supremes. Once you exhaust their catalog, you realize you can either look for another interesting songwriting team, like Gamble & Huff, who, you find, penned the amazing "I'm Gonna Make You Love Me" — a hit single for the Supremes and the Temptations but originally recorded by Dionne Warwick — or you can listen to some more definitive girl songs.

To explore the legacy of Philly soul hit-men Gamble & Huff, go to NINE.

To further scratch your girls-singing itch, go to SEVEN.

NINE

This Gamble & Huff album, *The Sound of Philadelphia*, really blows your doors off. While listening, you light a few candles and consider seducing yourself, but you're clearly kind of a nerd, so instead, you read about Gamble & Huff's Philadelphia International Records. This imprint of CBS Records was backed by legendary record-industry man Clive Davis and was a competitor to Motown Records, home of the Supremes. Gamble & Huff were inducted into the Rock 'n' Roll Hall of Fame in the nonperformers category in 2008. After a cursory look through the other inductees, you see that Isaac Hayes was the first soul act inducted, in 2002. Prince was the second, in 2004.

Go directly to TEN.

TEN

All roads lead to Prince. The best way to end your musical journey is by putting on his self-titled 1979 album and having a small dance party of one. Shake that money maker until you tire yourself out and fall asleep. *Sleep is the only exit from the music k-hole.*

ACKNOWLEDGMENTS

Thank you.

First of all, thanks to you for reading this book. Second, thanks to my agent, Laurie Abkemeier, for showing me the ropes, working incredibly hard to make this book a reality, and taking a chance on something I hope tickles her funny bone. To my editor, Meagan Stacey, who has massively indulged my artistic ego while simultaneously doing so much to make this book a million times better than I could have imagined it would be that words can't even express my thanks. And, naturally, thanks to everyone at Houghton Mifflin Harcourt for their support.

I could never have written this book without certain people, all of whom have changed my record collection in their own ways. Gina Esposito, with whom I've been discussing music and ripping apart relationships for long enough to know better (and who kindly let me put her life all over this book, like a good girlfriend would). Arye Dworken and Russell Sanzgiri, who big upped the idea from the start and gave me kicks in the butt full of supportive love. The Denton/Dallas boys, Josh Venable, Daniel Reid, Alan Reid, Jared Hoke, Glen Reynolds, Zac Crain, Shawn Francis: your conversations and obsessiveness changed me forever. Steve Seddon, whose enthusiastic amusement at "the toppermost of the poppermost" came when I felt I couldn't go on. Rodrigo Perez, Amy Doyle, and John Loscalzo, who probably thought I was crazy but continued to insist this could be done anyway.

And everyone who offered feedback and support that was very important to me: Peter Berard, Alex Sherman, Veleta Vancza,

Jacob Hurn, the Mishpucha, Susan Busch, Lacey Swain, Megan Jasper, Kerri Borsuk, Josh Legree, Liz Erman, Liz Hart, Adam Farrell, Kris Chen, Charlie Ebersbaker, Chad Ferman, Kristen Brown, Rawley Bornstein (still working on that chapter), Tricia Romano, Catonia Whalen, Miguel Banuelos, Colleen Quill, Michael Plen, and everyone who I forced to listen to numerous anecdotes about the Beatles and the Stones.

Special thanks to Kathy Valentine, Jane Wiedlin, and Charlotte Caffey of the Go-Go's, as well as Susanna Hoffs and Vicki Peterson of the Bangles, for taking the time to talk to me about being in girl bands (and Jenny Bendel and Taryn Kaufman for making sure those conversations happened).

And of course, thanks to my family, who are required to love and support me no matter what. Let's all remember that at Thanksgiving, okay?